THE RUSSIAN EXPERIMENT
IN ART: 1863-1922

THE RUSSIAN EXPERIMENT IN ART 1863–1922

CAMILLA GRAY

HARRY N. ABRAMS, INC. · Publishers · **NEW YORK**

*To my mother, to whom this book owes
its inspiration and realization*

Standard Book Number: 8109–0465–9
Library of Congress Catalogue Card Number: 76–106290
Copyright © 1962 in Great Britain by Thames and Hudson, London
Reissued 1970 in new format
Harry N. Abrams, Incorporated, New York
Printed and bound in Great Britain

2/2/76

Contents

Introduction

'Reality is superior to its imitation in art' – wrote Chernishevsky, the aesthetic propagandist of the 1860s in Russia. 'Let us tear ourselves away from our speculative activity [easel painting] and find a way to real work!' – was the cry of the Constructivists in the 1920s. The sixty years which divide these two quotations provide the scope of the present study.

Throughout this time and as a constant theme, now blazoned forth, now disguised, runs the idea of a renewal of art as a socially active force – 'which must not reflect, imagine or interpret, but really *build*' [the Constructivists] – 'to prevent the accusation that art is an empty diversion to be despised' [Chernishevsky, the spokesman of the 'Wanderers']. In this book I have tried to trace the thread of this debate and the way in which it was worked out in art in Russia.

The debate was brought to a head in the work of Malevich and Tatlin, of the Suprematists and Constructivists, when the idea of art as a spiritual activity was juxtaposed to that of propaganda-art; the artist–priest to the artist–engineer; art for today and the masses, and art for tomorrow and the *élite*.

I should like to explain that it was these works and ideas of Suprematism and Constructivism which first excited me and drew me to this study. These works are thus the focus of this book and my treatment of nineteenth- and early-twentieth-century developments has been governed by an attempt to trace back to the roots the ideas which culminated in the pioneer work of Malevich and Tatlin.

My task has met with many difficulties, for the documentation on this subject is rare and hard to find. There has been almost no general account of the period of 1910–20 in Russian art and I have had to turn to newspaper articles, unpublished memoirs, recollections of those artists still living – often so contradictory – exhibition catalogues, random references in published memoirs and occasional references in literary histories of the period which are far more numerous than those dealing with painting. The piecing together of this incoherent

6

information dealing with a period of such historic importance but immense complexity has been difficult.

I have many people to thank for their help and encouragement over the four years during which I have been working on this book. I would first like to thank Mr Jay Leyda who first made the ideas and personalities of my story come alive to me and Mr Alfred Barr who has allowed me to use unpublished material from his personal archives of Alexander Rodchenko; they have both given me invaluable help and encouragement in the course of my researches. Others whom I must thank for their practical help and advice are Professor Meyer Schapiro, Mr Herbert Spencer, Professor George Heard Hamilton, Mr M. Abramsky, the late Sir Herbert Read, the late Mr Eric Gregory, Professor David Talbot Rice, Mr W. Sandberg, Mr J.B. Neumann, Mrs Valerie Jensen, Lady Norton and Sir Isaiah Berlin.

There are others to whom I owe much: Miss Violet Connolly for first introducing me to Russia; Miss Dora Cowell and Mrs Anne Fremantle who have made this book a possibility through their generous support; and very specially to my sister Cecilia Gray for her generous and patient co-operation in providing me with so much of the photographic material.

I must also thank the following for providing me with photographs: Mr Eugene Rubin, Mr Andrzej Dyja, Miss Zoe Dominic and Mrs Leslie Bonham-Carter. I must also acknowledge my thanks for photographs to The Museum of Modern Art, New York; Yale Art Gallery, New Haven, Connecticut; The Hermitage, The Theatrical Museum and The Russian Museum, Leningrad; and the Tretyakov Gallery, Moscow.

I must also record my gratitude to the Directors and staff of the above-mentioned institutions for the facilities with which they provided me in the course of my studies: likewise those of the Slavonic Division of the New York Public Library; the Widener Library, Cambridge, Massachusetts; the library of The Museum of Modern Art, New York; the British Museum, London; St Antony's College, Oxford; the School of Slavonic Studies, London University and most particularly the Victoria and Albert Museum library in London where I have received every attention and a lively co-operation during the four years of my researches there. I must also acknowledge my thanks to the House of Friendship organizations in Moscow and

Leningrad which provided me with invaluable assistance in forwarding my researches in Russia.

Without the patient and generous co-operation of those surviving artists who took an active part in the story I have tried to relate, little would have been possible. I must therefore thank most particularly, for their help and permission to reproduce documentation from their personal archives, Mikhail Larionov and Natalia Goncharova; David Burliuk and Yury Annenkov; Naum Gabo and Anton Pevsner, Paul Mansurov, Vladimir Izdebsky, Zhenia Bogoslavskaya-Puni, Bertold Lubetkin, Mart Stam, Hans Arp, Ivan Tschichold, Nelly van Doesburg, Sonia Delaunay, Alexander Benois, Sergei Makovsky, Dr Zarnower, Mr and Mrs Rostislav Dobuzhinsky, as well as many others unnamed here.

Last but not least I must thank the many friends whose interest and encouragement has sustained my courage, among whom very specially Katia Zoubtchenko and my brother Edmund.

CAMILLA GRAY

1860's–90's

The cradle of the modern movement in Russian art can be traced to the colony of artists which was brought together by Savva Mamontov, the Russian railway tycoon of the 1870s. On Abramtsevo, his estate near Moscow, Mamontov surrounded himself with the most progressive personalities of his day, not only painters, but composers, singers, architects, art historians, archaeologists, writers and actors. Together they constituted the first challenge to the all-powerful Petersburg Academy of Art whose half-courtly, half-bureaucratic system had entirely controlled the artistic life of the country since its foundation by Catherine the Great in 1754. It was not until the 1870s that the patronage of the Tsar, the aristocracy, and the army of bureaucrats was replaced by the millionaire merchants of Moscow of whom Mamontov was so illustrious an example.

'Mamontov's circle', as this colony of artists came to be called, was drawn together by the common determination to create a new Russian culture. It grew out of a group of artists who had declared their secession from the Academy of Art in 1863 – two years after the emancipation of the serfs. The thirteen artists who made this heroic gesture of apparent economic suicide were inspired by ideals of 'bringing art to the people'. They called themselves the 'Wanderers' because they thought to put their ideals into practice by taking travelling exhibitions throughout the countryside. Like their contemporaries and friends, the writers Dostoevsky, Tolstoy and Turgenev, and the composers Moussorgsky, Borodin and Rimsky-Korsakov, these artists sought to justify their activity by making their art 'useful' to society. They repudiated the philosophy of 'art for art's sake' which they identified with the current academic tradition. Centred in the Petersburg Academy, this tradition derived its standards mainly from international neo-classicism, tempered by the introduction of German romanticism (for example, the Nazarenes) in the 1820s. The 'Wanderers' defied this tradition, saying that art should be primarily concerned with, and subordinate to, reality. 'The

true function of art is to explain life and comment on it'; 'Reality is more beautiful than its representation in art.' Such were the dogmas proclaimed by Chernishevsky,[1] the aesthetic propagandist of the 1860s in Russia, who together with Dobroliubov and Nekrassov had a great influence among these artists, and were in large part the spiritual directors of this nationalist movement in the arts.

The 'Wanderers' interpreted the current idea that art should be an active force in the cause of social reform by laying an emphasis on the subject-matter of their works. 'Only the content is able to refute the accusation that art is an empty diversion . . .' proclaimed Chernishevsky, and they therefore sought, in at first an only too literal and literary fashion, to depict the peasant as the new hero, and his innocence and the austerity of his life as the all-important theme. This mission of the 'Wanderers' to arouse compassion and sympathy for the common man was an unprecedented subject for art in Russia, not only by virtue of its 'social' impulse, but by its emphasis on the traditional Russian way of life, for since Peter the Great's europeanization of the country, everything Russian had been dismissed as barbarous and boorish, and 'culture' had come to mean something essentially foreign.

The 'Wanderers' were not themselves directly involved with the Slavophile movement which rejected the Western culture and economic pattern which Peter the Great had introduced into Russia, but many of the following generation of artists turned away from the West and sought to create a new national culture which would be based on the Russian peasant and the long-neglected national artistic traditions. The Slavophiles felt that Russia's was a peculiar destiny which would pursue an historical pattern of development radically different from that of the West; a destiny inspired by the mission of Orthodox Christianity to the West, in which Moscow and the former glory of Muscovy would supplant the present sovereignty of Petersburg and all that she stood for. It was this turning to Moscow which is significant in art.

For Moscow became the centre of this nationalist movement which lies at the base of the modern movement in Russian art. The repudiation of international neo-classicism which had dominated the Russian artistic field since the end of the eighteenth century, and the ensuing rediscovery of the national artistic heritage, was the starting-point of a modern school of painting in Russia.

It was, as we have seen, among the Moscow merchants that this new movement found its patrons. The 'Wanderers' found an immediate and faithful supporter in the gentle, modest P. M. Tretyakov, who after consistently buying paintings from these artists for thirty years gave his collection to the city of Moscow in 1892. The Tretyakov Gallery, as it is still called today, was the first museum of painting to be devoted entirely to Russian works of art. Other members of the same class whose discerning patronage made significant contributions to culture in nineteenth-century Russia were Soldatenkov, who sponsored the publication of many scientific, educational and cultural works; Bakhrushin, with his pioneer collection of theatrical art; and Belyayev, the patron of the 'five' nationalist composers – Rimsky-Korsakov, Cui, Balakirev, Moussorgsky and Borodin. In the early years of this century the tradition was continued by many others, among whom were the Shchukin brothers with their collections of Oriental art, Russian folk-art, and French Impressionist and Post-Impressionist painting. This latter collection of Sergei Shchukin, together with that of a friend and contemporary, Ivan Morosov, is now housed in the national museums of Moscow and Leningrad and is still considered to be the finest of its kind in the world.

But more than any other it was Savva Mamontov who directed the course of the modern movement in painting in Russia. Himself a singer, sculptor, stage director and dramatist, he founded the first Russian private opera company and was an abundantly generous patron of art, the inspiration of three successive generations of painters. His great wealth came to him as the builder of the pioneer railroads which ran from Archangel to Murmansk and again south to the Donetz Basin bringing coal to the north.

Oddly enough, it was in Rome that he and his wife Elizabeth first came in touch with contemporary Russian painters. They had gone there for the first of a number of winters, in 1872, partly for the sake of their young son Andrei's health, and partly to indulge their own interests. For they were both already deeply interested in art; Mamontov had trained as a singer in Italy, and his wife, a devoutly religious woman, was involved with the revival of the liturgy of the Orthodox Church and was particularly interested in the adaptations of Late Roman art to Early Christian uses. It was Elizabeth Mamontov whose forceful personality and deep religious convictions later

inspired the building of a little church at Abramtsevo which, as we shall see, led directly to the practical revival of Russian medieval art and architecture, an influence which it is difficult to overestimate in the development of modern art in Russia.

The circle of Russian painters which the young Mamontovs discovered in Rome was headed by two adherents of the 'Wanderers' ideals. One of these, the sculptor Antokolsky (1843–1902), was among the earliest members of the group and enjoyed an enormous popular success in his time. The other, the painter Vassily Polenov (1844–1927), was from Moscow and had studied at the Moscow College and been influenced by the first Russian landscape painter, Savrassov. Polenov spent much of his life at Abramtsevo, and was possibly the most important personality in the creation of the colony. The third outstanding figure in this *émigré* Russian art world was the young art historian Adrian Prakhov who, like the artists, was studying in Rome on a scholarship (his from Petersburg University, that of the artists from their Academies). Later, as a professor, Prakhov began the restoration of medieval works of art and architecture in Russia – condemned as disastrous by subsequent restorers.

The young Mamontovs made immediate friends with this little band of art lovers and a very lively programme of 'mutual education' was organized between them. The organizing spirit was largely Prakhov, who would conduct daily expeditions round the ancient capital indicating items of interest in the museums, ruins and catacombs. At other times they would all gather in the artists' studios, and paint or carve. Antokolsky gave Savva Mamontov lessons in sculpture, for which he soon showed much aptitude; sculpture remained a favourite occupation throughout his life, proving of great solace to him when he was confined to his house under guard for a year, after his financial crash in 1890. In the evenings the group would meet and talk of their plans for the creation of a new Russian culture. This new culture was not to be confined only to the arts. The Mamontovs no less than the painters and Prakhov were inspired by ideals of bettering the life of the people. When they had first bought Abramtsevo and the surrounding large estate in 1870, the young couple had vowed that they would continue the tradition of its former owner, the well-known writer of the 1840s, Sergei Aksakov. Aksakov was a close friend of Gogol, who had been a

1 Leonid Pasternak, *Moscow Artists*, 1902. Some members of the Abramtsevo colony: in the centre, thumbs in his waistcoat, is Konstantin Korovin; Valentin Serov is seen drawing at the table, and behind him Apollinarius Vasnetsov

frequent visitor at Abramtsevo, where he actually wrote part of *Dead Souls*. Many other of the 'nationalist' writers of the 1840s had also been at home there; what Abramtsevo had been to the writers of the forties, it was to be for the painters of the seventies. The Mamontovs began their tenancy with the practical gesture of building a hospital on the estate in 1871, following a cholera epidemic. The following year a school was added, which was temporarily housed in an empty wing of the hospital, but later established in a traditional peasant's wooden house which had been bodily transported from the neighbouring village of Bibinok. It was the first school in the region. The teaching and organization of this school for the children of the neighbouring peasants was undertaken by Elizabeth Mamontov, and it was as an adjunct to this school that a sculpture studio was first installed at Abramtsevo, built in the 'Russian' style by the architect Ropet. This was later taken over as a professional enterprise and

became one of the chief activities of the colony. It was a workshop both for craftsmen skilled in traditional arts, and for artists of the colony who were interested in this practical revival of ancient artistic traditions, of which Abramtsevo in retrospect emerges as the pioneering force.

In the spring of 1874, when the Mamontovs returned home from their winter in Italy, they were accompanied by some of their friends from Rome. This year they also stopped for a few days in Paris and there met Ilya Repin, a colleague and close friend of Polenov's, who was studying in Paris at this time. Both were eager to return to Russia, finding little to interest them in Paris, and under Mamontov's warm invitation and Polenov's eager support, Repin decided to move to Moscow. Also living in Paris at this time was the widow of the opera composer, Serov. Serov had been a colleague and great friend of Mamontov's, and so with typical generosity he invited the widow and her nine-year-old son Valentin to come and live with him at Abramtsevo. With Polenov, Repin, the Serovs and the Mamontovs as foundation-members, the Abramtsevo colony thus came into existence. It was augmented in 1879 by the Vasnetsov painter-brothers, Victor and Apollinarius.

> From now on a communal life of immense interest was carried on by Mamontov's circle. In winter they met at Savva Mamontov's attractive and comfortable house on the Spasskaya Sadovaya in Moscow, where they held communal readings and drawing sessions and put on theatrical productions to which the Moscow intelligentsia streamed in eagerness and delight.
>
> In the summer they all moved to Abramtsevo or near-by places. Here Repin lived for several years with his family . . . Polenov made studies of its woods and streams . . . Apollinarius Vasnetsov abandoned Petersburg and here found himself beginning to paint 'in the bogatyr spirit'. . . . Here Serov lived for many years.[2]

Ilya Repin (1844–1930) later described himself as 'a man of the sixties', and although he belongs to the second generation of nationalist painters, his philosophy and work exemplifies the ideals of the early pioneers. He was, moreover, a far more articulate and distinguished master of his medium than any of the original 'thirteen'. One of *Ill. 2* Repin's best-known works is *They Did Not Expect Him*. This painting, which was executed at Abramtsevo, is one of his few full-sized paint-

ings, for Repin spent much time working on studies before executing a painting in full-scale. These studies are generally considered to be finer than his large works, and in many of those executed at Abramtsevo one can discern an extremely talented draughtsman with a real perception of nature. However, he subordinated the natural artist to his social ideals: 'After the crude propaganda style of the men of the sixties, a movement of intellectual nationalism arose which valued a painting for its broad idea and poster-style of expression: in technique an intellectual anonymity was sought. Even the great talent of Repin was diluted in this dead atmosphere; the lack of artistic intensity gave to his work a characterless form.' Thus wrote the biographer of Repin's great pupil, Mikhail Vrubel.[3]

2 Ilya Repin, *They Did Not Expect Him*, 1884

Polenov, the great friend of Repin – also of Tolstoy and Turgenev – was one of the first painters of the Russian countryside. The Russian school of landscape painting was a development peculiarly connected with Moscow. Since its foundation in the 1840s, the Moscow College of Painting and Sculpture (in 1865 an architectural faculty was added) had laid stress on *plein air* studies of nature. From the very beginning we find, therefore, a fundamental difference between the Petersburg and Moscow schools. This difference is an outstanding characteristic of the modern movement in Russia. Not only did the Moscow College encourage study from nature which was almost unheard of at the Petersburg Academy, it was also a more liberal institution, depending less on the court and more on private sponsorship than its Petersburg counterpart. In the 1850s a complete break was made in the Moscow College from the Petersburg academic tradition of teaching – a three-year course of drawing from prints and plaster casts of classical sculpture – and from this date on a free choice of subjects was introduced for the students in Moscow and an increasing stress laid on study from nature. In the sixties the first students to have graduated from the Moscow College returned to it as teachers. Among these was Savrassov (1830–97), who is known as 'the father of the Russian school of landscape painting'. Savrassov's landscape paintings were, however, few and it was left to his followers, Polenov and Shishkin, to develop this part of his work. These painters were still hampered by a stylized, literary approach in their work, and it is not until Isaac Levitan (1860–1900) that the Russian school of landscape painting produced a really creative and expressive master.

Polenov's contribution to the Abramtsevo colony, however, was not primarily as a painter, but rather as an archaeologist and teacher. In the Moscow College, where he was appointed a professor in 1882, his liberal influence and forceful personality encouraged such painters as Levitan and Korovin, both of whom he was responsible for introducing to the Abramtsevo colony as theatrical designers in the 1880s. During the early formative years of the colony, Polenov contributed much scientific and archaeological knowledge to the group. His influence was particularly significant in the building of the little *Ill. 3* Abramtsevo church, begun in 1880.

The idea of building this church was prompted by the severe flooding of the local river which bounded the Abramtsevo estate in

16

the spring of 1880, thus preventing the local population from reaching a church that Easter. It was decided therefore to build one on the estate against such another occasion. The idea was taken up with immense enthusiasm by the members of the colony, who all began doing designs for the building. After much discussion it was decided to build the church in the style of a medieval Novgorod church according to Apollinarius Vasnetsov's (1845–1926) design. To forward the project Polenov dug out many archaeological documents which had belonged to his father, a pioneer archaeologist who had inspired his son with his own enthusiasm for medieval Russian architecture and painting. He had taken the sixteen-year-old boy round the countryside on horseback, pointing out the surviving examples of this tradition, and Polenov, who was already fond of drawing, had made many sketches on this journey which he now produced in Abramtsevo for general study. Elizabeth Mamontov read aloud excerpts from

3 The Abramtsevo church, 1880–2

historical works while discussion about the church raged among the colony's members. Everyone contributed designs, ideas, scraps of historical information – there was little relevant material published at this date, as scholarly research into Russian medieval art had only begun in the 1850s.[4]

In fact, even icon paintings were almost entirely unknown in their original state, for centuries of overpainting and the tradition of encasing paintings in gold and silver had obscured their surfaces. The discovery of icons as works of art and the consequent demand for restoration to their original brilliant colour and purity of line was a slow affair in Russia and was not systematized until after the Revolution of 1917. Scholarly work on the history of icon paintings began at the beginning of the nineteenth century with the Stroganov family, who started collecting together the commissions that their ancestors had given to contemporary painters for their famous seventeenth-century workshop. The Abramtsevo colony was the pioneering force in the artistic application of these early scientific studies and discoveries.

As a result of this group-examination of Russian medieval art and history, inspired by the idea of building a church on the estate, the Abramtsevo colony decided to visit Yaroslavl and Rostov-the-Great, where some of the finest buildings and wall-paintings were to be seen. The expedition was organized by Polenov. They returned loaded with sketches, and work on the little church began in earnest. Many alterations were made to Apollinarius Vasnetsov's original plans, Polenov in particular contributing ornamental designs inspired by carvings on local peasant buildings. While looking for such motifs, *Ills 4, 6* Polenov decided to bring back a carved lintel from a neighbouring village house which had particularly pleased him. This was the foundation of the museum of national peasant art which still exists at Abramtsevo and which later was the direct source of inspiration for the revolutionary theatrical designs of the Mamontov 'Private *Ills 11, 12* Opera': for instance, Rimsky-Korsakov's *Snegurochka*.

The little Abramtsevo church was completed at the end of 1882. It was the first communal labour of the colony. Everyone had contributed to its decoration and even to its physical erection. The elaborate wooden ornaments were carved and painted by the artists in the newly established workshop on the estate. Repin, Polenov, Mikhail Nesterov and Apollinarius Vasnetsov together painted the

18

4 Traditional peasant carving from the Abramtsevo Museum collection begun by Vassily Polenov

Резная доска.
Нах. в Абрамцевском музее.

Резной валек.
Из того-же музея.

5 Table designed and executed on the Princess Tenisheva's Talashkino estate near Smolensk which was organized on the pattern of Abramtsevo. Designed by A. Zinoviev, *c.* 1905

6 The Abramtsevo Museum

7 Ceramic stove designed by
Mikhail Vrubel in the Abramtsevo
pottery, *c.* 1899

Ill. 8 iconostasis and wall-paintings. The women, Elizabeth Mamontov,
Maria Yakunchikova and Elena Polenova, embroidered the vestments
and covers to designs by Polenov. Victor Vasnetsov not only designed
the mosaic floor in the form of a single spreading flower, but in his
enthusiasm personally helped to lay it.

The first ceremony held in the little church was Polenov's wedding
– to Maria Yakunchikova, Savva Mamontov's cousin, who had
joined the colony to help with the work on the church. Yakunchikova
was one of the first female artists in Russia; another was Polenov's
sister, Elena Polenova, who was also an historian – indeed it was her
interest in Russian history which had attracted her to the colony's
work of reviving the styles of the Middle Ages. The two women were

20

8 The Iconostasis of the Abramtsevo church. The paintings on it were executed by Apollinarius Vasnetsov, Ilya Repin and Vassily Polenov

the most enthusiastic and persistent protagonists of this revival of folk-art traditions at Abramtsevo, and soon they took over the wood-carving and embroidery workshops which were by now flourishing on the estate.

After the completion of the little church, interest in the revival of medieval Russian art grew rather than diminished. Both the Vasnetsov brothers began to specialize in historical reconstructions of medieval Russia: Victor in icons and fairy-tale scenes, Apollinarius in the pictorial re-creation of medieval Moscow, to which he devoted the rest of his life.

Actually the first painter to apply himself to the pictorial reconstruction of medieval Russia had been Vyacheslav Shwartz (1838–69).

Shwartz was an historian, and it was in the course of his studies that he conceived this idea of reviving a forgotten past in all its detail by means of painting. His pictures are frankly those of an historian, and it is for his attention to detail and painstaking accuracy that they are valuable.

Vassily Surikov (1848–1912) was the first of the 'Wanderers' to combine national ideals with an urge to find a new language in which to express those ideals. Born in Krasnoyarsk, an outpost of Siberia, Surikov set out for Petersburg on horseback in 1868 to join the Academy. He was a year on his journey, for on his way he made frequent and leisurely stops in the ancient towns through which he passed. In particular Kazan and Nizhni-Novgorod impressed this twenty-year-old Cossack, but it was Moscow that bowled him over. 'Coming to Moscow, to that centre of national life, I immediately saw my way,' he wrote later.[5] Surikov's masterpiece, as it is generally *Ill. 9* considered, *The Boyarina Morosova* (1887), depicting the persecution of the 'Old Believers' by the patriarch Nikon, is set in the streets of medieval Moscow. It is an enormous painting – both in size and scale it is in the nature of a wall-painting. The pictorial construction of this work reminds one of the great Italian monumental painters whose work Surikov so much admired – Michelangelo, Tintoretto, Titian and, more than any other, Veronese. It is full of movement – the fresh, solid colour glances from form to form, gesture carries on to gesture, until finally one's eye is arrested by the central figure of the Boyarina with her dramatic uplifted hand and pointing finger. This dynamic quality had always been a fundamental characteristic of Russian painting, and in Surikov's work it re-emerges from the medieval traditions for the first time. With Surikov the peculiar colour range of Byzantine art is likewise revived – the rich browns, sombre reds and clear yellow which we find again in Natalia Goncharova's work. A decorative surface rhythm and strong horizontal are other characteristics common to Russian art, both ancient and modern, and likewise first recovered in the work of Surikov.

Surikov was a frequent guest at Abramtsevo, but he was not a 'member' of the colony. He did not, for example, take part in their communal activities such as the Sunday evening readings. These readings from the classics gradually developed into mimed pageants. From pageants they had grown by 1881 to full-blown theatrical

9 Vassily Surikov, *The Boyarina Morosova*, 1881–7

productions which Savva Mamontov would stage in the winter in his Moscow house. The script for these early amateur productions was usually by Mamontov himself and would re-tell some folk-tale or historic episode. Everyone took part; Savva Mamontov would demand from each according to his gifts, which were often most unexpectedly revealed to their owners. Thus Victor Vasnetsov found himself painting theatre décor, although he had, as he himself later confessed, not the slightest idea how to approach his task. In this use of a painter, rather than the traditional artisan, to paint sets, the idea of realistic theatrical décor was born, which directly influenced Western Europe. It grew from the work of Vasnetsov, and of his followers: Korovin, Levitan, Golovin and Roerich, who all worked for Mamontov's 'Private Opera' theatre productions during the 1880s. By the 1890s the Imperial theatres could no longer ignore Mamontov's revolutionary use of professional painters to paint décor and also began replacing the craftsman stage-designer of tradition with artists such as these. Finally, with Diaghilev, they were introduced to Europe. Where before the backcloth had been a decorative background to the acting, it now became an integral part of the production. This brought about, in its turn, a revolution in the idea of theatre. The production began to be looked at as a whole, and the

10 Mikhail Vrubel,
Egyptian costume design,
1890's

actor had to subordinate his performance to the other elements:
décor, costume, gesture, music, language. Thus a synthesis emerged,
a dramatic unity. Stanislavsky, a cousin of Mamontov's, who often
used to come and perform in these domestic productions of the early
1880s, has attributed to them the birth of his 'realistic theatre', which
in its turn has been so influential in the West.

Mamontov's venture into amateur theatrical production soon led
to the founding of his professional 'Private Opera' in Moscow. It
was made possible by a recent edict of the Tsar's, and it meant that
a new field of activity was opened to the artist, and one peculiarly
suited to the Russian who has such a happy gift for decorative art,
and to whom movement is life. It opened in 1883 with Rimsky-
Ills 11, 12 Korsakov's opera *Snegurochka* (The Snow Maiden) with stage set-
tings by Victor Vasnetsov. As time went on, the 'Private Opera'
introduced not only the music of Rimsky-Korsakov, Dargomuishsky,
Moussorgsky and Borodin to the Russian public, but also the mag-
nificent voice of Fyodor Shalyapin.

24

11 Victor Vasnetsov,
Snegurochka,
a costume design, 1883

12 Victor Vasnetsov,
Snegurochka,
design for a stage set, 1883

13 Konstantin Korovin, *Don Quixote*, stage set for Scene 4, 1906

14 Isaac Levitan, *Above Eternal Peace*, 1894

Mamontov's theatre thus began attracting the younger generation of painters. Polenov introduced two of the most brilliant students from the Moscow College: Isaac Levitan, who has already been discussed, and Konstantin Korovin (1861–1939). Korovin was the first Russian artist to reflect the art of the French Impressionists, with which he came in contact in 1885, on his first visit to Paris. In the same year Korovin met the Mamontovs and almost immediately became an intimate member of their household. More than any other, he was responsible for bringing about the revolution in theatrical design, and it was in this medium that he most successfully interpreted *Ill. 13* French Impressionist ideas. He was an important liberal influence in the Moscow College, where he was appointed a professor in 1901, and almost all the *avant-garde* of the first decade of this century were his pupils and of his Abramtsevo friend, Serov – Kusnetsov, Larionov, Goncharova, Tatlin, Konchalovsky, Mashkov, Lentulov, Falk, not to mention the many Futurist poets who began as painters – the Burliuk brothers, Kruchenikh and Mayakovsky.

Valentin Serov (1865–1911) was almost like a son to the Mamontovs. As we have seen, he had come as a small boy to live at Abramtsevo with his widowed mother in 1874. He thus grew up in the atmosphere of constant creative activity which characterized the Mamontov

15 Valentin Serov, *October. Domotkanovo*, 1895

household. From a very early age Serov was given drawing lessons by Repin, who was very fond of the little boy, and he soon showed himself to be a remarkably precocious draughtsman. He would catch the likeness of a model often more quickly and surely than the older artists in the merry 'drawing competitions' which were so much part of the gay, ideal life of Abramtsevo. This talent for catching a likeness Serov later developed and he became the most successful and brilliant portraitist in the 1890s and first decade of this century. But before this he was a remarkable landscape painter in a more sensuous and less nostalgic vein than his master Levitan. Serov, like Korovin, was a most beneficial influence in the Moscow College where he taught from 1900 up till 1909. Though Larionov reports that he was too busy to be a really good teacher, he was so superb a technical master of the many media in which he practised, that his personal professional attitude to composition and extraordinarily high standard of technical discipline did not fail to impress students at a time when such accomplishment was all too rare in Russia. Serov, like Korovin, was one of the few Muscovites to bridge the gap between the two art worlds. He collaborated on the essentially Petersburg *World of Art* magazine (which will be discussed in the next chapter) and took part in this group's exhibitions which brought together the artistic *avant-garde* of the 1890s.

Ills 15, 16
Ill. 14

In 1890 Serov introduced his close friend Mikhail Vrubel (1856–1910) to Mamontov. It was to prove the turning-point of Vrubel's artistic life. He had had a brilliant early career at the Petersburg Academy, which he entered in 1880. There it was his good fortune to be taught by Chistyakov, an outstanding draughtsman, a great admirer of the Italian Fortuni. Chistyakov counted among his pupils almost all the most talented 'Wanderers' – Repin and Surikov, and among the younger generation, Serov and Vrubel. All these artists, and in particular Vrubel, paid tribute to the teaching of this master who instilled in them so excellent an academic discipline.

Even before he had graduated, Vrubel's teachers at the Academy recommended him to Professor Prakhov, who came to the school in 1883 to find students who would help him with the restoration of the twelfth-century Church of Saint Cyril in Kiev which he had undertaken. This opportunity to become familiar with Byzantine art at first hand and under such intimate conditions proved decisive

29

16 Valentin Serov,
Portrait of the actress Ermolova, 1905

in Vrubel's development. At this point began that relentless search for a new pictorial vocabulary which was the driving force throughout his work. As he himself wrote to his sister: 'The mania of being absolutely obliged to say something new does not leave me . . . only one thing is clear to me, that my researches are exclusively in the technical field.'[6]

Vrubel's work in Saint Cyril was to help restore the original wall-paintings and, in cases where these were quite lost, to paint new ones in a sympathetic style. It was a task which delighted the young student and to which, he said towards the end of his sad life, he would most

17 Mikhail Vrubel,
Valery Briussov,
1905

18 Mikhail Vrubel,
The Dance of Tamara,
1890

of all wish to return. It was here that Vrubel discovered the eloquence of line –

> The chief mistake of the contemporary artists who try to revive the Byzantine style is their lack of appreciation for the Byzantine artists' use of drapery. They make of it a mere sheet where they [the Byzantine artists] revealed so much wit. Byzantine painting differs fundamentally from three-dimensional art. Its whole essence lies in the ornamental arrangement of form which emphasizes the flatness of the wall.[7]

Ill. 18
This use of ornamental rhythms to point up the flat surface of the canvas was constantly exploited by Vrubel. An example of this is *The Dance of Tamara*, a watercolour of 1890. This is one of the series by Vrubel illustrating Lermontov's poem *The Demon*, commissioned through the banker Konchalovsky for a jubilee edition published in 1890. It was Vrubel's first Moscow commission. In *The Dance of Tamara* Vrubel has juxtaposed the formal elements to create a complex surface-pattern, a rhythmic patchwork design. The work divides into three different planes which merge into each other like dream-images – the melancholy brooding demon leaning against a rock surrounded by desolate mountains, the lovely Tamara dancing with her elegant Georgian bridegroom on a rich carpet at the foot of a carpeted stair, and the strumming orchestra whose music seems to hammer at the richly ornamented scene from another world. The players have been arbitrarily cut short by the edge of the canvas, and thus impinge on our own world as they complete themselves in real space.

The passionate study of Byzantine art which Kiev inspired in Vrubel took him next to Venice. In Kiev he had discovered line; in Venice he discovered colour. The mosaics of San Marco and the work of Carpaccio and Bellini were his particular preoccupations. During this year in Italy he worked with that intense concentration which he retained throughout his life even in times of appalling isolation and poverty.

Ills 18, 21
In 1885 Vrubel returned to Russia, to Odessa, but he failed to find work. Then began a period of great physical, but above all, mental anguish. He began the series of 'Demon' pictures inspired by Lermontov whose image came to haunt him more and more persistently.

32

Vrubel described it as 'A spirit which unites in itself the male and female appearances, a spirit which is not so much evil as suffering and wounded, but withal a powerful and noble being.'[8] As this symbol came increasingly to dominate his work, his mental breakdown became more apparent. One can trace the development of its mood. From a confiding presence, a soaring sorrowful spirit, it becomes a hostile sentry and a glowering, angry head. Finally, in the last years of his creative life, it is a crushed or swooning body, sucked into a giddy whirlpool. In some of his last works Vrubel resurrects the figure as a massive head with tragic staring eyes: a pure spirit which looms out of the mist, dominant at last, but with its empire gone.

During the years 1885–8 Vrubel lived a poverty-stricken life in Kiev, to which he had returned, after his short stay in Odessa, with memories of so much former happiness. In 1887 his hopes for working again on religious monumental painting were revived by the announcement of a competition for designs for the new Cathedral of Saint Vladimir. This church had been begun in 1862, in the full tide of Slavophile enthusiasm, to celebrate the millennium of the Russian nation. Although Vrubel more than any other contemporary artist would seem to be the obvious person to be given the commission, Victor Vasnetsov, fresh from his work on the little Abramtsevo church, won the competition instead. Vasnetsov's designs were weak and derivative, altogether lacking in understanding of the peculiar medium of monumental painting in which Vrubel had already shown such mastery. Vrubel himself had the final bitter experience of being offered the job of designing ornamental panels on the lower side walls of the church. These, with his innate humility, he executed with an intuition for ornamental decorative motifs which again and again strikes us in his work.

Apart from his work on monumental painting, Vrubel had concentrated largely on watercolour during these last ten years; he considered this medium to be the most exacting discipline. While still at the Academy he and his intimate companion Valentin Serov had taken seriously to the study of nature which was so foreign to the tradition of their institution. Both of them were pupils of Repin, but Vrubel soon violently reacted against the philosophy of his master. It is interesting to read his reaction to the 'Wanderers'' exhibition of 1883 at which a painting by Repin was the *pièce de résistance*: 'Form, the

33

most pre-eminent plastic quality, has been abandoned: a few bold, talented strokes is the extent of the artist's communion with nature, he is entirely engrossed with impressing the spectator as forcefully as possible with his ideas.'[9] In the same letter Vrubel rejects the 'Wanderers'' interpretation of art as a weapon for social propaganda:

> The artist should not become the slave of the public: he himself is the best judge of his works, which he must respect and not lower its significance of that of a publicity stunt . . . to steal that delight which differentiates a spiritual approach to a work of art, from that with which one regards an opened printed page, can even lead to a complete atrophy in the demand for such delights: and that is to deprive man of the best part of his life. . . .

It was shortly after these remarks that we are told he began reading Kant, which strengthened his belief in the study of nature. Vrubel was not only at home in contemporary German philosophy, but was very

19 Mikhail Vrubel, *Vase of Flowers*, 1904

20 Mikhail Vrubel,
Still-life of Roses,
c. 1900

widely read in the classics. He was an outstanding Latin scholar, a rare accomplishment in Russia at this date. In many ways he belonged more to Pushkin's generation than to his own provincial world which all but rejected him.

More than any other artist Vrubel was the inspiration to the *avant-garde* in Russia during the next twenty years. He might be termed the Russian Cézanne, for they share a number of characteristics: both artists bridge the centuries in their work, and not only the centuries, but the two visions which so radically divide the nineteenth century from the twentieth; 'modern art' from the art of Western Europe since the Renaissance and the birth of 'easel painting'.

Like Cézanne, Vrubel met with little recognition during his lifetime; what little he had was almost entirely due to the vision and efforts of Savva Mamontov with whom he worked in the theatre, and in the Abramtsevo workshops, and for whom he executed almost his only paintings.

35

21 Mikhail Vrubel, sketch for an illustration to the jubilee edition of Lermontov's poem *The Demon* published in 1890

Ills 19, 20

Unlike his friend Serov, it was not so much landscapes and a direct interest in nature that engrossed him. Most of his drawings are studies of flowers, but not of flowers growing in the fields in their natural environment; they are penetrating close-ups of the tangled interplay of forms, giving them in their artificial isolation a peculiar dramatic rhythm. Or, again, a vase of flowers whose play of jostling forms cascade in a splendid curling mass. Vrubel is at his greatest in these exquisite watercolour and pencil sketches. His searching pencil attacks the model from every viewpoint: in transparent interweaving patterns, in balancing mass against mass, in forms built up in cleaving angled thrusts, in mosaic-like patterning. It is for this tireless, exhaustive examination of the possibilities of pictorial representation that the next generations so revered Vrubel, as well as for his extraordinary imaginative vision. Although he formulated no new pictorial vocabulary and founded no school, he made possible the experiments of the following decades; he pointed the way.

36

1890–1905

The 'World of Art' movement in Russia was similar in make-up, contemporary in time and parallel in its historical role, to the French Nabi group. It emerged from a schoolboy society, the 'Nevsky Pickwickians', who had formed themselves into this 'society for self-education' under the leadership of Alexander Benois in the late 1880s. The school they all attended, May College, was a private upper-middle-class institution for the children of the well-to-do intelligentsia of Saint Petersburg, many of whom were of foreign descent; such was the typical background of the members of the 'World of Art' which emerged as a movement in the early 1890s. Paralleling the English and European 'Art Nouveau' movements, it came to stand for the artistic *avant-garde* in Russia in the 1890s and the early years of this century.

In his own account of its history, Benois describes the 'World of Art' as a society, an exhibiting organization, and a magazine.

> I consider that the 'World of Art' should not be understood as any one of these three things separately, but all in one; more accurately as a kind of community which lived its own life, with its own peculiar interests and problems and which tried in a number of ways to influence society and to inspire in it a desirable attitude to art – art understood in its broadest sense, that is to say including literature and music.[1]

Alexander Benois (1870–1960) was the initiator of the May College society and remained the intellectual force behind the 'World of Art' movement. Painter, theatrical designer, producer, scholar, art critic, art historian, Benois is the epitome of what the 'World of Art' came to stand for, the renewal not only of art, but of the whole man, not only of painting but of art which embraces the whole of life; the idea of art as an instrument for the salvation of mankind, the artist the dedicated priest, and his art the medium of eternal truth and

beauty. In short, the philosophy which has been much abused as 'art for art's sake'.

Alexander Benois was born in 1870 in Saint Petersburg of mixed German, French and Italian ancestry. The Benois family belonged to that foreign colony in Saint Petersburg which had existed ever since Peter the Great had first begun importing artists, composers and architects from the West. Since the eighteenth century it had contributed enormously to Russian culture, and many of its families, like the Benois, produced a succession of talented artists. The Benois themselves had arrived in Russia in the late eighteenth century, but it was chiefly from the maternal side, the Venetian Cavos family, that the artistic talent derived. Caterino-Cavos, the son of the Director of the Venice Theatre, was a highly successful composer and organist, but after the fall of the Republic he fled his native city and was appointed Director of Music to the Imperial Theatres in Saint Petersburg. He settled there with his family, and his son, Alberto Cavos, became a well-known theatrical architect, designer of the Mariinsky (now the Kirov) Theatre in Leningrad and of the Bolshoi Theatre in Moscow. Camilla Cavos, Alberto's daughter, married Nicholas Benois in 1848. Nicholas Benois was by birth half-French and half-German. As a student at the Petersburg Academy of Art he was awarded, in 1836, a gold medal in architecture and, following the current tradition, went to Italy. Here he made the acquaintance of the Russo-German colony of artists, the German Romantic painter Overbeck, and the Russians Ivanov (the painter) and Gogol. The influence of these artists and writers and in particular the ideas of the German Nazarenes for the revival of medieval architecture, had a profound influence on the young architect. He returned home inspired to bring about a similar revival in Russian architecture.

This atmosphere of romantic ideals in which Alexander Benois grew up shaped his artistic taste, and through him that of the 'World of Art'. The family was not attracted by the Russian Populist ideas of the 1860s and 1870s which they felt to be provincial and barbarous, and unlike many of their contemporaries they did not cut themselves off from the West. On the contrary, partly because of their mixed ancestry, they were familiar with contemporary French and German as well as Italian ideas. This international culture was a basic characteristic of the members of the 'World of Art' who felt it their mission

to restore to Russia the culture which had been lost during the reign of the 'Wanderers'. But they did not envisage the return of a European-dominated culture in Russia. On the contrary, they believed that Russia should not return to the status of a provincial outpost of Western Europe, nor remain the stronghold of an isolated national tradition. Their aim was to create in Russia an essentially international centre which would for the first time contribute to the mainstream of Western culture. To do this they set about restoring contact again with German, French and English ideas, as well as by encouraging an interest in the national heritage, not only that of medieval Russia to which the Abramtsevo colony had dedicated themselves, but also to the much neglected art produced under Peter and Catherine the Great which had been completely dismissed by the 'Wanderers' as alien. Alexander became the moving figure in this ambitious programme.

The 'Nevsky Pickwickians' consisted of Benois's school-friends, chief among whom were Dmitri Filosofov, Konstantin Somov and Walter Nuvel. Filosofov was a charming, elegant and beautiful boy, the son of a prominent member of the government, an aristocrat who had married a famous beauty. Like Benois's parents, they were both elderly when their son was born and his father died before he was grown up. This was perhaps another reason for the extreme sophistication of these young men, of whom it was said they were 'world-weary in their twenties'. Madame Filosofov was famous not only as a fashionable hostess whose drawing-room was the centre of the intelligent minor aristocracy, but also as a very cultivated person in her own right who had been a founder of the first 'Women's University Courses' in Russia. Filosofov was the most literary member of the group, although he was not himself a creative writer. It was he who later introduced Merezhkovsky, the Symbolist religious thinker, who contributed the 'mystical' vein to the group's discussions. Later, when the magazine was being produced, Filosofov ran the literary section which published the early work of Blok, Bely and Balmont, the representatives of the first generation of Symbolists in Russian literature.

A strong musical interest was contributed by Walter Nuvel, who, like Benois, was of mixed German and French descent and grew up trilingual. Konstantin Somov, another early, though not at first very active, member of the schoolboy society, was the son of the Director

of the Hermitage Museum who later contributed much to the pictorial section of the *World of Art* magazine. There were other May College members of the 'Nevsky Pickwickians', but in 1890, when they all left the college, they dropped out of the group.

In this year Benois met a young student at the Petersburg Academy of Art, where he was attending an evening course (a year of drawing classes which was the only formal art training that Benois had). This was Lev Rosenberg, better known as a painter and revolutionary theatrical designer under the name of his adored Epicurean grandfather Léon Bakst. He made immediate friends with Benois and rapidly became one of the leaders of the group. Bakst was its first professional artist. He was, however, among its most fervent anti-academic propagandists for he had experienced at first hand the prevailing academic prejudice against anything which overstepped the traditional formulae. The previous year a competition had been announced on the subject of the 'Pietà'. Bakst, pupil of Chistyakov and admirer of Nesterov, the religious painter of the 'Wanderers', was full of ideas of the value of absolute realism in painting. Thinking along these lines, he painted the Madonna as an old woman, her eyes red with weeping over her dead Son. What was his dismay, when called before the jury, to see his canvas crossed out by two furious strokes of crayon! The next day he left the Academy and soon afterwards joined the 'Pickwickians', attracted by their war on the Academy and the 'Wanderers' alike.

The friends would meet several days a week after college at the house of Benois or Filosofov, both homes with a sympathetic atmosphere of cosmopolitan culture. They would read each other lectures – interrupted by constant laughter and witticisms quite unquelled by Benois's frequent calls to order on his mother's bronze bell! The lectures would be on any subject to which the member was personally attracted at the moment. Thus Benois spoke on Dürer, Holbein and Cranach – also on the German school which his family so much admired: von Marees, Menzel, Feuerbach, Leibl, Klimt and the German Impressionists Liebermann and Corinth. Benois himself tells us that the French Impressionists were still unknown in Russia at this date and were not directly introduced until the 'World of Art' exhibitions in the early years of this century and in the later numbers of their magazine.[2] Zola's book *L'Œuvre*, published in 1918, was,

40

22 Léon Bakst, *Les Orientales*, design for a backcloth (unrealized), *c*. 1910

according to Benois, the first source of Impressionist ideas in Russia, where it was much read. The chief sources for Russian painters on the history of contemporary French and German art up till the 1920s were Richard Muther's pioneer history of nineteenth-century painting[3] and that by Meier-Gräfe, the friend of Bing and champion of the 'Art Nouveau' movement,[4] which appeared in 1908. We find many references to their works in Kasimir Malevich's writings. The chapter on Russian art in Muther's history was written by Benois at the request of the author, whom he had known in Munich on his frequent visits in the early 1890s.

If Benois usually spoke on painting and architecture, Filosofov would talk on Turgenev and his times, or the ideas during the reign

of Alexander the First. Bakst, who looked more like a clerk than an art student, with his red hair, small close-set, blue eyes, steel-rimmed glasses and retiring manner, would speak less than the others, but was always ready to join in with his gay laughter and quick wit. This modest young man had a hard life, for he was left with a dependent mother, two sisters and a younger brother to support while still a student. It is reported that he never became despondent, however, and was always generous and sympathetic with the quarrelsome friends. Although he was the least colourful personality of the group, it is Bakst more than any of the friends who has become identified with its creative work. In his exotic décors for Diaghilev's ballet, such as

Ills 22, 23 *Shéhérezade* or *Les Orientales* and his Hellenistic *L'Après-midi d'un Faune* and *Narcisse*, the 'World of Art' found its fullest realization.

Towards the end of 1890 a country cousin of Filosofov's arrived in Saint Petersburg from his native Perm and was introduced to the 'Pickwickians'. This stocky plump young man with rosy cheeks and a large sensuous mouth was Sergei Diaghilev. The presence of this hearty young provincial with the boisterous laugh was at first accepted cautiously by the young aesthetes, and only as a favour to his cousin whom they all admired very much. On his part, Diaghilev

23 Léon Bakst, *L'Après-midi d'un Faune*, settings and costumes, 1912

rather despised the friends with their dowdy clothes and intellectual pursuits, and would only rarely turn up for their meetings, preferring to attend balls and grand social functions.

In 1890 the May College group left school, most of them going abroad for a year, as was the custom among such families in Russia, before entering Petersburg University. It is typical that Benois chose to go to Munich rather than Paris, in order to acquaint himself with contemporary art, and that Diaghilev and Filosofov, who did go to Paris, should have been impressed not by the Impressionists of whose existence they appear to have been still ignorant, but by Zuloaga, Puvis de Chavannes and the Scandinavian painter, Zorn.

On their return from abroad and during their university careers the friends began more seriously to develop their ideas on art and to define their feeling of a mission to create a new art-conscious intelligentsia in Russia. None of the group seems to have taken his university career seriously – Diaghilev, we are told, was far more interested in his music lessons with Rimsky-Korsakov and with meeting important people, than with working for his legal degree; it is hardly surprising that he took six years instead of the usual four to graduate!

They were joined at this point by the Muscovites Serov, a great friend of Bakst's from his student days at the Petersburg Academy, and Korovin. This added to the professional status of the group of dilettantes. A little later Nicholas Roerich joined them. Roerich had also been at the May College, but was a few years junior to the 'Pickwickians'. He was passionately interested in archaeology and took part in a number of digs from the 1890s onwards, contributing essays on these scientific discoveries to historical journals. In 1893 he entered the Petersburg Academy and also began training as a painter, at which point he came in contact with the 'Pickwickians'. He later became an important contributor to the *World of Art* magazine, and with Bakst was among the most striking of Diaghilev's pre-war stage designers. His décor for *Prince Igor* with its evocation of the *Ill. 24* remote Russian past, infinite space, the mystery of pagan rites and elemental forces was both Symbolist in its associations and a direct outcome of his archaeological work; his knowledge of folk-art at this time derived from the museum and workshops of Abramtsevo and those of the Princess Tenisheva at Talashkino. (The latter was a centre near Smolensk, founded in the 1890s, which was based very much on

Mamontov's Abramtsevo experiments in reviving the cottage industries. As at Abramtsevo, many professional artists used to come and work in the wood-carving workshop, among whom were *Ill. 5* Vrubel, Golovin and Malyutin as well as Roerich and the Princess Tenisheva herself. Thus a second generation of artists in Russia was directly inspired by practical contact with Russian folk-art.)

In 1893 a French diplomat, Charles Birlé, then serving in the French consulate in Petersburg, was introduced to the 'Nevsky Pickwickians' and soon became an intimate and valued member. Birlé remained in the group for only a year, but during that time he revolutionized their opinions on contemporary French painting, introducing them to the work of the Impressionists and Gauguin, Seurat and Van Gogh. It was also he who introduced Alfred Nurok to them. Nurok posed as a great cynic and perverted sinner. 'Huysmans, Baudelaire's *Fleurs du Mal*, Verlaine's erotic poetry and the Marquis de Sade were his favourite reading, and one of these books was always sticking out of his pocket,' says Benois.[5] He introduced the group to T. T. Heine, Steinlen, Fizze and Aubrey Beardsley. The latter in particular was to have a great following in Russia, revolutionizing book illustration and introducing the significant idea of the page as an expressive entity.

The idea of a magazine now began to be mooted among the group's members; Benois and Nuvel, who were intimate friends, united by their passionate love of music, especially Tchaikovsky and eighteenth-century music, were particularly interested in the project. It was decided, however, that they had too little experience. The truth of the matter was probably that no one wanted to take on the administrative responsibility involved in producing a magazine. Benois was too erratic and sensitive; Filosofov was irresponsible and physically rather frail; Bakst, Serov and Korovin were by now taken up with their own affairs, and Nurok and Nuvel hated any responsibility. It soon became apparent that Diaghilev was the obvious person to bring together these diverse personalities in a series of creative enterprises, first the magazine, then exhibitions, and finally the 'Russian Ballet', the most significant expression of the 'World of Art' movement.

Diaghilev was of course much less cultured than his companions; his one claim to authority lay in music and even that he soon gave up as a creative activity on the plain-spoken recommendation of his

24 Nicholas Roerich, *Prince Igor*, design for stage set, 1909

teacher, Rimsky-Korsakov. He was, however, 'full of health, strength and provincial energy and freshness' in contrast to the other 'Nevsky Pickwickians', who, although still in their twenties, lacked the will to accomplish any active programme. In 1895 Diaghilev went abroad again, this time on his own and began collecting paintings. He returned to Russia with a large number of newly acquired works – and jokingly suggested to Benois that he would make him the Director of the S. P. Diaghilev Museum! On this visit Diaghilev found his feet and returned to his friends as an equal. Benois continued to be his 'mentor' in art matters, but his personality made him a natural leader whose drive and talent for practical affairs was soon to involve his friends in a whirl of creative activity. Having published a few articles on art which had a successful reception, Diaghilev's public ambitions were aroused and from this time he began to look for an opening in the administrative art field. Two years later he organized his first exhibitions: 'English and German Watercolours' and 'Scandinavian Painters'. These were followed in 1898 by an 'Exhibition of Russian and Finnish

Painters'. They were brilliant artistic events and marked the beginning of the 'World of Art' as an exhibiting society. Shortly afterwards the magazine appeared.

The year 1896 had proved a year of dispersal among the group's members. Benois, now graduated from the University and married, left for Paris. Somov and Benois's young nephew Lanseray, who had recently joined the society, also went to Paris. Benois, preoccupied by his enthusiasm for French eighteenth-century culture, remained there for the next two years. He did not return to Russia until Diaghilev wrote to him and insisted on his coming to help him with the magazine which he was hoping to launch:

> . . . I am now working on a magazine in which I hope to unite the whole of our artistic life, that is, as illustrations I shall use real painting, the articles will be outspoken, and then in the name of the magazine, I propose to organize a series of annual exhibitions, and finally, to attract to the magazine the new industrial art which is developing in Moscow and Finland.[6]

The others of the group were immensely taken by Diaghilev's project, and there were lively discussions among them, but Benois, caught by a mood of spiritual depression in Paris, did not respond. Diaghilev wrote him a further letter which reveals that half-bullying half-coaxing attitude to his artist friends which later brought together that remarkable undertaking, the 'Ballet-Russe de Serge Diaghilev'.

> In the same way that I am unable to ask my parents to love me, so I am unable to ask you to sympathize and help me in my enterprise – not as a support and blessing, but directly, single-mindedly and in a creative way. In a word I am not able to argue or ask you for anything, and O God, there's no time, or I would come and wring your neck. That's all, and I hope the frank and brotherly tone of my abuse will shake you out of yourself and that you will cease to be a foreigner and spectator and will quickly put on your dirty overalls like the rest of us. . . .

Shortly after, Benois returned to Russia and began writing for the projected magazine. He wrote an article on the Impressionists and another on Brueghel. The latter was, however, turned down by the editors 'as not sufficiently modern'. At this time an ideological 'left'

46

and 'right' began to split the members of the group into two camps: those who were for the 'new' above all, who on principle attacked everything they considered narrow, provincial or outmoded; and the more conservative 'right' who were scholarly and even eclectic in the broadness of their knowledge and sympathies. The first category included Nurok, Nuvel, Bakst and Korovin, the second Benois, Lanseray and Merezhkovsky. Between the two came Filosofov the 'peacemaker' and Diaghilev, who intellectually always took second place to his brilliant cousin. Serov sided sometimes with one camp and sometimes with the other, but as both he and Korovin were only visiting members of the group, their opinion counted for less in the continual debates which shaped the future magazine.

Having decided more or less on the content and format of the magazine, which was to be in every way epoch-making, the next problem was to find a patron to finance the enterprise. Princess Tenisheva, whose crafts centre on her estate at Talashkino has already been mentioned, had been very friendly with Benois during the last two years. She was therefore considered an obvious person to approach about the ambitious project. When she learnt that Diaghilev was to be the general editor of the magazine, however, she was sceptical about the idea, for she, like many society personalities, knew Diaghilev only as a frivolous and smart young man, not as a serious student of art. It was only after the two exhibitions which Diaghilev arranged in 1897 that the Princess decided to back the magazine. Another patron had still to be found to share the burden of the heavy initial cost, and Savva Mamontov was obviously the most hopeful choice, in spite of his relatively straitened circumstances at this time. Since his bankruptcy of 1890 he had worked fanatically hard to restore the fortune of his family and had been so far successful that the Abramtsevo pottery was now on a sound commercial footing. He was, in fact, able to share the financial launching of this new venture so reminiscent of his earlier efforts.

The first number of the *World of Art* magazine appeared in October 1898. Its actual appearance was due to the personal efforts of Filosofov, who was in charge of the technical side of production. He prepared the illustrations which were printed on a special kind of 'verger' paper which had never been used in Russia before. A great deal of trouble was taken over the preparation of the blocks, which were a whole

47

year in the making in Germany. The type they eventually decided on was an eighteenth-century face of which they had managed to find the matrices. It was thus a pioneering enterprise in printing techniques, as well as in art.

It was also due to Filosofov that the work of Victor Vasnetsov was illustrated in the first number. This choice provoked a storm of protest among the group. Filosofov and Diaghilev regarded Vasnetsov as 'the radiant sign of the new Russia, the idol before which one should kneel and worship'. Benois, Nuvel and Nurok protested that this was to confuse purely artistic standards of value, which they held to be the essential tenet of the 'World of Art', with a cultural-historical phenomenon. They were, however, told that they were foreigners at heart and were ignoring the real nature of Russian art. The philosophy of 'art for art's sake' was thus disputed even within its own stronghold. However, the 'World of Art' in so far as it can be identified with a single philosophy was inspired by the idea of an art which existed in its own right, not subservient to a religious, political or social propaganda motive. 'The "World of Art" is above all earthly things, above the stars, there it reigns proud, secret and lonely as on a snowy peak.' Thus Bakst described the emblem which he designed for the magazine.[7] Art was seen as a form of mystical experience, a means through which eternal beauty could be expressed and communicated – almost a new kind of religion.

Symbolist ideas were further and more explicitly introduced by the writers who shortly joined the magazine. The poets Blok, Balmont and the religious writers Merezhkovsky and Rosanov were represented side by side with the parent French school: Baudelaire, Verlaine and Mallarmé. The music of Scriabin was also discussed in its pages, thus making it a true 'World of Art'.

The visual section of the magazine in the early numbers included many illustrations of the 'Art Nouveau' artists from the various countries of Western Europe – Beardsley, Burne-Jones, the architecture and interior designs of Mackintosh, van de Velde and Josef Olbrich. The French school was represented by Puvis de Chavannes – who had a great following in Russia, particularly influencing Nesterov – Monet and Degas. But it was not until 1904, the last year of the magazine, that the Post-Impressionist French painters were taken up. The natural sympathies of the group were initially much more drawn

48

25 Alexander Golovin, *Boris Godunov*, design for a backcloth, 1907

to the Vienna Secessionist group, Böcklin and the Munich school, and only gradually came to appreciate the current French discovery of primitive and folk-art, which so closely paralleled the contemporary Moscow movement begun by the Abramtsevo and Talashkino communities. Contact between the indigenous Moscow movement and the work of Gauguin, Cézanne, Picasso and Matisse began in 1904 and continued up to 1914. Its course was marked by a succession of historic exhibitions which were the logical continuation of the 'World of Art' movement. The joining of forces of these two movements provided the dynamic which impelled and directed painting in Russia during the next decade.

These 'World of Art' exhibitions were the first public demonstrations of the group. They were intended to be as international in scope as the magazine, but this proved too expensive an undertaking. The first one took place in 1898, a few months before the magazine was launched. It was called 'An Exhibition of Russian and Finnish Painters'. Apart from the original Russian group, the Finnish school of late romantic painters was shown, together with work by members of the Abramtsevo colony: Levitan, the Vasnetsov brothers, Korovin, Serov, Nesterov, Malyutin and Vrubel – the god of the 'World of Art'.

The first official 'World of Art' show was held in the following year, 1899. It included pottery from the Abramtsevo factory and embroidery designs by Elena Polenova. In the section illustrating new ideas in industrial design were examples of Tiffany and Lalique glass. The international character of the exhibition was more pronounced this year and included works by the French engraver Rivière whom Benois so much admired, Puvis de Chavannes, and a few minor works by Degas and Monet. The English school was represented by Brangwyn and Whistler, and the German by Böcklin and one or two other members of the Munich school.

For their third exhibition in 1900 the group elected a permanent body of exhibiting members which included all the original Petersburg group, together with Korovin, Serov and Golovin, the latter a highly successful stage designer and close collaborator of Korovin. They worked on many productions together, with Mamontov, at the Imperial theatres and in the early Diaghilev productions such as *Boris Godunov*.

Ill. 25

From this time on the exhibitions ceased to be 'international' and representative of every school – they had even shown drawings by Repin in the first exhibitions – and acquired a more integrated and individual stylistic character. There were two trends in this new style which could be roughly defined as the Petersburg and the Moscow school: the school of line and the school of colour. The artists of the Petersburg school now included a younger generation (e.g. Bilibin and Stelletsky), as well as Benois, Somov, Lanseray, Dobuzhinsky and Bakst. Newcomers to the Moscow group were Igor Grabar, Pavel Kusnetsov, Utkin, the Miliuti brothers, Sapunov, and the leaders of the future *avant-garde* of the following decade, Larionov and Goncharova, who made their début with the 'World of Art' at the 1906

50

exhibition. The Symbolist painter *par excellence*, Borissov-Mussatov, was the only artist to combine the characteristics of both the Moscow and Petersburg schools. The differences between them gradually became more and more emphasized as the first decade of the twentieth century came to a close.

The initial predominance of the English and German schools in the 'World of Art' was not superseded by the French until the early years of this century. The last numbers of the magazine, however, were entirely devoted to the French Post-Impressionists – Bonnard, Vallotton and the ideas of the Nabi group; and with the final number of 1904, Gauguin, Van Gogh and Cézanne were introduced to the Russian public.

With this discovery of the French Post-Impressionists, the magazine ceased. The group felt that their propaganda mission was accomplished. They had succeeded in restoring contact with the Western European artistic *avant-garde* and made the Russian intelligentsia aware of the national artistic heritage as a whole. With the ground prepared for the new international culture which they had dreamed of, they abandoned preaching for the arena of creative activity.

It is in the theatre and particularly in the ballet that one must look for the creative work of the 'World of Art'. Here their ideals of an integrated, perfected existence, a complete realization of life-made-art was possible. In a medium where every gesture could be synchronized with a musical pattern, where costume and décor and dancer became integrated, they were able to create a visual whole, a complete illusion, a world of perfect harmony.

The man responsible for introducing the 'World of Art' to the stage was Prince Sergei Volkonsky, the newly appointed Director of the Imperial Theatres. Volkonsky appointed Filosofov to an administrative post in the Dramatic Theatre; and Diaghilev became a junior assistant to the Director. However, although only these two young men had official posts in the Imperial Theatre administration, the whole group would convene to discuss what innovations could be introduced through their friends' new position. Their first action was to take over the official Year Book of the Theatre's productions. Diaghilev managed with his friends to make this a brilliant, scholarly and impressive affair which even attracted the attention of the Tsar. Benois had meanwhile been given a commission to design the décor

26–28 Alexander Benois, *Le Pavillon d'Armide*, two costume designs and stage set, 1907

and costumes for a minor opera production at the Hermitage Theatre – again the whole group was called in to contribute and Somov designed the programmes. Bakst also made his début in the Hermitage Theatre with a ballet called *The Heart of a Marchioness* in which the great teacher Cecchetti performed. This was considered such a success that it was transferred in 1900 to the Mariinsky Theatre.

Thus the 'World of Art' had made its bow in the theatre, if a rather modest one, when Volkonsky was unfortunately obliged to resign his Directorship of the Imperial Theatres, following an incident involving a ballerina mistress of the Tsar's cousin. He was succeeded by his Moscow assistant Telyakovsky, a weaker character than his predecessor but whose lack of positive tastes made him an easy target for the energetic persuasion of the 'World of Art'. But, unwittingly, Diaghilev had fallen out of favour with Telyakovsky and the authorities and he now not only lost his job in the Imperial Theatre but was

dismissed in such a way that he was barred from any further employment in the service of the Crown. This was the reason why the 'Ballet-Russe de Diaghilev' was brought to Europe and America, but was never seen in Russia itself.[8]

Thus Telyakovsky came to rely mainly, not on Diaghilev, but on Benois. In 1903 Benois and the composer Cherepnin approached Telyakovsky with the idea of a ballet with a story in the style of *The Tales of Hoffman*, an old favourite of Benois: a young prince dreams about a Gobelin tapestry, which suddenly comes to life and its figures climb down and begin to dance with him. On waking he discovers a shawl left by the Princess Armida on the ground. Telyakovsky was not much taken by this unconventional idea and *Le Pavillon d'Armide* *Ills 26–28* was not actually put into production until 1907, by which time Telyakovsky himself invited the now established Benois to carry out his early project. Benois called upon a promising young choreographer

called Michael Fokine to arrange the ballet, and they worked on it all that summer with Cherepnin. Towards the end of that time Fokine suggested that a very brilliant pupil of his should be introduced into the ballet. This was Nijinsky. Nijinsky had created the part of Armida's slave for his début, and a *pas de trois* was inserted for him with Fokine and Anna Pavlova. Such was the first and only ballet production of the 'World of Art' to be seen in the Mariinsky Theatre. The success of this venture inspired the idea of taking a season of Russian opera and ballet to Paris. Having introduced Western ideas into Russia, they were now ready to complete the exchange by introducing the new Russian art to the West.

In 1903, with the end of the magazine and the 'World of Art' exhibitions, and excluded from any activity in the theatre, Diaghilev found himself at a loss, for, unlike his friends, he felt no creative call. What could he do to establish himself with the public, and in his own estimation? In a typically realistic fashion he analysed his gifts and decided that he would devote himself to furthering knowledge of Russian art. His first undertaking was an exhibition of eighteenth-century Russian portrait painting. This involved collecting together altogether forgotten and despised works of art from remote country houses all over the country. It was a gigantic task and was carried out by Diaghilev with his peculiar pertinacity and wholeheartedness. The result was a very brilliant occasion. The exhibition was held in the Tauride Palace in Petersburg and opened in the presence of the Tsar in 1905. The décor of the exhibition had been devised by Bakst and was conceived as a garden with sculpture relieving the monotony of the rows of canvases. It was typical of the ideals of the 'World of Art' that even an exhibition should be presented as a dramatic unity: the idea of thus relating the exhibits to an ensemble foreshadows the exhibition techniques evolved by El Lissitzky in the early 1920s.

The following year (1906) Diaghilev arranged to organize a Russian section at the Salon d'Automne in Paris. For this exhibition Diaghilev used many of the paintings from the Tauride Palace exhibition and again Bakst designed the décor in the twelve rooms taken over by Diaghilev in the Grand Palais. It was a much bolder enterprise, however, than that of the previous year and was designed to introduce the whole of Russian art to the West. The exhibition began with examples of icon painting – the least impressive works in

the exhibition, for few icons had been cleaned at this date. (It was not until the exhibition of 1913 held in Moscow to celebrate the tercentenary of the Romanov dynasty that Russian icon painting was revealed in all its original purity of colour and line.) In addition, Court portraits of the eighteenth and early nineteenth centuries and examples from all periods of Russian art were included – always with the exception of the despised 'Wanderers' – ending with the youngest Moscow artists who had only recently begun to exhibit with the 'World of Art': Pavel Kusnetsov, Mikhail Larionov and Natalia Goncharova.

This exhibition – still the most comprehensive of its kind to have been seen in the West – was a most ambitious undertaking on Diaghilev's part. It was a great success, not as spectacular as the later ballet seasons, but sufficient to encourage him in further projects in the propagation of Russian art in the West – perforce the West, since his activities in this direction had been so limited at home. In 1907 and 1908 Diaghilev introduced the 'five' nationalist composers in a series of concerts in Paris and in 1908 he brought to Paris the Imperial Theatre's production of Moussorgsky's opera *Boris Godunov*, with *Ill. 25*
Shalyapin in the title role and décor and costumes designed by Benois

29 Alexander Golovin, *Ruslan and Ludmilla*, design for a backcloth, 1902

and Golovin. The production had an enormous success, and Diaghilev, with Benois who was then living in Paris, and some of the other 'World of Art' friends who had accompanied the opera company, got together to plan further projects.

The outcome of the numerous discussions which absorbed the group during the next few months, reunited as in the early days of the 'Nevsky Pickwickians' and the later editorial meetings of the *World of Art* magazine, was the first, historic and overwhelming success of the 'Russian Ballet' which opened at the Châtelet Theatre in Paris on

Ills 26–28
19 May 1909. *Le Pavillon d'Armide* was chosen to head the programme,
Ill. 24
together with Borodin's *Prince Igor*. The ballet sequence of this opera, the famous *Polovtsian Dances*, seen against Roerich's superb sets, had a delirious reception. Also included in the first season were Rimsky-Korsakov's *Pskovtianka* – renamed for the Western public *Ivan the Terrible* – with a popular work by the mid-nineteenth-century

Ill. 29
composer Serov and the prologue from Glinka's opera *Ruslan and Ludmilla*. It was, however, the ballets which were the great success of the season. Apart from *Le Pavillon d'Armide* and the *Polovtsian Dances*, Fokine choreographed the exquisitely romantic *Les Sylphides* danced by Pavlova and Nijinsky, and *Cléopatre*, a musical hotchpotch with pieces taken from seven composers, and danced by Ida Rubinstein. This latter work was chiefly remarkable for Bakst's superb décor, an

Ill. 22
exotic peacock-brilliant vision like his *Orientales* and *Shéhérezade* with which he took Paris by storm.

During the next years, up to 1914, Diaghilev annually brought to Paris works in which one can trace the many tempers and tongues which went to make up the 'World of Art': the classical revival favoured by Benois; Roerich and Stravinsky's evocation of remote pagan cultures; the Hellenistic revival reflected in Bakst's designs,

Ill. 23
such as *L'Après-midi d'un Faune*, mingled with the influence of Persian interiors; the ornamental-decorative Impressionism of Golovin in the tradition of Vrubel; Korovin's Impressionistic designs; and the later designs by Larionov and Goncharova which not only reach back in their brilliant colour and formal motifs to the revival of folk-art by the Abramtsevo artists, but forward to the Futurist movement in painting of which they were the Russian pioneers.

Thus in Diaghilev's ballet one can rediscover a complete microcosm of the artistic life in Russia during the reign of the 'World of Art'. In

30 Matislav Dobuzhinsky, *Man in Glasses*, 1905–6

the great contribution which they made to both the Russian and Western scene, they saw their ambitions justified, and the creation of a new international culture springing from Russia as a reality.

We have already distinguished two main directions in the 'World of Art': that of Petersburg (line) and that of Moscow (colour). In both cases their most important work was done in the theatre, and the influence of 'theatrical' devices is paramount in the pictorial revolution which they continued.

To take the Petersburg school first: this was headed by Benois, and the chief innovation in pictorial composition was in finding new ways of rendering space without relying on perspective. Many of the devices were borrowed straight from the stage, for example, the use of wings to create depth in planes, or the use of overhanging frontal panels. These latter often represented leaves creating a pantheistic atmosphere, a secret world enclosed and guarded by mother nature, typical of Symbolist feeling. An emphasis on the 'felt' rather than

31
Alexander Benois,
Versailles under Snow,
1905

'explicit' sense of distance between the spectator and the world of the picture was often the aim: thus a heightened or drastically lowered

Ill. 33 viewpoint was used to create a sense of immediacy and intimacy with the pictorial scene: this was a device much used by Benois in his

Ill. 31 evocations of Versailles and the world of Louis XIV, or of the classical style of Saint Petersburg of Peter, or the Rococo of Catherine the Great. Another favourite device, derived from the Renaissance

Ills 16, 30 painters, was the painting of a window at the back of a scene through which another scene was glimpsed; or the repetition of a scene, or comment on it from another angle, achieved through reflections in a mirror. Another characteristic transferred from the theatre to easel

Ill. 32 painting was the use of silhouette, in particular the exaggerated

32
Konstantin Somov,
The Kiss,
1902

33 Valentin Serov, *Peter the First*, 1907

eighteenth-century silhouette. Often these costumed figures with
their high powdered wigs would be rendered even less human and
more doll-like by masks and by depicting them in profile or with their
backs to the spectator.

In all these ways these artists tried to break down the traditional
academic methods of picture construction, but their chief stylistic
characteristic was the reduction of the human figure to an ornamental-
decorative shape which emphasized the two-dimensional quality of
the picture-surface and the eloquence of line divorced from colour
and modelling. By 'unrolling' objects in silhouette moving parallel to
the picture-surface they emphasized the quality of their paintings as
visual impressions of a moment caught in time; by the use of costume
they reduced the individual to a type, and the particular to a generalized
definition.

This new emphasis on the flatness of the canvas surface which the Petersburg artists continued from Vrubel was likewise pursued by their Moscow friends in colour. Here a breakdown of the static, closed forms to open dynamic forms was brought about by the rejection of modelling and the use of all-over even colour, as in icon painting. In one of Serov's archaic scenes a chariot flies briefly on the horizon, its sketchy figures and horses on the strip of sand seem mocked by the vast unchanging sky. A sense of immensity, of all-pervasive atmosphere, is typical of this new mood in paintings: characteristics which reflect the Symbolist idea that the intangible, the mysterious, not the defined and understood, represents the deeper reality. A device often used by these painters is an unbroken foreground leading to tiny figures half-way up the canvas and a diffused even light which leads the eye back over the sky. This double journey of the eye is later to be found in the work of Pavel Kusnetsov, a direct descendant of these artists: *Mirage in the Steppes*, for example, where the flat ground stretches endlessly to the horizon and where the heat has thrown up great shimmering white curves in the equally measureless blue.

The influence of the Impressionist painters on Korovin's work was reflected not in a close attention to accurate visual representation of a scene in terms of light and colour: the Russian artist has never been notable for his interest in visual reality, but in his use of a continuous all-over brushstroke rhythm merging one element with another, weighting evenly background and object, so that the figure becomes a patch of colour rather than an isolated arbitrarily defined element. In a similar way Golovin developed Vrubel's experiments in his decorative 'carpet-like' weaving of motifs, which reduce the whole to a vibrating unity of colour rhythms. Golovin's work, like that of Korovin, with whom he constantly co-operated, is essentially of the theatre. It created an atmosphere into which the spectator is inevitably drawn. Such examples of Golovin's and Korovin's work as *Ill. 25* the décor for Diaghilev's Paris production of *Boris Godunov* and the *Ill. 29* 1902 production of *Ruslan and Ludmilla* at the Mariinsky Theatre were pioneers in their achievement of a visual unity, and continued directly the early productions of Mamontov's 'Private Opera' company.

The only painter to unite the costume-painting of the Petersburg artists with their inspiration derived from the eighteenth century,

and the Moscow artists with their colour experiments, was Victor Borissov-Mussatov (1870–1905). After Vrubel, Borissov-Mussatov was the most significant and influential painter in Russia at this time.

Borissov-Mussatov was a native of the eastern Volga city of Saratov, which was the chief provincial art centre in Russia at this time up to the 1920s. (In 1924 the large exhibition of German Expressionist painting which was sent to Russia visited Moscow, Leningrad and Saratov.) The Radishchev Museum in Saratov boasted an unusually enlightened collection for the time, with a particularly fine collection of Montecelli's work. At a very early age Mussatov began attending drawing classes at the Radishchev Museum. Showing promise, he then left his native town to enrol in the Moscow College of Painting, Sculpture and Architecture. In 1891 he transferred to the Petersburg Academy and was among the last of those taught by Chistyakov. Still unsatisfied, he returned after a year to Moscow and began working in earnest. His early work is academic, his line hard and his colour cold, but while still in Moscow the future Symbolist dreamer begins to show through this student discipline. In 1895 he left for Paris and during the next four years worked in Gustave Moreau's studio, famous for its brief housing of the future Fauve painters. Mussatov made no contact, however, with them. He was first struck, like Diaghilev the year before, by Bastien-Lepage. This early interest was soon succeeded by Puvis de Chavannes, alike the model of the Nabi group and the 'World of Art' painters. The similarity in interest and purpose of these two groups I have already pointed out, but it is one which would make an interesting detailed comparison, particularly in the idea of painting as part of a total environment.

It was under the influence of Puvis de Chavannes that Mussatov began working in an historical style. His fascination with the past, in the style of the 1830s, remained a constant characteristic in his mature work. It is not, one feels, a particular moment in history which he desired to evoke – unlike Benois and Somov, the Petersburg eighteenth-century *devoués* – but simply the past, the moment irretrievably gone for which he for ever seems to grieve.

Mussatov's use of historical costume also differs profoundly from that of Somov or Benois. It is not a conscious stylization in order to reduce the figures to a silhouette, a marionette, but a means of rendering the human figure more remote and mysterious.

34 Victor Borissov-Mussatov, *Autumn Evening*, study for a fresco, 1903

In 1895, after the death of Gustave Moreau, Mussatov went back to Russia. He returned to his native Saratov, and there began to work in surroundings which leant themselves to the melancholy dreaming which remained his constant mood until his premature death in 1905. A local landowner provided Mussatov with the ideal situation for working: an abandoned park with a derelict house built in the classical style – just such a house and pavilion as the English artist Conder loved to paint. With its white colonnades and rounded domes it appears in almost every work by Mussatov of this time. Vague crinolined figures gaze at their reflections in the lake, mysterious, lonely and silent. A typical example is *The Reservoir* of 1902; the melancholy bending figure is withdrawn into an enclosed, death-close world wrapped round by shadows and the immaterial rhythms of water. The soft blues and grey-greens which Mussatov always used are the Symbolist colours *par excellence* – Maeterlinck's *Bluebird*, Oscar Wilde's green carnation and later Kandinsky and Yavlensky's 'Blue Rider' all make use of the association of such colour-tones. There was also the 'Blue Rose', a group of Moscow artists who were directly inspired by Mussatov and who succeeded the 'World of Art' as the new movement in Russian painting after 1905, the second generation of Symbolist painters.

Ills 34, 35, 37

Ill. 36

35 Victor Borissov–Mussatov, *Sleep of the gods*, study for a fresco, 1903

36 Victor Borissov–Mussatov, *The Reservoir*, 1902

37 Victor Borissov-Mussatov, *Sunset reflection*, 1904

1905–10

The atmosphere of political turmoil which surrounded the abortive Revolution of 1905 was accompanied by a renewed vitality in all the arts. Just as the rapid expansion of industrialization, made possible by large foreign investments, brought Russia into the economy of Western Europe, so for these five years, from 1905 until 1910, movements in Russian art were intimately bound up with developments in other European centres. It was during this time that Russia became a meeting-place for the progressive ideas from Munich, Vienna and Paris, and springing from this cosmopolitan basis a style began to develop which in the following decade led to the creation of an independent Russian school of art.

This period of free exchange with Western art centres and general renaissance of culture in Russia can be directly attributed to the activities of the 'World of Art' members. In tracing their movements, therefore, one can rediscover the pattern of events.

When the *World of Art* came to an end as a magazine its literary contributors went on to found their own publications. In 1904 *The Scales* appeared.[1] This was followed two years later by *The New Way*.[2] In these magazines one of the most important innovations of the 'World of Art' was maintained: the conception of art as a unity, of a basic inter-relationship and common source of all inspiration regardless of the medium of expression. This spiritual affinity between the members of the 'World of Art' and the Symbolist school was later realized in a physical inter-development of literature and painting which is one of the most outstanding characteristics of the Cubo-Futurist and subsequent schools of abstract painting which developed in Russia during the years 1910–21. Thus these Symbolist magazines not only included the work of Briussov, Balmont and Blok and the French writers from whom they sought their inspiration, but also devoted space to developments in painting, music and architecture.

The pioneer work in Russian art history begun by the 'World of Art' was continued in a number of magazines established during this

period. The moving figure in this activity was Benois. Already in 1903 he had founded *The Artistic Treasury of Russia*,[3] in 1907 this was followed by *The Old Years*,[4] and in 1909 *Apollon* made its appearance.[5] These magazines mark the first attempt to create a systematic research into the history of art, and in particular of Russian art. Here we find the first attempts to relate Russian movements in art to their European counterparts. The history of Byzantine traditions in Russia is likewise traced, and the sources of Russian folk-art. The great private collections were given their first publicity in these publications, including those of the early patrons of icon painting, the recent collectors among Moscow merchants of later Europeanized court art, and the even more recent collectors of Oriental and modern European art.

The magazine *Apollon* is particularly valuable to an historian of modern art in Russia, for it contains detailed reviews of exhibitions during the period in which it was published – the vital years of 1909 up to the Revolution of 1917. These reviews are often the only reliable source of documentation for these historic exhibitions.

Apollon did not, however, continue the tradition of the 'World of Art' as a champion of the *avant-garde*. Its reviews of the little exhibitions which became typical of the scene during these next years are scholarly and accurate in their information, but often pedantic in their approach. Consolidation rather than creation was its contribution.

It was the 'Golden Fleece'[6] which continued the tradition of the 'World of Art' most completely. This not only championed the *avant-garde* in its magazine, but was also an active organization in sponsoring exhibitions. During its short life, 1906 to 1909, the 'Golden Fleece' was of fundamental importance and its formation, development and significance will be enlarged upon shortly.

Nuvel and Nurok, the musical members of the 'World of Art', founded a society called 'Evenings of Contemporary Music' in Saint Petersburg, in 1902. The purpose of the evenings was to bring together the musical *avant-garde*, and the concerts given on these occasions often comprised first performances in Russia of works by foreign or native composers. Those favoured by the society included Mahler, Reger and Richard Strauss, Debussy, Ravel, César Franck and Fauré, and among the Russians, Scriabin, Rimsky-Korsakov,

66

Rachmaninov and Medtner. The seventeen-year-old Prokofiev gave his first public concert at one of these evenings; and it was here too that Rimsky-Korsakov's young pupil Igor Stravinsky gave the first performance of an original work entitled *Fireworks*. It happened that Sergei Diaghilev was in the audience on this evening in 1909, and having heard and become enthusiastic over this unknown young composer's piece, in his inimitable fashion, Diaghilev demanded that he should take over the work of writing a score for his projected ballet *Firebird*. (He had already commissioned Liadov to do this work, but since that composer had so far produced nothing, Diaghilev decided to hand over the commission to Stravinsky.) Thus began a most happy and historic co-operative enterprise, in which Stravinsky wrote the music for ten of Diaghilev's ballets, and through this activity was introduced to the West, where he eventually settled.

Another direct outcome of the 'World of Art' movement, and one of no small consequence to the development of painting in Russia during the next fifteen years, was the creation of a picture-buying public among the middle classes. 'Culture' and collecting paintings became an essential adjunct of the respectable wealthy citizen. The subjects of these collections varied, and again reflect the influence of the 'World of Art' in forming the taste of the following generation. Thus Russian portrait painting of the eighteenth and early nineteenth century became fashionable after the Diaghilev exhibition of 1905 which brought this long forgotten school back to the notice and favour of the Russian public. The new collecting urge had an even more important effect, since it was the means through which examples of French Post-Impressionist paintings were brought into Russia, where they exercised a powerful influence on the younger painters. Most illustrious among such collections were those of Sergei Shchukin and Ivan Morosov, both of Moscow.

Sergei Shchukin was a small man whose half-Mongol features, with flashing black eyes under bristling eyebrows, have been so dramatically recorded for us by Henri Matisse. His collection was phenomenally rich in works by Matisse and Picasso.

He had four brothers, all of whom were collectors, but only Sergei was interested in contemporary art. As we saw in Chapter I, he first came across the work of the French Impressionists when his friend and fellow-collector Botkin, who was then resident in Paris, introduced

him to the gallery of Durand-Ruel and called his attention to a work of Claude Monet of whom he was a great – and in Russia a pioneer – admirer. Shchukin immediately bought a Monet, *Argenteuil Lilac*. This event took place in 1897 and marks the beginning of Shchukin's extraordinary collection. By the outbreak of the First World War in 1914 it numbered 221 works of the French Impressionist and Post-Impressionist schools, over fifty of them by Matisse and Picasso, including many vital Fauve and post-Fauve works by Matisse and examples of Picasso's latest period of analytical Cubism.[7] Not only was the work of Picasso and Matisse revealed to the Russian public in this way, but likewise the Batignolles school of the 1870s – Manet, Fantin-Latour, Pissarro, Sisley, Renoir, Degas and Monet – were all introduced to Russia by Shchukin. It was probably not until 1904 that he acquired his first Cézanne (although the still-life *Flowers in a Vase* may have been acquired by him directly after its sale by its previous owner, Victor Choquet, which took place in 1899). From 1904 onwards, Shchukin concentrated his attention on the Post-Impressionist school whose work he saw at the Salons des Indépendants and Salons d'Automne to which he was a regular visitor. First-class examples of the work of Van Gogh, Gauguin, the Nabi school, the Douanier Rousseau and Derain, rapidly appeared on the walls of his large Moscow house which was now open to the public on Saturday afternoons. The sudden impact of these pictures on the young painters of Moscow can easily be imagined. But scarcely had they learned to absorb these than the first works by Matisse and Picasso began to appear on Shchukin's walls. Shchukin first met Matisse in about 1906, although he had probably acquired a couple of his works two years previously.[8] During 1906 and 1907 Shchukin bought four early Fauve works, but in 1908 he became Matisse's most important patron when he acquired the crucial *Game of Bowls* and the enormous *Harmony in Blue* (which became *Harmony in Red* to match Shchukin's dining-room in which it was to hang). The following year he bought among other works *Nymph and Satyr* and commissioned the huge *Music* and *Dance*, which Matisse himself travelled to Moscow in the winter of 1911 to install *in situ*. On this visit Matisse is said to have been very impressed by the artistic activity of the town and to have spent much time studying Russian icon painting and folk-art. 'It was looking at the icons in Moscow that I first understood Byzantine

68

painting.'[9] The Moscow painters in their turn were impressed by no one so much as Matisse. Even Cézanne, Gauguin and Picasso, whose influences were immense on the contemporary Moscow *avant-garde*, could not touch the enthusiasm provoked by Matisse whose ideas came so near to their own in their reduction to essentials and in the decorative flat style of painting. A reflection of the esteem in which Matisse's work was held at this time is the special number of the Moscow magazine *Golden Fleece* devoted to the work of Matisse.[10] It included an essay by Henri Mercereau, permanent Paris correspondent of the *Golden Fleece*, on Matisse's position in the French movement, and a translation of Matisse's *Notes d'un peintre*. Alfred Barr describes this profusely illustrated number of the *Golden Fleece* as the most complete single publication on Matisse in any language up till 1920.[11]

It was Matisse who introduced Shchukin to Picasso. Between this first meeting in 1908 and 1914 Shchukin bought over fifty paintings by Picasso and he and Matisse were given individual rooms in the Moscow house. Matisse himself arranged his room on his visit in 1911; Picasso's room contained examples of African sculpture from the Congo and Madagascar to go with the Cubist works of which Shchukin had a number of extremely radical examples, both of the early period of 1908–9 and of the almost abstract, such as *Musical Instruments* of 1912–13. The latter is one of the few works executed on an oval-shaped canvas; it served Malevich as a direct model for his Cubist works of 1913, which were executed just before his first Suprematist abstract paintings.

Ill. 121

Ills 117–19

The Morosovs, unlike the Shchukins, were traditional collectors. Perhaps for this reason Ivan Morosov's taste was more conservative, less sure and personal than that of Shchukin, who always chose his own paintings regardless of advice. Morosov on the contrary needed encouragement. When he was first taken to Matisse's studio by Shchukin in 1908 he was uncertain about the more recent works, unlike his bold compatriot who seemed to delight in outraging the Moscow *bourgeoisie*. At first, therefore, Morosov bought only early works by Matisse; however, in a few years' time he was so far convinced by the talent of this painter that he even outdid Shchukin in the number, though not the quality, of his acquisitions. Morosov fought shy of Picasso. In fact, in his whole collection of 135 paintings,

there was only one Picasso. Predominant in his collection were Cézanne, Monet, Gauguin and Renoir. He also bought many works by the Nabi school and commissioned Maurice Denis, Bonnard and Vuillard to execute large-scale panels for his house.[12] Denis had a great following in Russia, which he visited several times during this period, for his work more than that of any other French painter was sympathetic to the Petersburg Symbolist school of literature among whom he found ardent supporters; work and articles by him were frequently reproduced in their magazines.

Thus through the collections of Morosov and Shchukin, the Russian artists were given as it were a concentrated course in the revolutionary French painting of the last forty years, and the most advanced ideas and movements of the last ten years were even more familiar in Moscow than in Paris itself where the public did not have the advantage of a selection made for them by the masterly eye of such men.

It is hardly surprising that such stimulus should have precipitated a revolution. Already by 1905 the successful establishment of the 'World of Art' movement and its original propagandists was provoking a restlessness and feeling of reaction among the younger painters, particularly those in Moscow, to whom the stylization of the dominant graphic style of the 'World of Art' was basically alien. They protested against the erudition which the 'World of Art' painters continued to emphasize, even though the battle against the 'Wanderers' which had provoked this drive for a high standard in the artist had long been won. Now that the need for a basic cultural education for themselves and the public was no longer urgent, the younger generation felt that the 'World of Art' members were pursuing knowledge for its own sake and had become lost among problems so obscure as to be irrelevant to all but the most highly cultured. In the first number of the *Golden Fleece* the voice of the new generation made its protest:

> In order to understand even a little the work of Somov, Dobuzhinsky, Bakst, Benois and Lanseray one must be familiar not only with the art of the eighteenth century but also with that of the early nineteenth century; one must have studied Gainsborough and Beardsley, Levitsky [the Russian eighteenth-century portrait painter, 1735–1822] and Briullov [Russian painter of classical school,

1799–1852], Velasquez and Manet, and the German woodcuts of the sixteenth century. . . . But can one create an art capable of general communication from such a sauce of history?[13]

This revolt against the 'World of Art' was paradoxically enough revealed at its own exhibition of 1906. It brought together a large number of works, by artists who now had little in common: the original 'old guard'; a second generation of Petersburg artists such as Bilibin and Stelletsky; and a number of young, chiefly Muscovite, painters whom Diaghilev had invited to contribute to both this exhibition and the one of the same year which he was organizing in Paris.

The works of the 'old guard' were chiefly designs for recent theatrical productions. Benois, recently returned from a three-years' stay in France, contributed a series of *Walks of Louis XIV* in the park of Versailles; Roerich a series of archaic mountain-scapes. Korovin, likewise recently returned from France, had now succumbed to imitation of Pissarro and Monet and exhibited classic Impressionist scenes of Paris streets. Serov showed a few of his brilliant portraits of prominent personalities such as that of the actress Ermolova. Vrubel *Ill. 16* was represented by some of his recent works done in the mental asylum not far from Moscow, where he was living at this time; among these was the portrait of his friend, the Symbolist poet *Ill. 17* Briussov.

The most exciting section of the exhibition, however, was that devoted posthumously to the work of Borissov-Mussatov, who was almost entirely unknown outside a small circle of artists during his lifetime. Diaghilev was a great admirer of this painter and considered him to be grossly underestimated. In the following year (1907) he organized a large retrospective exhibition of his work in Moscow. The section devoted to his works in this 'World of Art' exhibition of 1906 was the first attempt to assess his contribution to art as a whole. In bringing it together Diaghilev undoubtedly played a part in the formation of the 'Blue Rose' group, a second generation of Symbolist artists, who acknowledged this painter as their inspiration.

The artists who later formed this group contributed notably to the exhibition, 'bringing to it new colours, new tones and new life'.[14] For the most part they were students of the Moscow College under

Serov and Korovin. The most prominent among them were Pavel
Kusnetsov, Georgy Yakulov, an Armenian and future Constructivist
designer in the theatre, Natalia Goncharova, Mikhail Larionov, the
Greek Miliuti brothers Nikolai and Vassily, and the Armenian
Martiros Saryan.

The 'Blue Rose' group came together as a distinct entity after the
'Union of Russian Artists' exhibition of December 1906. This was a
Moscow exhibiting society which had been formed in 1903 and
which came in some measure to replace the 'World of Art'. It did not
identify itself with any particular philosophy or style, but was simply
an organization which arranged annual exhibitions to which anyone
could contribute. Many of the Petersburg 'World of Art' members
did so, and these exhibitions became the obvious centre for the mem-
bers of the Moscow College to show their work. These annual shows
were, however, usually lacking in excitement, since they included
artists of every school. But for the young student and emerging
painters they were often a first public appearance.

In the exhibition of December 1906 the pictures exhibited by the
group were in many cases the same as had already been seen in earlier
'World of Art' exhibitions, but against the confused background of
this Moscow exhibition the work of these young painters stood out
in vivid contrast.

38
Pavel Kusnetsov,
Holiday
c. 1906

39 Nikolai Sapunov, *Mascarade*, c. 1906

40 Nikolai Sapunov, three costume designs for Meyerhold's production of
Colombine's Best Man, 1910. Colombine's Best Man. The Dance Director. A Guest

41 Pavel Kusnetsov, *Birth—fusion with the mystical force in the atmosphere. The rousing of the devil, c.* 1906

The influence on them of Vrubel and Borissov-Mussatov was easy to see. On the one hand, one can discern a use of the imaginative imagery of Vrubel and his decorative pictorial construction; on the other, the soft blue colour range and flowing line of Borissov-Mussatov. It was from this point of departure that the 'Blue Rose' group, by boldly simplifying their forms and using increasingly pure, warm colour tones, began to defy the exhausted delicacy and sophistication of the 'World of Art'. Their aims, in the words of their spokesman, Nikolai Miliuti, were 'to bring clarity into the chaotic state of affairs . . . to create a centre into which all that is live would flow . . . to create a more prudent and conscious group'.[15]

In the following March (1907) the 'Blue Rose' held their own exhibition in Kusnetsov's house in Moscow. Fifteen painters and one

sculptor, Matveev, took part. Reviewing the exhibition, Sergei Makovsky, the Symbolist poet and future editor of *Apollon*, wrote: 'They are in love with the music of colour and line . . . heralds of the new primitivism to which our modern painting has come.'[16]

Pavel Kusnetsov was in every way typical of the 'Blue Rose' group. He had been a pupil of Borissov-Mussatov, their acknowledged inspiration, during the years 1895–6 after the painter's return from Paris. He too was a native of Saratov. Again perhaps the first-class Radishchev Museum, and the emphasis laid by Kusnetsov's Italian teacher Baracci in the local art school on the principal of *plein air*, played their part in encouraging the pantheistic approach character-istic of the 'Blue Rose'. The influence of the landscape painters Polenov and Levitan as well as that of the French Barbizon school is noticeable in the early work of Kusnetsov. He entered the Moscow College in 1897, where he worked under Levitan and his colleague, Professor Serov. Serov did not have much influence on the nineteen-year-old Kusnetsov, who had already found colour to be his chief interest. It was, however, due to Serov, who thought highly of his precocious young pupil, that Diaghilev invited Kusnetsov to

42 Pavel Kusnetsov, *Grape Harvest, c.* 1907

contribute works to the 'World of Art' exhibition of 1906 which has already been described, and which introduced his work to an immediately appreciative audience for the first time.

In contrast to Mussatov, Kusnetsov and the other 'Blue Rose' artists were not haunted by a sense of doom, by pessimism, by a sense of the world being an alien environment. Death, decay and illness had been the favourite themes of the early Symbolist movement, but the 'Blue Rose', which represents the second generation, painted subjects essentially connected with life. *Maternal Love,* *Ill. 41* *Morning, Birth* are typical titles of Kusnetsov's works, in which the figures are emerging as if still drowsy from a deep sleep. Stillness surrounds them, not the stillness of Mussatov's near-death, but rather a silence of awe before the mystery of life. As with Mussatov, there is a pantheistic sense of unity with the elements, but this time it is a joyful vision of man as an intimate part of the pattern of nature, not as a creature engulfed by a force stronger than himself. A contemporary critic writes of his works as 'alluring visions which lead us into a world of airy forms and misty outline . . . visions in tones of pale blue, matt peaceful tones, of trembling other-worldly silhouettes, transparent stems of mystical flowers bathed in the early light of day. On everything there lies the breath of things untold, of things to be grasped by dim premonition.'[17]

Kusnetsov's works are all, in fact, painted from nature, despite their fantasy. This was a rejection of the 'World of Art's' theatrical approach. Yet Kusnetsov still employed many of the devices of the 'World of Art' painters. Atmosphere is the prevailing element in his work; geometric perspective and individual characterization of forms in volume are entirely absent. The picture plane is flat and the figures brought up hard against the surface. The use of repetition is a prominent feature. Kusnetsov shared with Borissov-Mussatov a strong lyrical feeling, a sense of poetry and his blue-grey range of colours. His strong curved stroke is combined with a softness which he likewise derived from Mussatov. This flat and decorative manner of painting was to become more extreme, both in Kusnetsov's own work and in Russian painting generally.

A noticeable feature of the exhibition of 1907 was the fact that many of the works were not framed pictures but panels. This was in accord with the feeling – common to the Nabi and Austrian and

43 Pavel Kusnetsov, *The Blue Fountain*, 1905

German 'Art Nouveau' painters – that easel painting was no longer relevant to modern life. Art was now to be an integral part of society. They wished to reject the Renaissance idea of a painting as something which mirrored an ideal world different from everyday reality.

Among the most outstanding works at the exhibition was Nikolai *Ill. 44* Miliuti's *Angel of Sorrow* – a patchwork of streaming downward-

77

44 Nikolai Miliuti, *Angel of Sorrow*, c. 1905

running brushstrokes of brilliant pinks, mauves and turquoise. In the intensity of its rhythm and its embroidered surface it recalls Vrubel, its vision of a lost soul in the tortured face which stares from the gaudy pattern so vividly recalling later 'Demon' works by Vrubel. Water in every form is a constant element in the work of these 'Blue Rose' artists, and this again recalls Borissov-Mussatov. With these younger painters, however, the water is seldom a still lake or pond, and there is often the hint of a hidden source of light about to break through and flood the scene. Thus in Sudeikin's *Venice*, floating figures glide along the water's surface, their faces drugged and withdrawn, but behind them rises a splendid sight of great trees through which light is gently breaking, hinting, like the windows of a Gothic cathedral, at infinite light and space beyond. Utkin also allows the rhythms of water to penetrate his work. *Mirage* depicts a strange vision of figures standing at the water's edge, or more accurately, blown up by waves, whose substance they seem to share. Behind these willowy, swaying figures rears a monstrous curling wave, a pumpkin cloud of water

78

45 Martiros Saryan, *Man with Gazelles, c.* 1905

46 Martiros Saryan, *Deserted Village,* 1907

lit by brilliant light as if touched by an unseen hand. Another painting by the same artist entitled *Triumph in the Heavens* takes us to the brink of the world; we gaze through a veil of fine, hailing lines at an infinity of blue. Beyond and around this material fragment, nothingness, one feels, is waiting.

Beside these frail visions of immateriality in a 'measure lost to man', *Ill. 211* which recalls the Suprematist *White on White* series of paintings by Malevich, the work of the Armenian Saryan is gratefully solid. His use of paint is sensuous, and his colour bold. But here also there is *Ill. 45* mystery. *Man with Gazelles* shows a white figure with a shock of black hair, leading his flock of gazelles swiftly out into a blank-faced, white-walled desert city. There is no sky: the squat buildings hug the spaceless, timeless scene. The Symbolist in Saryan is also shown in his love of water scenes, as for example *Fairy Lake*. Here two naked girls dance to their long white water-shadows in a cloudy lake enclosed in an ornamental garden, whose sense of seclusion and protection reminds one of a Persian miniature. In common with the other members of the 'Blue Rose', Saryan's figures are still hardly defined forms, rather patches or streaks of bright colour, barely materialized. It is a de-materialized, primeval, half-born world into which these artists were plunged and from which they shortly emerged into one of bold forms and brilliant colour, brimming with life and movement.

Nikolai Miliuti's brother Vassily was another painter who con- *Ill. 47* tinued the tradition of Vrubel. In a work such as *Legend*, with its mosaic patterning, the relation of the formal composition to Vrubel's work is strikingly noticeable, and also the use of a similar imagery.

The *Golden Fleece* magazine was the organ of the 'Blue Rose'. One of their number was the wealthy Moscow merchant Nikolai Ryabushinsky, and he edited and financed the magazine, which had been founded the previous year in 1906. In its editorial it declared: 'We intend to propagate Russian art beyond the country of its birth, to represent it in Europe in a whole and integrated fashion in the very process of its development.'[18] The magazine was printed at its outset in both Russian and French, and the titles and authors of works which were reproduced were scrupulously – if occasionally somewhat whimsically – transcribed into Roman or, as occasion demanded, Cyrillic characters.

47 Vassily Miliuti, *Legend*, 1905

The 'Golden Fleece' organized three historic exhibitions. The first was held in 1908 in Moscow, and included works of both French and Russian painters. The French paintings were probably selected by Henri Mercereau and Ryabushinsky, who frequently visited Paris and would certainly have seen the Salons of the last few years at which many of the paintings sent to Moscow had been exhibited. In particular many of the first Fauve works which had created such a furore at the Salon d'Automne of 1905 reappeared at this first 'Golden Fleece' exhibition. 'It presented the most discriminating general exhibition of French Post-Impressionist painting held anywhere – including France – up to that time and with the exception of the London Grafton Gallery Show of 1912, up through World War I.'[19] The aim of the organizers was later stated in the *Golden Fleece*:

> In inviting French artists to take part in exhibitions, the group of 'The Golden Fleece' was pursuing two aims: on the one side, by juxtaposing Russian and Western experiments, to show more clearly the peculiarities in the development of young Russian painting and its new problems; on the other side, to emphasize the characteristics which are common to both Russian and Western painting, for in spite of the different national psychology (the French are the more sensual, the Russians the more spiritual) the new experiments of young painters have a certain common psychological foundation. Here it is a question of getting over aestheticism and historicism, there it is a reaction to the neo-academic art which gave birth to Impressionism.[20]

It was a very large exhibition, numbering 282 paintings and three pieces of sculpture. Of the sculpture, Maillol sent two works and Rodin his *Femme couchée*. The paintings included works by almost all the other members of the Nabi group: Bonnard, Vuillard, Sérusier, Vallotton and Maurice Denis – now a permanent correspondent of the *Golden Fleece*. The Fauve group was well represented and headed by Matisse. He showed four works, from his *Invalid* of 1901 to his Neo-Impressionist *Terrace of Saint Tropez* of 1904 and *Harbour at Collioure* of 1905, which was among his first Fauve works and the basis for his famous *Joy of Life* of the following year. Derain sent four of his brilliantly coloured views of London, Marquet two scenes of the Seine entitled *Quai du Louvre*. Another Fauve who had a great

82

success in Moscow from this exhibition was Van Dongen whose riotous colour fired the imagination of the Moscow painters.

The older school of Impressionists, likewise seen for the first time at this exhibition, was represented by works by Pissarro and Sisley; there were a few drawings by Renoir and Toulouse-Lautrec, whose influence was soon to be reflected in the work of Goncharova and Petrov-Vodkin. Early works by Braque and Le Fauconnier were also seen, and finally the three great Post-Impressionists, Cézanne, Van Gogh and Gauguin – although in number, and in the importance of the works exhibited, only Van Gogh equalled the Nabi group favourites. Van Gogh's five works included *Berceuse*, *Sun in the Trees* and *Night Café*, which was bought by Morosov at the exhibition. It is interesting to note that neither Morosov nor Shchukin would agree to lend any of the works from their collections to these 'Golden Fleece' exhibitions. When approached, according to Larionov who was one of the organizers, Shchukin replied that he and Morosov were about to organize their own exhibition and therefore could not be expected to lend anything. Such an exhibition, however, never took place. Ryabushinsky lent several of his fine collection of Rouaults, but of course he organized and financed the exhibitions himself. David Burliuk in his reminiscences[21] describes the setting as one of extreme luxury, with silk hangings as a background to the paintings and champagne to celebrate the occasion. It is described with some bitterness, for Burliuk was not included among the painters chosen to represent the analogous Russian up-and-coming movements, despite the fact that Larionov and Goncharova, who had taken part in the provincial 'Wreath' exhibitions organized by the Burliuks in 1907, were prominent among those who were represented.

The Russian section of this first 'Golden Fleece' exhibition was hung separately from the French and contained works by some of the 'Blue Rose' group – Kusnetsov, Utkin and Saryan – Ryabushinsky himself contributing a modest two paintings only – but the painter who dominated these rooms was Mikhail Larionov. He sent twenty works of a quasi-Impressionist style, including *Spring Landscape*, from the series *The Garden*, which reflected the influence of Vuillard and Bonnard. Goncharova also contributed to the exhibition although on a smaller scale, sending seven works in all, including *Bouquet of Autumn Leaves*, 1902–3. Kusnetsov and Saryan's work had become

48 Martiros Saryan,
Self-portrait, 1907

more bold in colour and outline, more markedly primitive in form, since the year before. In Kusnetsov's *Vision of a Mother in Labour*, the monumental pregnant woman stands centrally against a rainbowed vision of the unborn child; the square-jawed head and the squat figure of the woman are defined by thick, sweeping lines. In other works such as *Holiday* one can discern this new primitivism even more clearly in the simplified delineation of features and grimace of their attitudes which is derived more from Russian peasant art, particularly peasant woodcuts, than from the French school of Gauguin. Kusnetsov was, however, well aware of this school and was interested in the work of Gauguin in particular, but he preferred to go directly to the East, to Persian and Kirghiz Mongol painting, which fascinated him at this time and during the next ten years played a great part in the development of his later style. Kusnetsov, in common with a number of Russians at this time, exhibited regularly at the Paris Salons and himself often went to Paris. Larionov and Goncharova had also gone in 1906 with the exhibition of Russian art organized by Diaghilev. There was, in fact, a great deal of coming and going between the two cities at this time when Moscow was very much in Europe and bound up with its life, and its progressive painters were almost all 'School of Paris'.

Ill. 38

84

However, the primitive character of Saryan's works such as *The Poet* shown at this exhibition is again more indebted to Eastern traditions than to the new French School. But his brilliant colour and strong patterning are akin to the Fauves in their fearlessness and freedom; like theirs, his colour is full and unmixed, and he uses a strong outlining to depict his figures. There has been a great change since his work of the previous year, surely due in part to the new Matisses he would have seen at Shchukin's house, although, true to his Armenian blood, he interpreted them in an Oriental fashion.

Ill. 49

In the work of V. Miliuti a change has likewise occurred, and in *The Shepherdess* and *The Secret Garden* his curling twisted line pursues a pulsing organic rhythm in a freer form.

In the following numbers of the *Golden Fleece* magazine much space was devoted to discussion of this exhibition. The French school was given an entire issue to itself,[22] in which many works from the exhibition were reproduced; Cézanne's *Portrait of the Artist's Wife* and *Still-Life* were in full-page colour. The text included excerpts from Van Gogh's letters and articles such as 'Trends in new French painting: Cézanne, Van Gogh, Gauguin' by the Symbolist poet Maximilian

49 Martiros Saryan, *The Poet, c.* 1906

50 Mikhail Larionov, *Two women bathing in a river, c.* 1903

Voloshin, and 'Impressionism and New Movements' by another
Russian art critic G. Tasteven.

The following number[23] dealt with the Russian contribution. This
is a particularly useful document, for many of the works which were
exhibited in the Russian section are reproduced. Many Kusnetsov,
Saryan and early Larionov and Goncharova works were lost in 1911
when Ryabushinsky's entire collection was destroyed in a fire, so that
they would be otherwise unknown. Among them were also fine early
Rouaults of whom Ryabushinsky was an early and ardent admirer.
Few Russian works of this period have ever reached the West,
although some were seen at Diaghilev's exhibition of 1906, at the
Vienna Secession exhibition and at the Paris Salons up to the First
World War. Paintings by any of this 'Blue Rose' group, or examples

86

52 Mikhail Larionov, *A corner of the Garden, c.* 1905

51 Mikhail Larionov, *Rain*, 1904–5

of any of the pre-1914 Moscow painting movements, are objects of extreme rarity in Western museums and private collections. Even in Russia itself there are few on exhibition. Thus this period in Russian painting has become obscure and our knowledge of it is, alas, all too third-hand and derived from reproduction. For such painting to be known only in reproduction – and often of mediocre quality by modern standards – is additionally prejudicial, for it is primarily for its colour that it is exciting. The peculiarly soft and exquisite blue-greys of the work of Borissov-Mussatov and Kusnetsov, the brilliant dappled pinks and mauves of the Miliuti brothers are so essential to their works which in form are indecisive and ephemeral. We can, however, have some idea of the colour scheme typical of the 'Blue Rose' from the early works of Larionov, although his formal composition is far more mature and immediately related to the French School, than that of his Russian colleagues at this time.

In January 1909, the 'Golden Fleece' sponsored a second Franco-Russian exhibition. This was no longer in the nature of an introduction of French art to the Russian public, and only incidentally of the new Russian painting. It was instead an exhibition of work by artists of similar ideas, regardless of nationality. The paintings were not divided into French and Russian sections as on the previous occasion, but works by the French Fauves were intermingled with those by the Russians, the latter even more predominantly represented by Larionov and Goncharova.

Among the French works this year there were several important pre-Cubist works such as Braque's *Le Grand Nu* (1908) and *Still-Life* (both of which were illustrated in following numbers of the *Golden Fleece* devoted to this exhibition).[24] The French represented at this show were a far smaller and more definite group, limited, apart from Braque and Le Fauconnier, to the Fauves – Matisse, Vlaminck, Marquet, Van Dongen and Rouault. The first two painters sent very recent works influenced by Picasso's pre-Cubist works of 1907–8. Matisse sent less important works than the year before, chiefly drawings among which was the important *Nu appuyé sur le bras* (1907?). His reputation was now at its height among Moscow painters, who of course were familiar with Shchukin's superb recent acquisitions.

The Russian works which hung side by side with these showed a noticeable change since the previous show, for things were moving

88

53 Mikhail Larionov, *Fishes*, 1906

almost as quickly at this time in Moscow as in Paris. In Larionov's work there is a continuing influence of the Nabi group. In particular, that of Vuillard and Bonnard is noticeable in his gentle interiors and still-lifes such as *Fishes*. In their quiet colour and insistent brushwork *Ill. 53* they recall the Neo-Impressionists, Cross and Sisley; Seurat was as much neglected in Russia as in France – there was not a single work by this painter in either the Morosov or Shchukin's collections, nor, as far as I know, in any other Russian collection.

The arbitrary interruption of the scene depicted by the picture-frame, which was a favourite device with the Nabi group, was characteristic of the paintings exhibited by Natalia Goncharova at this second 'Golden Fleece' exhibition. These were chiefly circus scenes, and in their excited gesture, exaggerated silhouette and highly dramatic raised or lowered viewpoint, reveal an interest in Toulouse-

Lautrec. Likewise influenced by this artist, and also contributors to this second Salon, were Robert Falk (1886–1958) and Kuzma Petrov-Vodkin (1878–1939), newcomers to the Moscow group. Petrov-Vodkin had studied at Azbé's studio in Munich and also at the Moscow College under Leonid Pasternak, the portrait painter and founder-member of the 'Union of Russian Artists', Levitan, and Serov. Leaving the College in 1905, he travelled to Africa, where he was impressed by primitive art, but more particularly by the peculiar light and colours of that continent. On his return he became an intimate of the 'Blue Rose' group, although he did not contribute to the 1907 exhibition. It is typical of him that he did not become identified with any of the many schools in Russia – or elsewhere. A short while later, in the second decade of this century, Petrov-Vodkin began to work out a system of painting based on the idea that space can be most properly depicted pictorially by means of a curved horizontal axis, a theory that he later defined at length in two books.[25] He is important in the history of modern painting in Russia chiefly as

Ill. 1

54 Kuzma Petrov-Vodkin, *The Playing Boys*, 1911

a teacher: after the Revolution he became one of the most influential professors in the Leningrad Art Academy and helped to form the taste of many of the first generation of Soviet painters. *The Playing* *Ill. 54* *Boys* is a typical example of his early work. Both in his colour preparation and in the flat, even colour worked over the figures and background, his work clearly shows the influence of Byzantine art. This was perhaps by way of Matisse, for there is a mystical, pantheistic element common to the painting of both artists, and a strong connection between the blue and green colour combinations in such works as *Music* and *Dance* of Matisse and *The Playing Boys* of Petrov-Vodkin. The formal construction of this work with the gently upward-travelling curve was to become a constant in the Russian's work as a background to figures held, as it were, in a common ecstasy of rhythm.

Robert Falk, like Petrov-Vodkin, was a student of the Moscow College, but they hardly overlapped, for Falk came at the age of seventeen in the year the other artist left for Africa, in 1905. Falk belonged in fact to a different generation from the 'Blue Rose' group. He was untouched by their Symbolist feeling and was from the outset frankly of the Paris School. At first Toulouse-Lautrec, then Matisse, and last and most profoundly Cézanne, influenced and directed his work. He became one of the most prominent members of the Moscow 'Knave of Diamonds' group which was founded in 1909 and was to become the leading movement – for two years – of the Russian *avant-garde*. Later he was important as a teacher in the Soviet period and continued to paint sensitive melancholy portraits and still-lifes up to his death.

Alone of the 'Blue Rose' and 'Golden Fleece' artists, Saryan and Kusnetsov continued to be uninfluenced in the direct and almost slavish way in which their friends had succumbed to the French Post-Impressionist school, but the direction is ultimately the same. This second exhibition revealed a more developed primitive element in the work of both, but it was an Eastern rather than a Western primitivism, less a conscious stylization for ulterior motives than a natural, direct expression. In Kusnetsov's work, the veiled quality has almost disappeared; although his figures are still withdrawn, they are strongly delineated; although the colour is still muted, it is warm; desert colours, yellows and browns have replaced the Symbolist

55 Natalia Goncharova, *Haycutting*, 1910

blue-greys. The scenes are more obviously taken from life, and were in fact drawn in the Kirghiz steppes so beloved by the artist. A third dimension is also hinted at in the retreating dunes and the slight warmth of colour in the sky towards the foreground of paintings of this period. The internal development is thus analogous to the French movement, and soon there was to be a violent reaction against this French School, which marked the next phase in the Russian movement. This was already revealed, in fact, at the end of 1909, when the 'Golden Fleece' held a third exhibition which consisted almost entirely of the work of Larionov and Goncharova. These two painters now emerge as the new leaders in Russian painting and a new stage in the modern movement in Russian art begins.

92

56 Natalia Goncharova, *Dancing Peasants*, 1911

1909–11

Since the 1890s a literary element had been predominant in Russian painting, but already by 1907 this began to give way to new values of 'pure painting'. The first signs of this new movement had been the 'Blue Rose' group exhibition and the *Golden Fleece* magazine with its sponsorship of French Post-Impressionist and Fauve painting described in the previous chapter. During the next three years a primitivist movement arose in Russia and became a conscious style. This style was based on a cultivation of folk-art, and a synthesis of current European schools. Its chief exponents were the painters Larionov and Goncharova.

During these three years which mark the emergence of this new school in Russian painting, Moscow became a meeting-place for the most revolutionary movements in European art. Thus Cubism from Paris, the 'Kunstlervereinigung' of the future 'Blaue Reiter' movement from Munich and the Futurism of Marinetti had an immediate impact on the Russian art world.

The relationship between Italian Futurism and the Russian movement of the same name is complex and controversial. It is, for example, debated when exactly Marinetti first visited Russia: some say that he came in late 1909 or early 1910 to Moscow and Saint Petersburg on his general propaganda tour of European capitals with his newly announced Futurist ideology.[1] Other Soviet critics, notably Nikolai Khardzhev, the most distinguished scholar of this period in Russian art and literature, says that Marinetti came only once to Russia, in early 1914, when he was violently attacked by the Russian Futurist artists and poets. It was after this visit, which is the only one to be established beyond doubt, that Marinetti is reported to have said that 'the Russians are false Futurists, who distort the true meaning of the great religion for the renewal of the world by means of Futurism'.[2]

However, this date of Marinetti's first visit to Russia is perhaps of formal significance only, for his Futurist Manifesto was translated and published in the Russian press almost immediately after its appearance in *Figaro* in 1909.[3]

The name 'Futurism' is, however, almost all that unites the Russian and the Italian movements. This name, like almost all those used to describe artistic movements up to the First World War in Russia, is of obvious Western derivation. But as with Impressionism and Cubism, the interpretation of Futurism in Russia owes little more than a superficial calligraphy to the Western counterparts. 'Cubo-Futurism' is a happier term to describe this Russian movement, alike painting and literary, whose dual development is impossible to separate, and this is the term which I have used to describe work of post-1910, post-primitivist, in Russian painting.

Russia, in fact, became a truly international centre during these next years up to the outbreak of the First World War in 1914: on the basis of this international meeting-ground of ideas, the Cubo-Futurist movement emerged. While intrinsically bound up with, and owing much to, contemporary Western European movements – reflected in its name – Cubo-Futurism was a movement peculiar to Russia and immediately preceded the schools of abstract painting which arose in Russia during the years 1911–21, in which the Russians emerged at last as pioneers in the 'modern movement'.

The leader and organizer of the many little exhibitions which are characteristic of the years 1907 to 1913 was Mikhail Larionov.

94

57, 58 Gingerbread figures made in traditional wooden carved moulds from Arkhangelsk

59 Niko Pirosmanishvili, *The actress Margarita*, 1909

60 A nineteenth-century Russian lubok (peasant woodcut) illustrating a tale by Krilov

61 Mikhail Larionov, *The Soldiers* (second version), 1909

ʼLarionov the leader and Goncharova his brilliant pupil are two personalities of fundamental importance in the history of the modern movement in Russia. Their work in retrospect lacks the single-mindedness and logic of the development of Kasimir Malevich and Vladimir Tatlin, but it played a vital historic role in the Russian artistic world of the years leading up to 1914, and without it, it is difficult to imagine how Malevich and Tatlin could have arrived at their historic conclusions. For Goncharova and Larionov selected and sifted turn by turn the most live and progressive ideas in Europe and Russia from the beginning of the century up to the First World War,

96

when they left the country as designers for Diaghilev's ballet. It is, above all, for their receptive, selective minds that the work of these artists is important: in its development one can trace the course of that assimilation of the foreign and domestic influences whose synthesis is at the basis of the Suprematist and Constructivist movements.

At this moment – when all these different influences were on the point of synthesis – a third personality emerged to succeed Larionov and Goncharova. This third leader of the Cubo-Futurist school was Kasimir Malevich. Vladimir Tatlin was also, in 1911, drawn into this circle of intense activity by the forceful personality of Larionov. It was through Larionov and his exhibitions that these two artists first met, and that the Russian school became a reality.

At the third exhibition of the 'Golden Fleece' in December 1909, Larionov and Goncharova first launched the new 'Primitivist' style. From the works sent to this exhibition one can first discern a free use of a Fauve-derived boldness of line and abstract use of colour as expressive entities in their own right: this new freedom is likewise reflected in the turning to national folk-art traditions for that direct-ness and simplicity which Gauguin and Cézanne had taught them to appreciate. Embroidery from Siberia, traditional pastry forms and *Ills 57, 58,* toys, and the 'lubok' – peasant woodcuts – were the sources from *60* which Larionov and Goncharova drew their inspiration in this new primitive style. The 'lubok' dates from the seventeenth century in Russia and was similar to the English Chapbooks. They were at first religious, then political in subject, or often enough simply a means of circulating songs and dances to the peasants. They were produced in the towns for circulation among the peasantry. The 'lubok' was very far-reaching in its influence at this time in German as well as Russian art circles. Another national tradition which influenced this 'Primitivist' style was that of icon painting introduced by Goncharova, which later proved a highly significant influence in the development of both Malevich and Tatlin's work.

We must pause to fill in some of the background to the lives of Goncharova and Larionov.

Natalia Sergeevna Goncharova was born in a small village in the Tula province, south-east of Moscow, in 1881, of an ancient noble family. Her father's ancestor had been an architect to Peter the Great, and Sergei Goncharov continued the tradition. Like many of their

62
Natalia Goncharova,
Madonna and Child,
1905–7

kind, however, the Goncharov family had become much reduced in wealth since the rise of the merchant class in the nineteenth century. Sergei Goncharov was a descendant of the Pushkin family through his mother Natalia, who was the daughter of the poet. Natalia Goncharova's mother was a member of the Belyaev family which had done so much to encourage the nineteenth-century nationalist movement in music. This formidable family tradition marks Goncharova apart from the other members of this Cubo-Futurist movement, who were usually either peasant-born or of the small tradesmen class.

Goncharova grew up on the family's country estate, and in spite of her removal at the age of ten to a school in Moscow, she says that she always remained hostile to urban life. It is interesting that she, more than any other of her colleagues, shared the emotional preoccupation with machine-life of the Italian Futurists, a mood reflected in her works of 1912–14.

In 1898 she began attending sculpture classes at the Moscow College under Pavel Trubetskoi, one of the Russian sculptors of the 'World of Art' movement, whose work is related to Rodin. It was soon after this that Goncharova first met Larionov, likewise a student in the

63 Early nineteenth-century Russian lubok — *The Siren*

College at this time. From now on, the two artists were inseparable both in their work and life. In 1903 Goncharova began exhibiting at the big Russian Salons. Her work of this period was much more timid than that of Larionov. At first they were both much influenced by Borissov-Mussatov; such a work as *Hoar Frost*, which Goncharova sent to the 1906 'World of Art' exhibition, is an example of this early period. It was at this exhibition that these two artists first came in contact with the dynamic personality of Diaghilev, with whom they later became close collaborators. Already at this date, it was due to the perspicacity of Diaghilev that they began to emerge as new personalities in the artistic scene. He invited them to contribute not only to the 'World of Art' exhibition of 1906, but also to the Russian exhibition which he was organizing at the Paris Salon d'Automne of the same year (see p. 54). This latter exhibition was the occasion of Larionov and Goncharova's first visit to Paris.

64 Natalia Goncharova, *Study in Ornament*, 1913?

99

Goncharova's interest in icon painting was an early development and was probably influenced directly by the activities of the Abramtsevo colony, whose members were now successful and established artists working particularly in the theatre. There were others among the second generation 'World of Art' painters, such as Bilibin and Stelletsky, who were also engaged in an attempt to adapt the Russo-Byzantine tradition to modern pictorial demands. Goncharova's earliest works in this style date from 1903 to 1905, but most of these works the artist claims to have destroyed. But even in the

Ill. 62 surviving examples one can discern the characteristic brilliant range of colour typical of Goncharova's mature works; here also is the rich ornament and strong linear rhythm which this artist so brilliantly exploited in her later theatrical designs. This flair for ornament became almost a scientific investigation for Goncharova, and together with her use of icon painting as a source of pictorial composition is her chief independent contribution to the modern movement in Russia.

Thus one can distinguish two streams in Goncharova's work: her vigorous and independent research in reviving national traditions, and her more timid and academic interpretations of the current European styles. These two streams continued in her work until about 1910, when the student discipline based on studies of the work of Vrubel, Borissov-Mussatov, Brueghel, Cézanne, Van Gogh, Toulouse-Lautrec and Maurice Denis, to mention but a few, became reconciled with her experiments in the Russo-Byzantine styles under the impact of the French Fauves. These works of 1910–12 by Goncharova such

Ills 55, 56 as *Dancing Peasants* and *Haycutting* were, as we shall see, the direct source of Malevich's inspiration at this period. Not only did he make use of the same colour range and similar pictorial devices but often even the subject and title were the same as pictures by Goncharova.

Mikhail Fyodorovich Larionov was born in Teraspol on the borders of the Ukraine and Poland in 1881. He was actually born in the house of his maternal grandfather, Fyodor Petrovsky, a retired farmer, for his father, who was a military doctor, was stationed in a near-by barracks. Mikhail Larionov's grandfather was a sailor by profession and came from Archangel. It was to the Petrovskys and Teraspol that Mikhail returned for his summer holidays after he had been dispatched to the Voskresensky 'Real Gymnasium' in Moscow in 1891. This habit

65
Natalia Goncharova,
Flight into Egypt,
1908–9

continued throughout his later painting days up to the time he left
Russia in 1914; many of his most remarkable paintings were done at
the family home in Teraspol, away from the noisy bustle of the town.

At the age of fourteen Larionov left school and began preparing
for the competitive examination to enter the Moscow College of
Painting, Sculpture and Architecture. Two years later he took the
examination, one of 160 candidates trying for thirty places. He came
thirty-third on the list, but three successful candidates were turned
down for lack of other academic qualifications, and Larionov, who
had obtained a scientific certificate from his Gymnasium, thus scraped
into the College. He was seventeen when he signed the usual ten-year
contract with the College on entering in the autumn of 1898.

During the next ten years, however, Larionov rarely attended the College's studios, but worked at home. For the first year he was living with his parents, but then he was provided with his own studio and flat. From the beginning he worked with phenomenal ease, producing a record number of works. This was so overwhelmingly the case that on one occasion, on sending in paintings for the monthly inspection which was the only stipulation for the students of the College, Larionov took up the entire space allocated to the students of his year. The Director of the institution, Prince Lvov, intervened personally and asked Larionov to remove some of his works. Larionov – whose obstinacy is fabled – refused and was thereupon expelled from the College. The expulsion made little difference to him, and anyway he was taken back after a year, in the autumn of 1903. He continued at the College until 1908 when he was called up for military service. This lasted nine months, and Larionov spent the winter months in the Moscow Kremlin and the summer months just outside the city in a tent-camp. From this time dates his 'Soldiers' series which is of great importance in turning away from the French School towards the development of a nationalist 'Primitivist' style.

Ills 50–52 Larionov's first mature works earned for him the name of 'the finest Russian Impressionist'. This 'Impressionist' period covers the years 1902 to 1906. Gradually the initial Symbolist mood is dispelled, the forms become more clearly defined and the palette changes from the characteristic pale blues and greens of the earlier movement to more vivid reds and yellows. From wood and river scenes, still-life, portraits and figure-scapes become the dominant themes. Although

66
Mikhail Larionov,
Evening after the Rain,
1908

67
Mikhail Larionov,
Walk in a Provincial Town,
1907–8

usually described as 'Impressionist' it would, however, be truer to point to the work of Bonnard and Vuillard as Larionov's inspiration at this time, especially in works such as *The Courtyard* or *Spring Landscape*. In *Fishes*, Larionov used a longer stroke reminiscent of *Ill. 53* Van Gogh, producing an all-over rhythm on the canvas surface, a pictorial unity in which colour and form emerge as entities in their own right. This influence of Vuillard, Bonnard, Matisse and Picasso are all evident in Larionov's work of 1906–7. Individual objects and geometric perspective are now dismissed. The omission of sky and the 'close-up' approach to the elements of the composition become a constant characteristic. Unlike Goncharova and Malevich, Larionov seldom, even in his later Primitivist work, adopted the colour range of Russian folk-art but remained faithful to his early muted palette in which pale blues, soft greens and gentle yellows are predominant.

Again, unlike Goncharova, Larionov's mood is detached and restrained, whereas she, one feels, is swept away by her intense emotion. Goncharova's work hits one with violence, its impact is immediate; Larionov slyly insinuates his message with a spare but eloquent line and an extreme modesty of means. She glories in the sensuous qualities of paint and the eloquence of rhythmic line; he, it seems, is at pains to de-materialize his material almost in the way that Malevich strives in his Suprematist works to subordinate paint and canvas to a purely 'spiritual' level of communication.

Whereas Goncharova's work is highly eclectic – and at its fullest in the theatre – Larionov quietly pursued an internal logic, whose intuitive movement is reasoned and consciously examined. *Fishes* is

68
Mikhail Larionov,
The Hairdresser,
1907

the last of his 'Impressionist' works. They were succeeded by such paintings as *Bathers in the Morning*, which he sent to the second 'Golden Fleece' exhibition of March 1909, where the influence of Cézanne, Van Gogh and Matisse are clearly discernible, both in the formal composition and the theme. However, Larionov has not succumbed to a literal imitation of these artists as Goncharova did during this period. The hatching brushstroke of Cézanne has been replaced by an irregular, scrubby definition of forms; the typical Cézanne tree hanging over the water, and the gesturing nude bathers are almost caricatured and each figure pursues its own activity unrelated to the rest. This caricature of a social scene reducing it to a series of private, unrelated actions has been further developed in *Ills 66, 67* *Evening after the Rain* and *Walk in a Provincial Town*, among the first of his Primitivist works, both of which Larionov sent to the third 'Golden Fleece' exhibition of December 1909, which as I have already mentioned was the first public launching of this Primitivist style.

104

69
Mikhail Larionov,
Soldier at the Hairdresser,
1909

In the majority of Larionov's works at this exhibition, modelling
and geometric perspective have almost entirely disappeared, as in
Soldier at the Hairdresser. In the 'Provincial Dandy' sequence the figures *Ill. 69*
are doll-like caricatures, little more than skits on an easily recognizable
type. In many of these works the dominance of the horizontal is
evident. This is a noticeable new constant characteristic in which the
influence of the 'lubok' appears. This horizontal hems the action of
the work into a narrow strip; the figures seen in silhouette emphasize
this horizontal plane as they move parallel to the picture-surface.
One thus gets the impression of a brief moment arbitrarily cut short,
destroying the idea of a picture as a world complete in itself. Many of
these 'strip-cartoon' works produce an effect of child-like indifference
to conventional rules: the deliberate distortion of the figures in *Walk
in a Provincial Town*, for instance, is used to convey the salient charac-
teristic of each; the inconsequential sign hanging among the trees,
the unrelated figures and the delightful, sophisticated pig, so much the

70 Mikhail Larionov, *Soldiers* (first version), 1908

most dignified and purposeful personage – all strutting, posing and strolling along a space which by common consent, rather than visual probability, serves as a street.

In every way Larionov now began to mock at the prevailing conventions. In his 'Soldier' sequence of 1908–11 we can follow the stages of the artist's distortion of anatomy. The figure of the soldier in the foreground of *Soldiers* of 1908, for example, has been repeated in *The Relaxing Soldier* of 1911. In the later work the legs have been, as it were, pressed up against the picture-frame and the hands and feet have assumed monumental proportions. The use of erotic subjects was likewise a favourite mood of Larionov's during these next few years. Thus we have his 'Prostitute' series, and scribbled bawdy remarks and caricatures in his 'Soldier' works. The deliberate 'rude-

Ill. 70
Ill. 71

Ills 72–74

106

ness' of Larionov's work of 1907–13, his disrespect for both pictorial and social conventions, was a general characteristic of the so-called Futurist movement in Russia – so little resembling the Italian movement – of which Larionov's work is the first expression. In Russia Futurism came first in painting and later in poetry – indeed almost all the poets came to their writing from painting, and many of the literary devices in Russian Futurist poetry can be directly related to Larionov's painting of this time; for example, the use of 'irreverent, irrelevant' associations; the imitation of children's art; the adaptation of folk-art imagery and motifs. The manifestoes of the Russian Futurist writers such as 'A slap at public taste',[4] and the one quoted

71 Mikhail Larionov, *The Relaxing Soldier*, 1911

below, show how closely they followed Larionov's attack on every convention:

> The word against the meaning
> The word against language (of the Academies, 'literary')
> The word against rhythm (musical, conventional)
> The word against metre
> The word against syntax
> The word against etymology

Their use of epithet, street language, out of context and jumbled words, or eroticism and infantile language, of archaic language and breaking down words until nothing is left but sound – all these devices were typical of the Russian Futurist poets Mayakovsky, Kruchenikh, Khlebnikov, Elena Guro and the Burliuks during the years 1912–14 when this movement flourished in literature – all of them can be traced to the work of Larionov and Goncharova of 1908–13.[5] Although for the first time painting thus led the way in Russia, painting and poetry were still intimately bound up together, and almost all early publications of these Futurist poets had illustrations

72 Mikhail Larionov, *Manya, c.* 1912 73 Mikhail Larionov, *Manya* (a second version), *c.* 1912

74
Mikhail Larionov,
Spring 1912

by Larionov, Goncharova and other members of their group. In the same way as Larionov incorporated lettering into his works in the 'Soldier' works of 1908–9, in his portrait of Tatlin of 1913, in *Spring 1912* and his later stage designs such as *Bouffon* for Diaghilev, so the poets used Cubo-Futurist pictorial devices in their work. In many of these pages the poem is written out by the same hand that composed the design, and the two elements flow into each other to make a single visual entity; this represents very happily the relationship between artists and poets, and incidentally is a premonition of the Constructivist and Suprematist experiments in typographical design in which this visual unity was the consciously declared aim (see Chapter VIII).

Ills 61, 99, 74

Having digressed in order to trace the development in Larionov and Goncharova's work up to the Cubo-Futurist movement of 1912, we must now return to pick up the thread of the general history during these years.

The Primitivist movement was not simply a development in the work and activities of Larionov and Goncharova; it might even be said to spring from the meeting of these two artists with the Burliuk brothers. This meeting took place in 1907.

David Burliuk and his younger brother Vladimir were the sons of a wealthy bailiff who at this time was managing the estate of Count Mordvinov near the Black Sea at a place called Chernianka, or as the brothers liked to call it in the old Greek version of the name, Hilea. The two brothers attended the local Kazan school of art in Odessa, and then left in 1903 to study for two years with Azbé in Munich. After this they spent a year working in Paris before returning home to Russia. Their background is therefore fairly similar to that of Larionov and Goncharova, although their initial training in a provincial school was of a much lower standard. David Burliuk later made this good by attending the Moscow College from 1911 to 1913, when he was expelled in company with his close friend and colleague, Vladimir Mayakovsky.

David Burliuk first came to Moscow in the autumn of 1907, on the invitation of a Moscow businessman named Shemshurin. Shemshurin was typical of the many small patrons of art of this time in Russia; he kept open table to any artist who cared to turn up in his house at five-thirty in the evening. But woe to those who arrived too late, for Shemshurin was a man of fanatical punctuality; the doors of his dining-room were opened to whoever might be in the ante-room at five-twenty-five and firmly closed again at five-thirty. Many of the artists of this Primitivist movement who were poor and entirely unrecognized were grateful for such hospitality; it is related, for example, that Kasimir Malevich was a frequent visitor in this house. Shemshurin's house was almost an exhibition hall for these artists. The merchant refused to buy their work – saying that money always spoiled one's relations with people – but offered his walls for them to hang their paintings on. This was accepted with alacrity since many of the artists lived in such miserable lodgings that they were unable to see their own work as a finished whole – it is said that Goncharova worked on her large paintings in so small a room that she only saw them pieced together at exhibitions.

On this first visit to Moscow in 1907, David Burliuk soon came in contact with the Russian *avant-garde*. He met not only the 'Blue Rose'

group, but, more important, Larionov, Goncharova and the Kiev painter, Alexandra Exter. Soon after David's arrival he and his brother Vladimir, who had also now come to Moscow, arranged an exhibition entitled 'Stefanos/Venok' – 'The Wreath' – which brought together the above-mentioned artists. This little exhibition was important as the model for many other little group exhibitions which mark the development of painting in Russia during the next decade up to the Revolution of 1917.

The meeting of the Burliuks with these Moscow painters seemed to give new impetus to the modern movement. The pace of events in the Russian art world during the next few years is overwhelming; so much happened, so rapidly, in so many places, that it is difficult to piece it together so as to make a pattern of the whole. By reducing it to a pattern, one would miss the truth, for this chaotic confusion is the background and an intimate part of this story. I have therefore tried to pick out a few of the more obvious events and discoveries as an indication of the direction of ideas.

Both David Burliuk and Mikhail Larionov were personalities of formidable energy and organizing ability. During the brief marriage of their forces they together attracted all that was most vital in the current Russian art worlds. Both were large men and gifted with

75 Mikhail Larionov,
Portrait of Vladimir Burliuk,
c. 1908

great physical strength. The Burliuk brothers in particular were *Ill. 75* enormous young men; Vladimir indeed was a professional wrestler and always took a twenty-pound pair of dumb-bells around with him on his journeys in the cause of the new art and literature – it was David, however, who was made to carry this spectacular equipment, for Vladimir insisted that it would hurt his muscles.

Shortly after the 'Wreath/Stefanos' exhibition, on the marriage of their sister Ludmilla, the Burliuks moved to Saint Petersburg. As in Moscow, they began to collect around them a group of sympathetic poets, painters and composers. Soon they organized another exhibition, 'The Link', in which they all took part – for everyone in this little world painted and wrote poetry or music. 'The Link', however, had little success – none of the established 'Blue Rose' group took part, and the unknown Larionov, Goncharova, Exter, Fonvisin, the Burliuks themselves and Lentulov did not sell any paintings. Lentulov, a student in the Moscow College, shortly afterwards married the daughter of a very rich Moscow businessman which proved greatly to the advantage of his friends. It was from this source, for example, that the 'Knave of Diamonds' exhibition of December 1910 found its financial backing.

76 David Burliuk, *My Cossack Ancestor*, c. 1908

77 Vladimir Burliuk,
*Portrait of
Benedict Livshits,*
1911

Disappointed by the lack of response to their exhibition, the
Burliuks returned home to Hilea for the summer. Larionov accompanied them. They spent the summer months working together and
discussing their ideas and plans for the future, which were of the most
revolutionary and ambitious nature. It was during this summer and
the following year (1909) that the Burliuk brothers, following
Larionov's example, began working in a style less identified with the
French School, and with a growing interest in incorporating national
folk-art traditions. David Burliuk's work of this period, although
similar in its references to that of Larionov and Goncharova, is above
all literary in its approach. (Soon after his split with Larionov in 1911,
David Burliuk made friends with Mayakovsky and together they
began to devote themselves to poetry, both of them trying to
incorporate the previous years' experience as painters.)

Ills 76, 77

In the autumn of 1908 the Burliuks went to visit Alexandra Exter in Kiev. Here they organized another exhibition – in the street – which was a great success. It was almost identical with the one they had organized together in Petersburg earlier in the year, although a few of the recent works by those artists within easy reach of Kiev were included. From the proceeds on paintings sold, the Burliuk brothers returned to spend the winter in Moscow.

The year 1909 was to prove eventful. It brought together more sympathetic personalities and with the ensuing consolidation of ideas the Primitivist movement emerged as a definite school. After the second Franco-Russian 'Golden Fleece' Salon of January 1909 a number of small group exhibitions were organized, such as 'The Impressionists'. This exhibition was held in Saint Petersburg and sponsored by a well-known personality in the art world, the military doctor Kulbin. 'The crazy doctor', as he was affectionately termed by his acquaintances, was an ardent enthusiast of progressive painting, even more generous than Shemshurin, for Kulbin not only wrote about their exhibitions in the press and sponsored a number of shows, but also actually bought paintings. He himself dabbled in painting and contributed fourteen works to this 'Impressionists' exhibition. The exhibition consisted chiefly of landscapes, and was a very modest and unadventurous affair: it is notable chiefly for introducing new members to the *avant-garde*, among whom were the Futurist composer-painter Matiushin, a close friend of Malevich's, his wife the poet-painter Elena Guro, and Alexei Kruchenikh, the future champion of Malevich and a leader of the Futurist poets, but still at this time practising as a painter. Abramtsevo pottery by Vaulin, the head of the by now flourishing Moscow factory, was also included and thus a physical link was made between two nationalist movements, the Primitivist and that of the Abramtsevo colony.

'The Impressionists' exhibition did not include Larionov and Goncharova, who, it will be remembered, monopolized the third 'Golden Fleece' exhibition of December 1909 with their new Primitivist works.

In 1910 these various little groups in Moscow, Petersburg, Odessa and Kiev began to come together as a united movement. This was reflected in a number of exhibitions of a more ambitious nature held in the various towns during the year and culminating in the Moscow

'Knave of Diamonds' exhibition of December of that year, when the whole of this *avant-garde* was united for the first time.

In March a newly formed Petersburg society called the 'Union of Youth' held an exhibition, the first of many of this name. It was a fairly haphazard affair, although it did introduce two new members to the scene, Olga Rosanova and Pavel Filonov. The ensuing exhibitions of the society, which were held twice annually, were events of great interest and importance in bringing together the latest work of both the Petersburg and Moscow artists. The 'Union of Youth' was financed by another merchant, L. Zheverzheyev. Apart from exhibitions, it sponsored many public discussions which became a feature of Moscow and Petersburg life during the next few years. These discussions were always very well attended, for the Futurists were regarded as the best possible entertainment in their crazy enthusiasms, wild declamations and ludicrous appearance. The discussions, in fact, became the chief means of livelihood for many of the group. In an attempt to break down the prevailing conventions, the artists and poets carried on their battle in every conceivable guise. It was a regular sight to see members of this little world, Larionov, Goncharova, Mayakovsky or the Burliuk brothers, walking along a main Moscow street with flowers, and algebraic or Rayonnist signs painted on their cheeks. During their 'Futurist Tour' of 1913–14, in which Mayakovsky, Kamensky and the Burliuk brothers visited seventeen towns throughout the country, broadcasting their ideas, David Burliuk wore on his forehead the notice; 'I – Burliuk'. In 1913 they made a film together, named *Drama in Cabaret No. 13*. This was *Ill. 78* simply a record of their everyday behaviour, strolling in and out of shops and restaurants in brilliant coloured waistcoats, the men wearing earrings and with radishes or spoons in their buttonholes. This was a parody of the Symbolists with their cultivation of the exquisite, the green carnations and lilies of aesthetes such as Oscar Wilde. For these artists were very much a part of the society that they were attacking: their verse and picture construction differed little from that of the established Symbolist poets and 'World of Art' painters – only they blunted, coarsened, simplified and made emphatic the vocabulary of their predecessors. By thus bringing the language of these 'ivory tower' creators 'down to reality' – out into the street, into the everyday life of the common citizen – these artists sought, with the only weapons

78 A scene from the film *Drama in Cabaret No. 13*, 1914. This picture shows Larionov, his eyes painted with green tears and his hair combed over his face, with Goncharova in his arms, hair flowing and with a bawdy face drawn over her face and breast

they had, to bring about the reconciliation of art and the society which had dismissed art to its ivory tower. In their antics and public clowning, one can detect an intuitive, naïve attempt to restore the artist to his place in ordinary life, to allow him to become, as they themselves so profoundly felt the need to be, an active citizen. Surely it was for this reason that so much of the immense energy of these young artists was directed towards rousing a reaction in the public? How else can one explain their numerous appearances in cabarets and restaurants, their *Ills 79, 80* ludicrous and bitter public self-mocking or the ridiculous clothes in which they dressed themselves? Why this frantic desire for self-advertisement, unless provoked by a need at all costs to be noticed? Is this not again the social conscience that has always been so active in the Russian artist, even expressed in so twisted a form?

The first 'Union of Youth' exhibition was succeeded by a Salon arranged by Vladimir Izdebsky in Odessa. It marked the introduction of the Munich School in Russia. Vladimir Izdebsky was a founder-member, with Vassily Kandinsky and Alexei Yavlensky, of the 'Neuekunstlervereinigung' which they had founded in Munich the previous year. This Russo-German group of painters was the nucleus of the 'Blaue Reiter' movement of 1911 and 1912, which included a

79 A shot from the film *Creation can't be bought*, 1918. Standing in the background are David Burliuk and Vladimir Mayakovsky

80 A close-up of a scene in the ballet *Chout (Bouffon)*. The costumes and scenery for this production which Diaghilev first staged in 1921 in Paris, were designed by Mikhail Larionov in 1916

number of Moscow artists. Kandinsky first met the Burliuks and Larionov and Goncharova at this Salon organized by his friend Izdebsky in their native town. It was the first of such exhibitions to which Kandinsky had contributed in Russia and he sent fifty-two paintings; Gabriele Munther likewise contributed to this event as well as the Burliuks, Larionov, Goncharova and Exter.

It is interesting at this point to see exactly how close the Russian *avant-garde* stood to the progressive groups in other European centres. Many of the Munich 'Blaue Reiter' group were, in fact, Russians. This is less surprising when one recalls that in the 1890s and the first years of this century it was more natural for the Russian art student to make for Munich than for Paris, as we have seen with the 'World of Art' leaders, such as Benois. It is important to remember that Kandinsky belongs to this 'World of Art' generation, for in many ways this explains the lack of sympathy for his ideas among the next generation of his fellow-countrymen. Although there was actually little contact between Kandinsky and the original members of this movement of the 1890s, his paintings and drawings of pre-1911 bear a very strong relationship to the style of such people as Konstantin Somov, and his writing is very close to that of the 'World of Art' poets, in particular to that of Andrei Bely. Kandinsky is also very close spiritually to the *Ill. 81* Lithuanian composer-painter Čiurlionis, who worked in Saint Petersburg from 1906 until his death in 1911. In 1912 he had a section at the current 'World of Art' exhibition entirely devoted to his work, and there was a number of 'Apollon' likewise devoted to this strange artist.[6] Kandinsky's attitude and that of the 'Blaue Reiter' group as a whole is essentially Symbolist: the subjective truth, the sacred moment of inspiration, the very idea of the *Spiritual in Art* – as he entitled his book – all unite this movement with the 'World of Art'.

The Burliuk brothers were following in this same tradition of the Russian turning naturally to Germany when they set out for Munich in 1902 and were drawn – like Benois ten years before them – by the work of Holbein, Menzel, Liebermann and Leibl, as David Burliuk himself writes.[7] In Munich the brothers studied with Azbé, where Kandinsky was already working – though there appears to have been no contact at this date between them.

Kandinsky, like the 'World of Art' painters, sent his work to the Vienna, Munich and Berlin Secession group exhibitions, rather than

118

to the Paris Salons, and as a result these centres became aware much sooner than Paris of the work of the Russian *avant-garde* painters and architects. The following is a review of the Russian section at an exhibition of architecture and interior design held in Vienna in 1909:

A very short while ago it was a saying that if one scratched a Russian, one discovered a barbarian. Now we understand this more correctly, and in this barbarian we find a great artistic advantage. This fund of raw material succoured by geographical and ethno-graphical circumstances, is a national treasure-house from which the Russians will long draw. A few years ago Western art had to acknowledge the invasion of the Japanese. Last spring at our architectural exhibition the Russians spoke, and everyone's attention was attracted. We were made to envy them for the remains of barbarism which they have managed to preserve. The West has become a common meeting-ground, invaded by distant and foreign peoples as in the last days of the Roman Empire, and while they wish to learn from us, it turns out that they are our teachers. The barbarian embraces with the most elegant of modern-ists, and each completes the other.[8]

81
Mikalojus Čiurlionis,
Sonata of the Stars.
Andante, 1908

'This embrace of the Russians with the most extreme left movements of our Western art', as the above-quoted critic continues, soon led the Russians to turn their attention to Paris rather than Germany. The change happened about 1904, with the end of the *World of Art* magazine, the beginning of the Morosov and Shchukin collections of Post-Impressionist painting, and the subsequent 'Golden Fleece'. By 1906 Russian artists were beginning to attend Paris studios rather than those of Munich or Vienna, and Paris in its turn became aware of the Russian School with Diaghilev's exhibition of 1906 at the Salon d'Automne and was won over to enthusiasm by his ballet productions. After 1910 the influence of the various schools had become so widespread and intermingled with each other that one can no longer point to Russia as being a directly imitative home of various movements. It has become a centre in its own right of which the 'Knave of Diamonds' exhibition was a testimony.

This first exhibition of the 'Knave of Diamonds' is so important that it is interesting to analyze the works which were sent to it in detail.

The French works were selected by Alexandre Mercereau. This French writer and critic had been a regular visitor in the Russian art world since his appointment as correspondent to the *Golden Fleece*. The works which he selected for this exhibition were chiefly those of Gleizes, Le Fauconnier and Lhôte, and in consequence the ideas of these painters became increasingly familiar and influential in Russia at this time. Gleizes and Metzinger's work *Du Cubisme*, which was translated and published in two editions in Russia a year after its appearance in France,[9] became, together with the formulae and writing of Cézanne published by Bernard, the chief texts of the movement in Russia between 1910 and 1914.

Apart from work by these minor Cubists, no other French painters were represented, although in the following exhibitions of the same name a number of others were represented, in particular Léger, who had a great following in Russia. Although the name of Delaunay appeared in the catalogue to the second 'Knave of Diamonds' exhibition of 1912, no work of his was actually sent. More pointedly, Picasso and Matisse sent nothing to this exhibition, but their recent work was of course well known in Moscow due to the constant acquisitions of Shchukin and Morosov.

82 Natalia Goncharova, *The Looking-glass*, 1912

The Munich group was well represented at the first 'Knave of Diamonds' exhibition, which pre-dated the first 'Blaue Reiter' show by six months. The second 'Knave of Diamonds' exhibition was even more biased towards the Munich School, and this exhibition was, in fact, almost identical in its make-up with the 'Blaue Reiter' show of 1912.

To the first 'Knave of Diamonds' exhibition, Kandinsky and Yavlensky sent four works each. (Kandinsky sent four *Improvisations* – *a*, *b*, *c*, *d*.) In spite of the common interest in folk-art, the Munich group was isolated in feeling from the rest of the exhibition, although some of the Burliuks' work came close to it. It was not until the second 'Knave of Diamonds' exhibition that the 'Brücke' and 'Blaue Reiter' groups were fully introduced in Russia, by which time the chief personalities of the Moscow groups, Larionov and Goncharova, had become so extreme in their nationalist ideas that they had shaken off 'Munich decadence' and the 'cheap Orientalism of the Paris School'.[10]

The core of the first 'Knave of Diamonds' exhibition was the work of four Russian students from the Moscow College who had been expelled from the school in 1909 for 'leftism'. The four were Aristarkh Lentulov (1878–1943), Piotr Konchalovsky (1876–1956), Robert Falk (1886–1958) and Ilya Mashkov (1884–1944). At first they were known as 'the Cézannists'. Their 'leftism' consisted in a too marked devotion to the work of Cézanne, Van Gogh and Matisse. Later, when the German School and the Primitivists had abandoned them, these four remained and took over the name 'Knave of Diamonds', turning it – to Larionov's loudly remarked disgust – into an official exhibiting society.

Lentulov has already been mentioned in connection with the Burliuk brothers. He had exhibited with them and Larionov and Goncharova at all the little provincial exhibitions of the past three years: it was Lentulov's brother-in-law who had provided the 3000 roubles to launch the first 'Knave of Diamonds' exhibition. Lentulov's work of this date was typical of his three 'Cézannist' colleagues. In particular the influence of Le Fauconnier predominated in the works which he sent to this exhibition. (Le Fauconnier sent his *Portrait of Jouve* of 1909 and then *L'Abondance* of 1910–11 to the first and second 'Knave of Diamonds' exhibitions.) His portrait entitled *Study* shows the use of

83 Ilya Mashkov,
Portrait of E. I. Kirkalda,
1910

traditional perspective and shading which were soon to give way to
a more Matisse-like sweeping line and decorative pattern, using
brilliant colour.

The use of brilliant sated colour, an intense surface patterning and
a radical simplification of form were to become the chief character-
istics of these four painters' work. The work of Ilya Mashkov is per-
haps the most typical of this group. In his *Portrait of E. I. Kirkalda,* *Ill. 83*
which he sent to the first exhibition of the 'Knave of Diamonds', the
influence of Matisse is all too obvious and undigested. In particular
it recalls Matisse's *Portrait of Greta Moll* which was reproduced in
colour in the *Golden Fleece* of 1909. There is the same use of a thick
line to delineate the forms; brilliant, highly unnaturalistic colour, in
particular in the flesh tones; and a highly ornate silhouette in the
hair-styles of the two ladies. The curious juxtaposition of the entirely
two-dimensional Chinese painting as a background to the three-
dimensional seated figure emphasizes the inconsistency of the formal

123

84 Ilya Mashkov, *Portrait of a Boy in an Embroidered Shirt*, 1909

85 Robert Falk, *Portrait of the Tartar journalist Midhad Refatov*, 1915

composition. It is a painting midway between the academic perspective representation of space and a decorative surface patterning which is a characteristic of this artist's work (*Portrait of a Boy in an* *Ill. 84* *Embroidered Shirt*). Apart from the debt to the French Fauve school, the work of Mashkov is related to that of the German Expressionists, Kirchner, Pechstein and Heckel, who all contributed to the second 'Knave of Diamonds' exhibition of 1912. There is the same violence and feverish colour, although the work of the Russian is less jazzy in form and subject and his rhythm is rounded and enclosed, whereas that of the German tends to the angular.

Portraits and still-life subjects were the themes typical of these four Moscow painters. They used simple, insignificant objects as a means of avoiding literary anecdotal elements. In fact, they simply wanted 'pretexts' for abstract experiment in formal composition and colour.

It was colour above all which concerned Mashkov, and also Piotr *Ill. 86* Konchalovsky in his first works. His *Portrait of Georgy Yakulov* of 1910 again reveals the close connection between his work and that of Matisse. In his later work, however, the influence of Cézanne became paramount, and the preoccupation with colour was exchanged for a typically Cézannist monochrome palette, and a loose, hatching stroke.

Robert Falk was the most serious and sensitive artist of these four painters. His work was always more indebted to Cézanne than to Matisse. His subjects were likewise portraits (e.g. *Portrait of Midhad* *Ill. 85* *Refatov*) and still-lifes. There is, however, a Jewish melancholy and intensity which differentiates his work from the rather superficial and immature work of his 'Knave of Diamonds' colleagues. The sensitive manipulation of planes of colour in dry, quiet tones and insistent rhythm of brushstrokes removes his work from the rather provincial level of the group as a whole. Falk was the only one among them who later evolved a personal idiom built on this Cézannist grounding. He, in company with Konchalovsky and Kuprin, another early member of his group, were influential in training successive generations of Soviet painters.

The works which Larionov sent to the first 'Knave of Diamonds' exhibition were those which he had done during his stay with the Burliuks – many of which he had already sent to the third 'Golden Fleece' exhibition – and a number of others of the past year, as well

as earlier works of 1906 and 1907. *The Soldiers*, second version, was *Ill. 61* one of the most recent works included. This painting contains a number of elements which were developed by Larionov in the following year: the primitive smooth-backed animal chalked on the fence, graffiti-style; the crude-featured figures in positions depicted with a complete disregard for, or rather conscious sinning against, the rules of academic perspective. The strong horizontal movement and the abrupt cutting off of the work at the top of the fence, eliminating the sky, has been continued from works of the year before such as *Walk in a Provincial Town*, which he also included in this exhibition.

Goncharova sent works which were distinctly nearer to those of Larionov's Primitivist style. In *Fishing* the French influence is still *Ill. 88* noticeable, but it has become far more digested and free than in the works of the previous year. The scene is now set in Russia and the themes are taken from Russian peasant agricultural life – such as *Washing the Linen* (in the Russian Museum, Leningrad). Four of her

86
Pyotr Konchalovsky,
*Portrait of
Georgy Yakulov*,
1910

religious works were included. Gone are the whites and sickly pinks of Maurice Denis which had coloured the works of the previous year – *Ill. 87* such as *Picking Apples*, which she had sent to the last 'Golden Fleece' exhibition. With her confident emancipation from the parent school, Goncharova launches into a blazoned world of colour.

A newcomer to this exhibition was Kasimir Malevich. Malevich was not yet an intimate of the Moscow group, although he had arrived in the city in 1905. He had not contributed to any of the small group exhibitions and had shown his work only at the big public Salons. To this exhibition he sent works executed in a Bonnard/Vuillard style. Though he attracted little notice at this exhibition it is important as his first contact with Larionov and Goncharova. These three figures were to become the leading personalities during the next four years after which, when Larionov and Goncharova had departed with Diaghilev, Malevich was to take over sole leadership.

It was at the 'Knave of Diamonds' exhibition that the short period of co-operative activity between the Burliuk brothers and Larionov and Goncharova culminated and came to an end. David Burliuk sent to the exhibition works similar to those which he had contributed to the earlier group exhibitions, organized together with Larionov and Goncharova. These were chiefly scenes from the provincial country-side, and executed in a deliberately child-like style. After this period, in common with others of his group, he devoted his energies chiefly to the development of this style in poetry.

87 Natalia Goncharova, *Peasants Picking Apples*, 1911

88 Natalia Goncharova, *Fishing*, 1910

89 Natalia Goncharova, *The Evangelists*, 1910–11

Vladimir Burliuk was a more talented painter than his brother David and was much esteemed by Kandinsky, who later became a close friend of the brothers and took a flat next door to theirs when he returned to Moscow at the outbreak of war. He became the god-father to David Burliuk's second son. A poet in this Futurist circle, Benedict Livshits, recalls in his account of this period[11] how he first met David Burliuk in Kiev, where he was staying with Alexandra Exter. It was at Christmas-time in 1911. A formidable figure dressed in a frock-coat and magnificent silk waistcoat, and flaunting a lorgnette, descended on the flat of his friend Alexandra Exter, and then completely disarmed the young man by turning to him abruptly

and saying: 'Sonny, won't you come and spend Christmas with us at Chernianka?' There follows a description of the feverish train journey from Kiev to the Burliuks' estate on the Black Sea, of Burliuk scribbling verses while walking up and down the carriage quoting Baudelaire, Verlaine and Mallarmé to Livshits, who in his turn introduced Burliuk to his favourite Rimbaud. The description gives one a sudden insight into the tempo of this period of frantic activity in painting, writing and talking. The painting which Vladimir
Ill. 77 Burliuk did of the poet during this time is one of the few surviving works by this artist who was killed so prematurely six years later.

It distressed Livshits when he saw how Vladimir would take one of his newly finished canvases and dragging it through mud-puddles would even throw loose mud on the canvas. To his surprise David Burliuk remained undisturbed . . . and said in consolation: 'Vladimir will relay the thick elements of clay and sand with a thick coat of paint and his landscape will become one with the earth of Hilea.'[12]

90 Mikhail Larionov, *Rayonnist Landscape*, 1912

1912–14

In a very acrimonious spirit, Larionov and Goncharova formally dissociated themselves from the 'Knave of Diamonds' group at the public discussion on 'Contemporary Art' organized by David Burliuk in Moscow in February 1912. It was at this discussion that Larionov accused Burliuk of being a 'decadent Munich follower' and the Cézannists of conservatism and eclecticism. This accusation presumably relates to Burliuk's intimate co-operation with Kandinsky at this time, as a sort of Moscow and Munich go-between. However, although it was David Burliuk who arranged for the 'Blaue Reiter' group to send works to the 'Knave of Diamonds' exhibitions of 1911

91 Mikhail Larionov, *Sea Beach*, 1913–14

and 1912, there is specific evidence of Kandinsky's contact and interest in Goncharova's and Larionov's doings up to the spring of 1911 from a letter of his to Goncharova dated March 1911: 'About his published works [Larionov] only told me incidentally, but I should so much like to know what it is. . . . And what the group "Donkey's Tail" consists of.'[1] By 1912, however, Larionov's attitude to 'Munich decadence' seems to have become as scornful as to the 'lackies of Paris' – the Cézannists – and he did not repay Kandinsky's compliment of inviting him to exhibit at the first 'Blaue Reiter' by an invitation to join in the 'Donkey's Tail' group which held their first exhibition in Moscow in March 1912, shortly after the above discussion. The

92 Mikhail Larionov, *Glass*, 1911

93 Mikhail Larionov, *Blue Rayonnism*, 1912

'Donkey's Tail'[2] group was intended as the first conscious breakaway from Europe, and the assertion of an independent Russian school.

The exhibition of the group opened on 11 March 1912 in Moscow. Apart from the small December exhibition of the 'Union of Youth' the previous year, this was the first exhibition to unite the 'big four' – Larionov, Goncharova, Malevich and Tatlin. Larionov, Goncharova and Tatlin each contributed fifty works and Malevich twenty-three. The other artists who exhibited were all minor members of the Moscow *avant-garde* with the exception of Chagall, who sent one

work from Paris, entitled *Death*. It also included Niko Pirosmanishvili (1862–1918) the Georgian self-taught sign painter who was taken up by Larionov and other members of his Futurist circle at this time. The exhibition was greeted with howls of fury and derision by the press and the public. As usual with Larionov's enterprises a scandal was involved: the censor decided that to hang Goncharova's religious

Ill. 89 works such as *The Evangelists* at an exhibition entitled the 'Donkey's Tail' was blasphemous. And so these paintings were confiscated.

The works Larionov showed were largely soldier themes, developing the series of 1908–10 shown at the 'Knave of Diamonds' exhibition, executed in the 'Infantile-Primitive' style. Some of these works were intentionally indecent and blasphemous, but they appear to have been too sophisticated to trouble the censor.

Goncharova included a number of her new Primitivist works such

Ills 87, 55 as *Peasants Picking Apples* and *Haycutting* based on agricultural themes, and a series of works described in the catalogue as 'in Chinese, Byzantine and Futurist styles, in the style of Russian embroidery, woodcuts, and traditional tray-decoration'.

It is interesting to compare the 'Donkey's Tail' with the simultaneous 'Blaue Reiter' exhibition in Munich. Not only were there a number of common contributors, but also a common interest in folk-art and children's art – to the extent that the 'Blaue Reiter' group included seven nineteenth-century Russian peasant woodcuts in their exhibition. Both Kandinsky and Malevich derive their colour combinations from Russian folk-art, in particular from such woodcuts. Indeed, Malevich even went so far as to do a number of lithographs in strict imitation of these Russian 'lubki'. Larionov's fondness for the esoteric was a link between him and the German Expressionists. Likewise, in

Ill. 75 Larionov's *Portrait of Vladimir Burliuk* and Goncharova's *Wrestlers*, one can see a reflection of the German artists.

Malevich's work of this time is less directly connected with the Munich School; but reflects much more the influence of Matisse and the Fauves and, above all, Goncharova. In his agricultural peasant themes, his colour and pictorial construction, Malevich's work of this time can be directly related to that of Goncharova. He himself said of their co-operation: 'Goncharova and I worked more on the peasant level. Every work of ours had a content which, although expressed in primitive form, revealed a social concern. This was the basic difference

134

between us and the 'Knave of Diamonds' group which was working in the line of Cézanne.'[3]

Tatlin's contribution to the 'Donkey's Tail' was chiefly a large number of costume designs for *Emperor Maximilian*. These were not, as might be supposed, for a commissioned project; it was the custom in Russia at this time for an artist to devise the sets and costumes for perhaps an entire production and then present them like an architect's model, in scale, to some producer whom he hoped would buy them for his play. Apart from these costumes Tatlin exhibited mainly drawings and studies of 1909–11 done on his sailor's wanderings in Turkey, Greece or Libya and during his spasmodic attendance at the Moscow College. This early work of Tatlin, done when he had scarcely finished his school training, reflects an interest in Van Gogh, Cézanne, and also in the Primitivist work by Larionov, who closely befriended him at this time.

In the following year Larionov organized a second exhibition called 'The Target'. This was the occasion of the formal launching of

Ill. 141

Ills 94–97

94 Vladimir Tatlin, *Fishmonger*, 1911

95 Vladimir Tatlin, *Bouquet*, 1911

Ill. 92 Rayonnism. The first Rayonnist work *Glass* was exhibited at a one-day exhibition in the 'Society of Free Esthetics' in 1911; according to the critic, Nikolai Khardzhev, a work in this style was also included at the 'Union of Youth' exhibition in December 1911. It was however at this exhibition in 1913, that Larionov issued his Rayonnist manifesto:

> We declare: the genius of our days to be: trousers, jackets, shoes, tramways, buses, aeroplanes, railways, magnificent ships – what an enchantment – what a great epoch unrivalled in world history.

96 Vladimir Tatlin,
Vendor of Sailors' Contracts,
1910

97 Vladimir Tatlin, *The Sailor*, 1911–12. Probably a self-portrait

We deny that individuality has any value in a work of art. One should only call attention to a work of art and look at it according to the means and laws by which it was created.

Hail beautiful Orient! We unite ourselves with contemporary Oriental artists for communal work.

Hail nationalism! – we go hand in hand with house-painters.

137

Hail to our rayonnist style of painting independent of real forms, existing and developing according to the laws of painting. (Rayonnism is a synthesis of Cubism, Futurism and Orphism.)

We declare that copies never existed and recommend painting from works of the past. We declare that painting is not limited by time.

We are against the West, vulgarizing our Oriental forms, and rendering everything valueless. We demand technical mastery. We are against artistic societies which lead to stagnation. We do not demand attention from the public, but ask it not to demand attention from us.

98 Natalia Goncharova, *Cats*, 1911–12

99 Mikhail Larionov,
Portrait of Vladimir Tatlin, 1913–14

The style of Rayonnist painting promoted by us is concerned with spatial forms which are obtained through the crossing of reflected rays from various objects, and forms which are singled out by the artist.

The ray is conventionally represented on the surface by a line of colour. The essence of painting is indicated in this – combination of

100 Natalia Goncharova,
The Green and Yellow Forest,
1912

101 Natalia Goncharova, *The Machine's Engine*, 1913

102 Natalia Goncharova, *Portrait of Larionov*, 1913

colour, its saturation, the relationships of coloured masses, the intensity of surface working. The painting is revealed as a skimmed impression [Mayakovsky referred, in his public explanations of contemporary painting, to 'Rayonnism' as a 'Cubist' interpretation of 'Impressionism'], it is perceived out of time and in space – it gives rise to a sensation of what one may call, the 'fourth dimension', that is the length, width and thickness of the colour layers. These are the sole symbols of perception which emerge from this painting which is of another order. In this way painting parallels music while remaining itself. Here begins a way of painting which may be pursued only following the specific laws of colour and its application to canvas.

From here begins the creation of new forms, whose meaning and expression depend entirely on the degree of saturation of a colour-tone and the position in which it is placed in relation to other tones. This naturally encompasses all existing styles and forms of

140

the art of the past, as they, like life, are simply points of departure for a Rayonnist perception and construction of a picture.

From here begins the true freeing of art; a life which proceeds only according to the laws of painting as an independent entity, painting with its own forms, colour and timbre.[4]

Larionov's Rayonnist works date from the end of 1911 up till 1914, shortly after which date he and Goncharova left Russia to join Diaghilev as designers for the ballet. Rayonnism itself was a short-lived movement, and only one of the many styles in which Larionov and Goncharova were working at this period. Its importance as a pioneer 'abstract' school of painting lies not so much in these inconclusive works, although some of them are undoubtedly 'abstract', as in the theory which lay behind them and which rationalized the contemporary ideas in Russia, carrying to their logical conclusion Fauvism, Cubism and the indigenous Russian Decorative-Primitive movement: it was based on this rationalization that Malevich went on to found Suprematism, the first systematic school of abstract painting in the modern movement.

103 Natalia Goncharova, *The Cyclist*, 1912–13

Ills 90–93

Larionov's Rayonnist works, however, differ profoundly from those by Goncharova. His are theoretical experiments, an objective analysis worked in muted colours. Hers are closer, both in subject and feeling, to the Italian Futurists. While Larionov's subjects are mostly still-life or portraits, Goncharova uses such titles as: *The* Ills 101, 103 *Cyclist, The Factory, The Electrical Ornament* or *The Machine's Engine*.

105 Kasimir Malevich,
Flower Girl, 1904–5

Her colour is brilliant: blues, blacks and yellows predominate. The sensations of speed and machine animation are her concern, rather than the objective analysis of the abstract qualities of colour and line which Larionov proposed in his manifesto of 1913.

Malevich first came in contact with Larionov's group when he exhibited three works at the 'Knave of Diamonds' exhibition of 1910. It was the beginning of a dramatic association.

Malevich was born near Kiev in 1878. He came of humble Polish-Russian stock. His father was a foreman in a sugar factory in Kiev; his mother, a simple affectionate woman, probably illiterate, was a close and constant companion to her son; she lived with Malevich until she died in 1929 at the age of ninety-six. Malevich received little education as a boy, but through his extraordinary perseverence and remarkable intuitive intelligence he gained a wide background of knowledge. Besides being an avid reader, he worked with great speed and concentration, in a typically Russian fashion, ruthlessly pursuing an idea to its logical conclusion. His many writings, which have an almost patriarchal tone, do, however, bear the signs of his unsystematic education in their confused thought and language. His simple background was probably an additional barrier between Malevich and Kandinsky, a man of sophistication and cosmopolitan upbringing; but although in life these artists made no contact, in ideas they have much in common and are both fundamentally related to the Symbolist movement.

Malevich was a brilliant speaker and a man of great charm and humour. Although reserved about himself and his personal feelings,

143

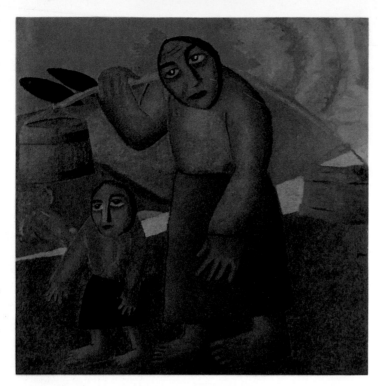

106
Kasimir Malevich,
*Woman with Buckets
and a Child*,
1910–11

107
Kasimir Malevich,
*Taking in the
Harvest*, 1911

he was vociferous in the cause of art, both in public discussions and in private pamphlets and manifestoes.

When he was nineteen Malevich entered the Kiev School of Art. In 1900 he left and began working on his own. 'Impressionist' is how these early works were described in Russia, but this is the manner of execution rather than the principle of the works, for Malevich from the outset was not concerned with nature or analyzing his visual impressions, but with man and his relation to the cosmos.

He came to Moscow in 1905 when he was twenty-seven. His arrival coincided with the outbreak of the December Revolution in which, like many artists, he took a lively interest and was even responsible for distributing illegal literature. Malevich never entered the Moscow College, but worked in Roerburg's studio, considered the most *avant-garde* of its kind; he remained here until 1910. It was through Roerburg that Malevich was brought to the notice of Larionov. Malevich's works of 1905-8 were executed in a highly rhythmic brushstroke; in construction they were based on the work of Cézanne, Van Gogh, Gauguin, Bonnard, Vuillard and Derain, which he studied avidly in periodicals and the Shchukin and Morosov collections.

In such a work as *The Flower Girl* of 1904–5, which he exhibited at *Ill. 105* the first 'Knave of Diamonds' exhibition of 1910, one can already discern a master's hand. From Bonnard he has borrowed a double plane, simply divided, using a prominent foreground figure seen against a plunging perspective. The immediacy of this figure is further emphasized by the strong horizontal division of the painting, which cuts the background scene into a separate entity – it is significant that this background scene is executed in a light, typically Impressionist brushstroke, while the figure of the flowergirl is delineated in a close even stroke: the contrast between the manner of execution is repeated in the difference between the Parisian figures and buildings of the background, and the Russian model for the flowergirl, although, again typically, she is not treated as an individual. For Malevich's figurative work deals throughout with human figures, but only as symbols of mankind. An emphasis on the flat nature of the canvas is expressed in the policeman-gesture of the flowergirl's outstretched arm aligned with the shoulder-blade, which gives the impression of the girl having been pushed up flat against the canvas surface. This

ironing of the figure against the surface of the painting is an aspect of that elimination of three-dimensional perspective which Malevich continued to develop up to his Cubo–Futurist period.

Malevich's first independent works date from 1908. These were large gouache paintings on peasant rural themes – themes largely derived from Larionov and Goncharova's 'Agricultural' series which they had begun exhibiting at the third 'Golden Fleece' exhibition of *Ills 110, 112* 1909, and many of his titles such as *Peasants in Church* and *The Wood-cutter* are identical with theirs. In pictorial construction and manner of execution these works were particularly inspired by the Matisses which Shchukin was acquiring at this time: *Game of Bowls* of 1908; *Nymph and Satyr* of 1909, and the famous panels *Dance* and *Music* of *Ill. 104* 1910. For example, Malevich's work *The Bather* is obviously related to these works. This 'Peasant' series of gouaches, five of which he contributed to the second 'Union of Youth' exhibition of spring 1911, established Malevich in Larionov's group. This trio, Malevich, Larionov and Goncharova, formed the spearhead of Larionov's all-Russian group exhibitions, the 'Donkey's Tail' of March 1912 and 'The Target' of March 1913.

The twenty-three works which Malevich contributed to the 'Donkey's Tail' included a number of the 'Peasant' gouache series of *Ill. 108* 1909–10 – such as *Man with a Sack* and *Chiropodist in the Bathroom*. The latter is particularly interesting as an indication of his method of *Ill. 109* work, for it is clearly based on Cézanne's *The Card Players*. This was a favourite work of Malevich's and one of which he always kept a reproduction on his wall, although he had probably never seen the original.

In *Chiropodist in the Bathroom*, Malevich has taken Cézanne's painting as a model of pictorial construction, his only variation being a raising of the viewpoint. In Malevich's painting his three figures have been arbitrarily fitted into this borrowed pattern. Malevich's literal modelling on Cézanne is again revealed in an unfinished work begun by blocking in the formal skeleton of the *Mont Sainte-Victoire*. This preliminary landscape sketch – on the reverse of another painting, *Ill. 116* *Head of a Peasant Girl* – has lightly traced on top of it a dissection in cubes, spheres and cylinders according to Cézanne's famous instructions, although no attempt has been made to refer the method, as originally intended, to nature.

146

108 Kasimir Malevich, *Chiropodist in the Bathroom*, 1908–9

In his gouaches of 1909–10 Malevich has used a loose rough stroke. The massive figures drawn in a sweeping black or blue line, with enormous hands and feet, are treated as elements of a dynamic pattern. It is an interesting detail that in *Washing the Floor* the figure facing the spectator has two left feet, a device which is repeated in *The Bather* of the same year, emphasizing the solid and monumental quality of these figures. However, this monumentality is, one feels, only asserted in order to be subdued. The subjection of all that appears most unyielding and immovable to a fluid rhythm is a remarkable feature of Malevich's works from this time onwards: in this last-mentioned work, the burdened attitude

Ill. 104

109 Paul Cézanne,
The Card Players,
1890–2

and expression of the figures reiterates this sensation of submission to an implacable cosmic rhythm which was to reach its culmination in *The Knife-Grinder* of 1912.

Ill. 157

Another characteristic already present in these gouache works, and indicative of the artist's future development, is his shortening of perspective. In *Chiropodist in the Bathroom* the eye is brought up so short by the blank wall that the massive figures seem violently compressed within the frame. In *The Bather* and *Washing the Floor* all pictorial elements except for the figures have been reduced to a brief indication and the figures themselves to a stylized pattern, vehicles of a dynamic rhythm.

Ill. 108

Ill. 104

Peasants in Church of 1909–10 goes one step further. The cleanly interwoven rhythms of the previous gouache series have become a static fused mass of repeated gesture and expression. Three-dimensional space has been almost entirely crowded out. The figures in this huddled group of scarfed peasant women – reminiscent of the 'crowd-scenes' in Byzantine icons – have lost any separate identity of form, face or gesture. Only a cylindrical pattern of shapes emerges, whose solidity is emphasized here and there by a brilliantly contrasted colour highlighting. From gouache, Malevich has reverted to oil, and the rhythm of his brushstroke has become closer and covers the canvas with an even insistent rhythm, typical of all his later work. The scrubby outline of the *Peasants in Church* has been replaced in *Woman with Buckets and a Child* by a tiny dabbed brushstroke and the figures are cleanly and delicately delineated. This composition, although not exhibited at the 'Donkey's Tail' exhibition, is a direct continuation of *Peasants in Church*. Here the pointed foreheads and heavy generalized features have become more emphasized, and the fused mass of people are reproductions on two different scales of virtually the same figure. The splayed hands and feet flatten the figures against the surface of the canvas, while the violent curved line and dynamic movement in the background further isolate the two foreground figures, who remain static. *The Carpenter* (first exhibited at the 'Union of Youth' exhibition of December 1912) and the two studies entitled *Peasant Head* (exhibited at the 'Donkey's Tail' and the 'Blaue Reiter' exhibition of 1912) are comparable works. They mark the next step in Malevich's development from the Decorative-Primitive period towards Cubo-Futurism.

Ill. 110

Ill. 106

148

110 Kasimir Malevich, *Peasants in Church*, 1910–11

The Carpenter is directly based on the earlier 'Peasant' work, *The Little Country House* of 1909–10 (both of these paintings are in the Russian Museum, Leningrad). Malevich has here abstracted the colour and forms to create a highly organized, geometrical whole. The modelled colouring of the pink-yellow fore- and background, and the blue, white and black of the figure have become smoothed in surface, full and even in tone. Light and shade have been dismissed; the naturalistic colouring of the face and hands has been replaced by a lacquer-red. The various elements in the paintings, such as the man's clothes, have been formalized to geometrical patterns created by the juxtaposition of strongly contrasting tones. The background perspective has been foreshortened and its elements marshalled in a geometrical order on a dynamic cross-pattern.

149

Ill. 111 *Haymaking* of 1911 continues this geometricization of the figure and relates it to the background. The heads, torsos and haystacks have been formalized to a broad spade-shape, and further abstracted by their division into brilliantly contrasting colour-blocks. A centrally placed foreground figure runs almost the length and breadth of the picture, dominating the scene; the illusion of a deep perspective finishing at a high horizon is given by the progressively diminishing scale of the figures in the background. This sense of distance is furthered by the criss-crossed ground of broad stripes running against each other diagonally and horizontally – almost like fields seen from the air, with this colossal superman suspended above the receding world of nature.

The touches of naturalism in the sky-line of *Haymaking* have been
Ill. 107 completely eliminated in *Taking in the Harvest* also of 1911. This was Malevich's most radical work at the 'Donkey's Tail' exhibition. Here the whole canvas has been organized in a sustained Cubo-dynamic

111
Kasimir Malevich,
Haymaking,
1911

rhythm. The brilliant colour of the earlier primitive 'Peasant' works has now gained an additional metallic quality, introduced by the mechanical rhythm of the work, the tubular forms and engaged positions of the stylized figures.

The Woodcutter of 1911 is Malevich's first mature Cubo-Futurist work. It was first exhibited in Moscow in December 1912 at the otherwise insignificant exhibition 'Contemporary Painting', and then almost immediately afterwards at the Petersburg 'Union of Youth' exhibition. Apart from *The Woodcutter*, the pictures which Malevich exhibited in Moscow were far more important and radical than those he sent to Petersburg. There were only five in all, but they summed up Malevich's development of Cubo-Futurism: *Woman with Buckets and a Child*, *Head of a Peasant*, *Haymaking*, *Taking in the Harvest*, and *The Woodcutter*.

The Woodcutter has pursued this particular method to a logical conclusion. The figure has become merged with the background in a

Ill. 112

Ills 106, 116, 111, 107, 112

112
Kasimir Malevich,
The Woodcutter,
1911

113
Kasimir Malevich,
Woman with Buckets.
Dynamic arrangement,
1912

114
Kasimir Malevich,
Morning in the
Country after the
Rain, 1912–13

115 The embroidered end of a towel from North Dvinsk province of Russia. The motif is known as 'Cavaliers and Ladies'. The influence of folk-art traditions on Malevich's work of this period was very strong, both directly derived from such embroidery, or the peasant lubok, or more indirectly through Goncharova's work of 1909–11

series of dynamically articulated cylindrical forms. In this all-over unity which has emerged, the three-dimensional perspective has been replaced by colour-contrast to indicate the solidity of form. The figure of the woodcutter bows to the general rhythm, and with his uplifted arms grasping the axe is locked in tense immobility. The movement of the crowded piston-like logs is likewise arrested in a series of collisions. It is a timeless, spaceless situation isolated from the natural world. One small illogicality interrupts the ruthlessly de-humanized idea – the quietly realistic slipper on the woodcutter's left foot, perhaps expressing the artist's 'Alogist' theory.[5]

During 1912 and 1913 Malevich continued to work in this Cubo-Futurist style. The most important of these compositions were exhibited beside Larionov and Goncharova's Rayonnist works at 'The Target' exhibition of March 1913, and at the 'Union of Youth' exhibition of November 1913. Gradually from a mechanized figure, such as *The Woodcutter*, a mechanical man, such as *The Knife-Grinder*, *Ill. 157* emerges; from a vision of the natural world subordinated to a mechanical rhythm – like *Morning in the Country after the Rain* – a *Ill. 114* world created by a dynamic mechanical force is reached in *Woman Ill. 113 with Buckets*. Malevich's *Portrait of Ivan Kliun* – sometimes called

153

116 Kasimir Malevich, *Head of a Peasant Girl*, 1913

Ill. 116

Kliunkov, a close follower of Malevich – of 1911 represents this in a literal mechanization of man's brain: *Head of a Peasant Girl* of 1913, an almost abstract composition, is built up in cylindrical elements. In this work, Malevich has surpassed both the analytical Cubists and Léger in his logical approach towards abstract picture-construction.

Malevich's Cubo-Futurist works are in a number of ways analogous to Léger's work of the same period: *Nus dans un paysage* (1909–11), *Les Fumeurs* (1911) and *La Femme en Bleu* (1912). Malevich certainly saw the latter work when it was exhibited in Moscow in 1912, and

Léger's work as a whole was familiar to him through his intensive reading of periodicals. *L'Escalier* of 1914 probably comes closest to Malevich's ideas, and has a number of characteristics in common with *The Knife-Grinder* of 1912, but as the dates indicate, Malevich *Ill. 157* had reached this point two years before Léger. Whether there is any ground for thinking that Léger was influenced by Malevich has yet to be ascertained. If Malevich and Léger share a formal construction in the dynamic cubic division of pictorial elements in their canvases, their colour, so important in Malevich's work, is quite unrelated. Up to his *La Femme en Bleu*, Léger's colour echoes the monochrome palette of the Cubists. In this and subsequent works he uses the primary colours and a brilliant green, with white highlighting to express a machine-like quality. His manner of execution also differs profoundly from Malevich at this date – 1909–14 – in his light, spare brushwork, and typically French elegance. Malevich has no elegance: his full, intense colour is applied in a dense, even rhythm throughout the canvas surface.

Towards the end of 1913 the influence of the Synthetic-Cubist works by Picasso and Braque begins to be reflected in Malevich's work, leading to a radical change of colour and the abandonment of Cubo-Futurism. In the manner of Picasso and Braque, small realistic details are inserted, such as the man in the bowler hat in *Lady on a Tram* of 1913 and the stars on *The Guardsman*'s cap. By 1914 these effects *Ill. 117* have grown to Surrealist proportions. Enormous letters, making scraps of words as in *An Englishman in Moscow*, are accompanied by a *Ill. 121* completely inconsequential series of objects: a tiny Russian church biting into an enormous fish which in its turn half obscures the top-hatted figure of the Englishman – with a motto hanging like an epaulette at his shoulder, reading 'Riding Club'; the exquisitely careful delineation of the lit candle in a bedroom candle-holder suspended in mid-air, the ladder tipping perilously, the workmanlike sabre embracing the candle, the ladder, the fish blowing streams of fire – everything reversed, mocked at: a premature piece of Dada one might say. Actually, however, this 'Non-sense realism' was a pictorial interpretation of the contemporary ideas in poetry put forward by Khlebnikov and Kruchenikh under this term. It has been mentioned earlier how closely the Futurist movements in poetry and painting were related in Russia at this time.

117 Kasimir Malevich,
The Guardsman, 1912–13

118 Kasimir Malevich,
Portrait of M.V. Matiushin,
1913

119 Kasimir Malevich,
*Woman beside an
Advertisement Pillar*,
1914

120 Pablo Picasso,
Musical Instruments,
1912–13

121 Kasimir Malevich,
An Englishman in Moscow,
1914

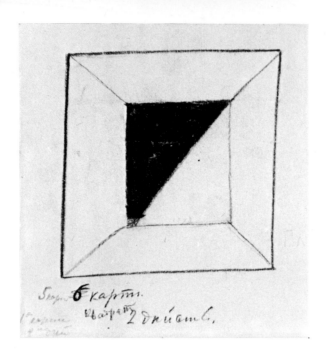

To *Victory over the Sun*, Kruchenikh's Futurist opera, Malevich traces the beginning of Suprematism. One of the backcloths designed by Malevich was in fact abstract: a white and black square. The other sets for this production were very close in character to the Cubist

works of 1913–14. As in *The Guardsman* one can recognize the future Suprematist element in the trapeze form on the right-hand side, so in the designs for *Victory over the Sun* various geometrical elements were prominently incorporated.

122–25 Kasimir Malevich, three backcloth and twelve costume designs for
Victory over the Sun. It was to this production that Malevich ascribed the birth of
Suprematism. As is demonstrated here, one of the backcloths was an entirely
geometrical abstract design. *Victory over the Sun* was first produced in the Luna
Park Theatre in Petersburg in December 1913

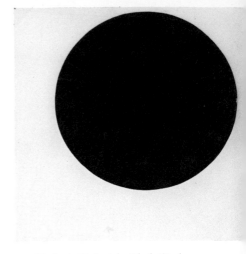

126 Kasimir Malevich, *Black Square, c.* 1913 127 Kasimir Malevich, *Black Circle, c.* 1913

Ill. 126 It is probable that Malevich began working out his Suprematist system in 1913 as he claimed. At what point the actual *Black Square* painting was executed it is difficult to ascertain precisely. The fact that it was not exhibited until late 1915 would in no way indicate that it dates from that year. As we have seen, Malevich did not always, or even usually, exhibit his most revolutionary works immediately. His Cubo-Futurist works were almost all exhibited a year, if not two, after their completion.

Ill. 119 However, if Malevich, as he frequently claimed in his writings, began his Suprematist works in 1913, then these Dada or 'Non-sense Realist' works and some of the more serious collage works – such as *Woman beside an Advertisement Pillar* – were done more or less simultaneously. These were the paintings which he sent to the 'Knave of Diamonds' exhibition – to which he again contributed from 1912 onwards as a protest after quarrelling with Larionov; the last 'Union of Youth' exhibition of November 1913; the Moscow exhibition 'Contemporary Painting' of 1913; and finally 'Tramway V', the first Futurist exhibition of painting held in Petersburg in February 1915, the historic occasion when all the present and future members of the abstract painting schools of the years leading up to 1922 first came together.

160

It was not, however, until December 1915, at the second exhibition of the above artists' work, '0.10', that Malevich proclaimed his Suprematist system.

In all he showed thirty-five abstract works. None of these was termed 'Suprematist' in the catalogue. By way of explanation Malevich wrote in the catalogue: 'In naming some of these paintings, I do not wish to point out what form to seek in them, but I wish to indicate that real forms were approached in many cases as the ground for formless painterly masses from which a painterly picture was created, quite unrelated to nature.'

Black Square headed the list of works. It is by far the most straight-forward of any of the titles, other works being described as *Two-dimensional painterly masses in a state of movement* – or *In a state of tranquillity; Painterly realism of the footballer – painterly masses in two dimensions.* The fact that *Black Square* had a title so much simpler than any of the other works shown at this exhibition is an indication that it was already well known perhaps from the *Victory over the Sun* production.

Ill. 126

128 Kasimir Malevich, *Black Cross, c.* 1913

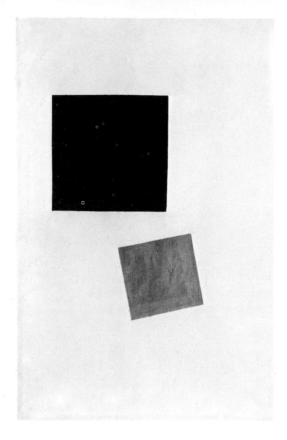

129 Kasimir Malevich,
*Black Square and Red
Square, c.* 1913

130 Kasimir Malevich,
Suprematist Composition,
1914

131 Kasimir Malevich,
Suprematist Composition,
1914–15

132
Kasimir Malevich,
*House under
Construction*,
1914–15

134 Kasimir Malevich, *Suprematist Composition*, 1916–17

135 Kasimir Malevich, *Suprematism: Yellow and Black*, 1916–17

The works which these titles describe were by contrast the most pure and simple combinations of geometrical elements. Beginning with the black square on a white ground, the circle follows, then two identical squares placed symmetrically. Then red is introduced and the black square is pushed up to the left while a smaller red square moves off on a diagonal axis. This dynamic axis is then seized as a fundamental. Simple rectangular bars of red and black, then blue and green pursue this movement. The rectangle shades off into a trapezium; the diagonal is repeated on a double axis, then through repetition of an element in two scales, space is reintroduced. Simple progressions using these basic geometrical elements then ensue; at first these are stated in black and white; then red, green and blue are again introduced: the Cubo-Futurist colour scale is again present.

 In about 1916 Malevich began introducing more complex colour-tones of brown, pink and mauve; more complex shapes appear: a cut-out circle, tiny arrow-shapes; more complex relationships, cutting, repeating, overlaying, shadowing, producing a third dimension. Soft shapes, almost immaterial, fading forms are typical of these later Suprematist works, and the 'propaganda' element is no

Ill. 127

Ill. 129

Ill. 130

Ill. 134

Ills 133, 135, 145

165

133 Kasimir Malevich, *Superematist Composition*, 1916–17

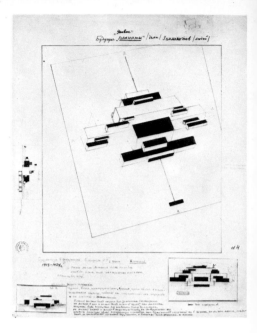

136 Kasimir Malevich,
Supremus No. 18, 1916–17

137 Kasimir Malevich,
*Future Planits. Homes for
Earth-dwellers; People*, c. 1924

longer present. The initial clarity and concreteness, built up from colour entities and enclosed forms, are now contrasted by these rounded looming shadows. This new mystical element is described by Malevich as a sensation of infinity, of the new space in which there is no human measure. As stars in the cosmos, these colour-bolts move upon an appointed way, irrevocable, inevitable. It is not a moment of nature held on canvas, nor an ideal world existing independently, it is a corner of the cosmos caught on its journey through time, close to the symbolism of Bely in its frail materiality, a bridge erected over the subconscious, the world of chaos.[6]

More and more these half-present shapes drown the brilliant flags of colour, the 'semaphore in space' as Malevich called it. These later Suprematist works have quite different titles such as: *Suprematist Elements of Diminution* or *Suprematism Destroyer of Constructive Form*. We are no longer confronted with space, but are sent into 'the infinite whiteness' in such works as *Sensation of a Mystical Wave coming from the Earth* (1917) and *Sensation of the Space of the Universe* (1916). This painting 'of pure sensation', as Malevich himself defined Suprematism,
Ill. 211 culminated in the famous 'White on White' series of 1917–18. All

166

colour has been eliminated, and form in the purest, most de-humanized shape of the square, has been reduced to the faintest pencilled outline.

Already in 1915 Malevich had begun experimenting in three-dimensional idealized architectural drawings. He called these *Planits* or *The Contemporary Environment*. With the culmination of Suprematist painting in 1918 – and the Revolution – Malevich virtually gave up painting (except as illustrations to his theories on art). During the 'twenties he pursued these architectural projects in three-dimensional sculpture. From 1918 up to the end of his life in 1935 Malevich devoted himself to working out his pedagogical method and to writing treatises on the history of the modern movement and on the nature of art. All his later painting was by way of illustration to these theories, except for the portraits of himself, his friends and family which he painted in the last five years of his life. *Ills 136, 137*

Ills 138, 139

Vladimir Tatlin, the founder of Constructivism, was born in 1885. He grew up in Kharkov and was a Ukrainian by nationality. His father, Evgrav Tatlin, was a technical engineer by profession, and a man of education and culture. His first wife, who was a poet, died two years after the birth of their son Vladimir. Soon afterwards he married again. According to Larionov, who knew him as a young boy since he frequently came to stay at the Larionov's home in Teraspol, Tatlin disliked his stepmother only a little more intensely than his

138, 139 Examples of Malevich's *Arkhitektonics*, 1924–8

father. His father seems to have been a stern and unimaginative man in dealing with his son, who was a reluctant scholar and in general a recalcitrant and unco-operative boy. Perhaps Tatlin's morbid distrust of people, and lack of self-confidence in his work, was a result of his unhappy childhood. Vladimir was finally rendered so desperate that he ran away from home to become a sailor at the age of eighteen. The ship which he joined was bound for Egypt. This voyage fired his imagination, and many of his early drawings are of seaports and fishermen, and throughout his life he spoke of the sea with great love. He continued to earn his living spasmodically as a sailor up to 1915, and in the course of his travels visited Syria, Turkey and the Levant.

Ills 94, 96, 97

He returned home from his first voyage in 1904, the year his father died, and entered the Penza School of Art, where he studied under a capable and fairly well-known painter: Afanasiev. In 1910 he came to Moscow and entered the Moscow College of Painting, Sculpture and Architecture. He shared a studio with Alexander Vesnin, one of the three brothers who were to become the leading Constructivist architects in Russia. For a year Tatlin studied at the Moscow College, and then left to become a free-lance painter. He had already sent works to the 'Union of Russian Artists' exhibitions, where most of the students from the Moscow College exhibited, and in 1911, through Larionov, he made his début with the *avant-garde* by contributing eleven works to the second 'Union of Youth' exhibition

Ill. 95

of 1911. These works included still-lifes under the influence of Cézanne, and a number of sea-drawings. From this time on, until they quarrelled in 1913, Tatlin worked in close contact with Larionov and Goncharova. Goncharova remembers him at this time as a tall, thin young man, 'rather like a fish', with his long upper lip, upturned nose and prominent, melancholy eyes. But if he was plain, he had great charm, to those who were able to penetrate his shyness, and would talk with wit and on occasion with brilliance on art or the sea.

It was probably through Goncharova that Tatlin discovered icon painting, for Goncharova, who had long been an enthusiast of this tradition, had access to many private collections. It was not until the superlative exhibition of 'Ancient Russian Painting' of 1913 held in Moscow in honour of the tercentenary of the Romanov dynasty that any number of icons were exhibited in their cleaned condition to the public. Goncharova still remembers the excitement caused by this

168

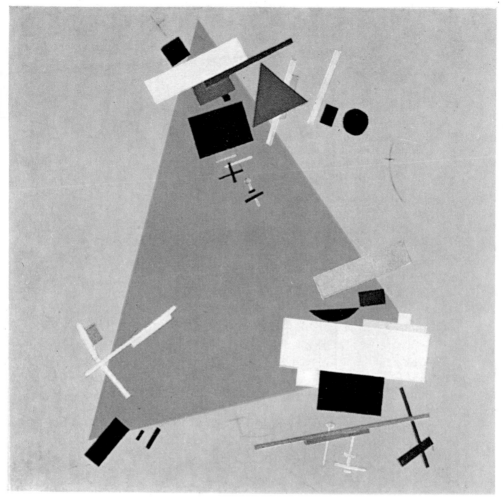

140 Kasimir Malevich, *Dynamic Suprematism*, 1916

brilliant exhibition. It was of lasting consequence in its influence among artists. There is much of the icon-painting tradition in Tatlin's work, both in his use of colour and his flat, decorative, curved rhythm, as in *Composition from a Nude* of 1913. *Ill. 144*

This ruthless resolution of everything to curved planes was pursued into the third dimension very early by Tatlin in his theatrical designs.

141 Vladimir Tatlin, *Hall in the Castle*. Design for a backcloth for
Emperor Maximilian and his son Adolf, 1911

Among the fifty works which he sent to the 'Donkey's Tail' exhibition
of 1912 were thirty-four costume designs for the production of
Ill. 141 *Emperor Maximilian and his son Adolf*, which was staged by the 'Moscow
Literary Circle' in 1911. Unlike Malevich, Tatlin was soon invited to
contribute to the 'World of Art' exhibitions, and to both the exhibi-
tion of 1913 and 1914 he sent designs and models for Glinka's opera
Ill. 142 *Ivan Susanin*. This project was not realized, although Tatlin took
immense trouble over its preparation, making three-dimensional
models of each act.

142 Vladimir Tatlin, *Wood*. Sketch for a backcloth for the opera *Ivan
Susanin*, 1913

143 *Descent from the Cross*. Icon of the
Northern School of Russia, 15th century.
The influence of icon-painting was very
strong in Tatlin's early development as a
painter. It was a source he later
returned to towards the end of his life

144
Vladimir Tatlin,
Composition from a Nude,
1913

The last exhibitions to which Tatlin contributed before he made his historic journey to Berlin and Paris were those of the 'Union of Youth' and 'Knave of Diamonds' of 1913, and the second Moscow exhibition entitled 'Contemporary Painting'. Tatlin seems not to have been a prolific painter, unlike his contemporaries, Larionov, Goncharova and Malevich, whose fertility was amazing. Many of the works sent to these exhibitions were the same, or were minor drawings. The fact that he earned his living at this time as a sailor was probably responsible for this, but even later Tatlin worked slowly and painfully. The most advanced work which he executed before leaving in the

Ill. 144 autumn of 1913 for Berlin was the *Composition from a Nude*, mentioned above.

It is interesting to compare this work with the Cubo-Futurist
Ill. 157 works by Malevich of much the same date. In *The Knife-Grinder* or
Ill. 113 *Woman with Buckets* Malevich has followed Cézanne's dictum – when he wrote to Bernard 'There are no lines, there is no modelling, there are only contrasts; when there is richness of colour, then there is fullness of form.' Tatlin too has modelled his work on this precept, but his rough, unfinished edges come closer to Cézanne's own technique than the carefully defined boundaries of Malevich's forms. Though both artists modelled themselves more on Cézanne than any other painter, though many circumstances and influences in their common environment unite these two artists, it would be hard to find two more diverse. However, Tatlin can be compared with Malevich in his attitudes to the model for the painting and in this they were both very Russian: like Malevich, Tatlin is not concerned with the object or person as an individual entity and both, though in such different ways, subordinate their figures to a geometric pattern. But if Malevich's Primitivist series of 1909–10, and his later Cubo-Futurist works, emphasize the two-dimensional character of his medium, Tatlin is concerned not with a new pictorial space, but ultimately with real space. He dissects an object not in order to arrive at a truer visual representation of the object like the Cubists, but in order to incorporate real space created through colour and surface play. Colour and canvas are treated as materials in their own right.

In spite of the constant rivalry between Tatlin and Malevich – which several times ended in physical violence – Malevich was the only one of his Russian colleagues whom Tatlin really seems to have

145 Kasimir Malevich, *Yellow Quadrilateral on White*, 1916–17

respected. Even though his unhappy jealousy later led Tatlin to extremes, declaring that he could not bear to be in the same town as Malevich, nevertheless he secretly kept in close touch with his work and ideas. In support of this are the papers and articles which were in Tatlin's possession when he died. Apart from those which mention his own work, Tatlin had underlined in blue pencil all references to Malevich. There is no reference to any other artist, apart from Picasso. There are also one or two copies of essays by Malevich in this collection. Tatlin attended Malevich's funeral in Leningrad in 1935, although he had not seen him for years previously.

Apart from Malevich, the painters whom Tatlin respected were few. First and foremost he admired Cézanne, whom he knew from the superb Shchukin and Morosov collections; after Cézanne, Chistyakov, the Russian nineteenth-century painter and teacher of the 'Wanderers' (see Chapter I), Picasso and Léger were the only other artists whom his one-time pupils from the Vkhutein (Higher Technical Institute, where Tatlin taught in the late 'twenties and early

Ills 146, 147

'thirties) can remember their teacher having spoken of with respect. But if his interests were narrow, they were passionate. For example, he apparently read little, only stories by Leskov and Khlebnikov's poetry – but these he read constantly. Khlebnikov in fact was his personal friend, and his last work *Zan-Gesi* was Tatlin's first theatrical production of moment. He produced this play in Leningrad in 1923, the year Khlebnikov died amidst the general famine, in terrible circumstances and completely destitute, in Santalovo near Novgorod. Kklebnikov's death was a great sorrow to all the *avant-garde*. For if Mayakovsky, Larionov, Kamensky and David Burliuk were the constant apologists and propagandists of the new movement in art, Kklebnikov, a man of extraordinary gentleness and unworldly to the point of asceticism, was considered by many of them to be the creative genius of the movement.

Tatlin also lived in great poverty in those pre-revolutionary, pre-war days in Moscow. He turned his hand to many odd jobs in order to keep himself. Goncharova recalls how he once worked as a wrestler in a circus act – but was so frail and inexpert that he put up a poor fight and lost the hearing of his left ear as a result. In 1913 he decided to accompany a group of his friends, Ukranian singers and musicians, who were going to Berlin with the 'Russian Exhibition of Folk Art' which opened there in the autumn of that year. Tatlin played the accordion in the group. There is an amusing story about Tatlin in Berlin. Apparently he posed as a blind musician, and somehow attracted the notice of the Kaiser – who gave him a gold watch! This Tatlin immediately sold, and together with the money he had made by more legitimate means at the exhibition bought himself a ticket to Paris. This was late in 1913. The great object of the trip was to visit Picasso. Since he had seen the first Cubist work brought back by Shchukin, Tatlin had dreamt of meeting Picasso who was then working on his Cubist constructions. He was overwhelmed when he visited Picasso and begged him to let him stay and work with him – saying that he would clean his brushes, stretch his canvases, even sweep his floors, if only the great painter would let him stay. But it was to no avail. Picasso had too many demands from his own destitute friends at this time to be able to allow for an unknown stranger, however appealing. But he remembers him often paying visits to his studio with his accordion during that short month. At last his money

146, 147 Vladimir Tatlin, Maquette of stage set and costume design for Khlebnikov's play *Zan-Gesi*, produced by Tatlin in the Museum of Artistic Culture in 1923

148, 149 Vladimir Tatlin. Two stage sets for the production of Ostrovsky's play *Comedy of the 17th Century*, Moscow Arts Theatre, 1933

150 Vladimir Tatlin,
The Bottle, *c.* 1913

ran out and he returned to Moscow full of revolutionary ideas. Soon after, he held an exhibition of his first 'constructions' in his and Vesnin's studio in Moscow. These works are of course directly related to Picasso's constructions but are already more radical in their abstraction.

It was during the winter of 1913–14 that Tatlin made his first 'Painting Relief'. This was the first step in his three-dimensional development of the conception of form from that of an enclosed, sculptured mass, to that of an open dynamic construction sculpturing space. For the first time in Tatlin's constructions we find real space introduced as a pictorial factor; for the first time interrelationships of a number of different materials were examined and co-ordinated.

176

All that remains of Tatlin's early 'Painting Reliefs' and his later 'Relief Constructions' are the indifferent photographs which we reproduce here and the compositions *Old Basmannaya* and *Construction: Selection of Materials*, both of 1917, which are preserved in the Tretyakov Gallery, Moscow, and which I was able to study on a recent visit to the Soviet Union. Any analysis based on reproductions is bound to be at best inadequate and at worst false. The basic tactile qualities of these works, and the complexity of the ideas involved make it a particularly difficult task. For example, the construction of 1914 is reproduced here from the only monograph on Tatlin written by the contemporary art critic Nikolai Punin entitled *Tatlin: against Cubism,* published in 1921. The oblique angle at which this

Ills 150–56, 158, 160

Ill. 154

151 Vladimir Tatlin, *Painting Relief,* 1913–14 152 Vladimir Tatlin, *Painting Relief,* 1913–14

153 Vladimir Tatlin, *Relief*, 1914 154 Vladimir Tatlin, *Painting Relief: Selection of materials*, 1914

photograph was taken points up the dynamic thrust of the two dominant forms. In a front-on photograph taken at the exhibition 'Tramway V', at which the work was first exhibited, the impression is of a quiet folding and cupping of space, emphasizing the geometric basis of the construction.[7]

Ill. 150 *The Bottle* was one of Tatlin's first 'Painting Reliefs'. It is interesting as an early stage in these experiments with real materials in real space. The object, the bottle, is still whole; that is to say, recognizable. But it is not an individual object but 'bottleness' analyzed: the familiar silhouette is isolated as a shadow, incised in a flat strip of metal; the transparency of the glass essential to a bottle – the sensation of 'looking

178

through' – is isolated, and indicated by a wire-grill pinned to the 'bottle-shape'. Glass is smooth and polished as we know by its powers of reflection, so a piece of curved polished metal, cone-shaped, the typical shape of a fat bottle reflection, is seen through the grille and bottle-shape. The generous curve, so intimately part of a bottle, is isolated in a piece of curved polished metal, the tail of which has already served as the reflection; wittily the isolated curve contrasts by physical juxtaposition with its pathetic two-dimensional silhouette. The lesson is further emphasized by the piece of wall-paper: the illusion of its deep perspective pattern is shown up by its curled and torn edges. The cylinder-shape, while dominating the foreground, embraces the other elements whose flat, two-dimensional character is in this way emphasized. The cylinder form continues its circular movement into 'real' space by cutting behind the other elements – we see a tiny edge of its reverse side as it disappears. Thus, a typical 'enclosed' form is dissected part by part, attribute by attribute, the analysis being conducted in a series of planes which contrast the idea of 'real' and 'illusory' space.

155 Vladimir Tatlin, *Board No. 1: Old Bosmannaya*, 1916–17 156 Vladimir Tatlin, *Relief*, 1917

Ill. 153 'Real' materials were introduced in Tatlin's next compositions of
tin, wood, iron, glass, plaster. In one of these works of 1914 we are
confronted by a simple composition in which each contributing
element has been stripped naked, as it were, and made to play against
the others in its essential qualities to contribute to an entity. A
cylindrical tin (with its label still attached, thereby emphasizing its
down-to-earth 'reality') supports a jointed piece of wood on one side
and has a thin painted piece of plywood fixed to the other. Between
the two is wedged a piece of jagged glass. Thrust up behind these is a
thin rod of wood which is capped by a square piece of iron, in its turn
screwed to the rough, slightly curved plank which forms the play-
surface of these various rough shapes and materials.

Ill. 154 Next, space is introduced as a pictorial factor. In *Relief* of 1914 the
materials used are plaster, iron, glass and pitch. Two contrasting
materials and forms strike the basic chord: the opaque, dull-surfaced
piece of sheet-iron cut in a triangular shape, and the transparent piece
of glass cut into a concave shape, like a tumbler sliced in half. The iron
triangle skewered against the plaster ground presents a flat, downward-
running plane folding through an angle of 180 degrees. The central
axis runs through the triangle and supports the opened cone of glass
on its right.

Ills 158, 160 In his corner constructions of 1915–16, Tatlin did away with the
'frame' or 'background' which had restricted his earlier works,
limiting them in space and time. For the frame does much to isolate
a 'work of art', to hallow a selected moment, lifting it to the plane
of the 'eternal': cordoning off a perfect, private, ideal world. It was
this separation of the reality of art from the reality of life that Tatlin
sought to destroy. 'Real materials in real space' was his cry.

These complex constructions of 1916 were actually attached to the
wall by a wire, but one has the impression that they would be free-
flying but for the technical lack of skill of their author. It is typical –
and the tragedy – of these artists that their ideas were far beyond their
technical capacity. That Tatlin should have devoted the last thirty
years of his life to the design of a glider – which never left the ground –
and that Malevich should have designed *Planits* for living in is surely
a prophecy of the rocket age. Surely this urge to master space – which
has sprung from Russia – is the rationalization of the urge expressed so
vehemently by these artists.

157 Kasimir Malevich, *The Knife-Grinder*, 1912

These corner constructions were Tatlin's most radical works. In them he has created a new spatial form: a continually intersecting rhythm of planes whose movements jut into, cleave, embrace, block and skewer space.

From such abstract constructions Tatlin began to concentrate on studies of individual materials examined in a series of basic geometric

181

158 Vladimir Tatlin,
Complex Corner Relief, 1915

forms. This 'culture of materials', as he called it, was the basis for his
later system of design which he taught first in Petrograd in the local
Inkhuk, then in Kiev, and when he turned to Moscow in 1927, where
he was appointed Director of the Ceramic Faculty in the reorganized
Vkhutemas, the Vkhutein – Higher Technical Institute. It was at this
Ill. 159 time that he began working on his glider which he called *Letatlin* –
the word is a combination of 'to fly' and Tatlin's own name. This was
made entirely of wood and was based on a close study of natural

159 Tatlin's model of his glider *Letatlin* in Moscow in 1932

160 Vladimir Tatlin, *Corner Relief*, 1915

forms. Tatlin would take baby insects and grow them in boxes; when they were fully grown he would take them out into a field and watch them respond to the wind, unfold their wings against it and fly away. His finished glider looks like a great insect itself, so closely has the organic structure been interpreted. It is reported that new experiments are being done in Russia on the basis of this design of Tatlin's. Thus perhaps Tatlin's dream may come true. He may intuitively have arrived at a solution through his 'culture of materials' and attention to organic forms, which he called the basis of all design: 'My machine is built on the principle of life, organic forms. Through the observation of these forms I came to the conclusion that the most aesthetic forms are the most economical. Work on the formation of material is art.'[8]

183

161 Liubov Popova, *Seated Figure, c.* 1915

1914–17

In tracing the individual development of Malevich and Tatlin I have anticipated events, and will therefore now return to the development of Larionov and Goncharova's Rayonnist theory and their Futurist works of 1913 and 1914. The Cubo-Futurist movement was now at its height and the partnership between the poets and painters at its closest. This partnership reached its climax in two theatrical productions put on by the 'Union of Youth' in December 1913. One was Vladimir Mayakovsky's first play, *Vladimir Mayakovsky, A Tragedy*, which had décor by Filonov, and will be discussed later. The other was *Victory over the Sun*, a Futurist opera with music by Matiushin and a non-sense libretto by Kruchenikh. The sets and costumes were by Malevich. Both of these were produced in the Luna Park Theatre in Petersburg on consecutive evenings in December 1913. After this, the Cubo-Futurist marriage of the poets and painters broke up and they proceeded to develop their own discoveries and experience in their own media.

Ills 122–25

It was during these next four years that a school of abstract painting developed and became dominant in the Russian modern movement, and gave birth to a number of minor schools. It was headed by Malevich, who was the leading personality in this war-time *avant-garde*, succeeding Larionov and Goncharova, who had left the country in 1915 to join Diaghilev.

From the beginning of the century Russia had been a centre of a continuous meeting and exchange of ideas from all over Europe. With the outbreak of the First World War in 1914 she was thrown back on her own resources. During this period of enforced isolation, which was to last throughout the war and ensuing Revolutionary period until the break in the blockade in 1921, Moscow and Petrograd, as it was now called, became the scenes of a fierce, concentrated activity among the artists. During this time, the pre-Revolutionary movement of Suprematism and the post-Revolutionary school of Constructivism emerged and became crystallized so that when movement and

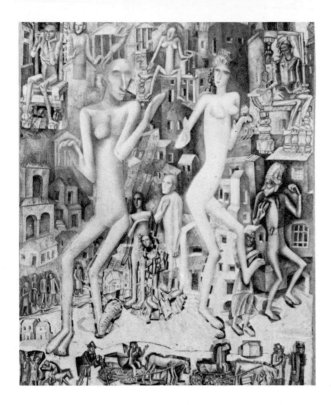

162 Pavel Filonov,
Man and Woman, 1912

exchange of ideas with the outside world again became possible in the
early 'twenties, these two unknown movements made a tremendous
impact on post-war Western Europe. Ideas from all over Europe met
in Germany, particularly in Berlin, and it was here that a synthesis, in
which the Russian contribution was so notable, was created. In
particular in the development of the international functional style of
architecture and design, the ideas of the Russian Suprematist and
Constructivist movements were of fundamental importance.

Yet in many ways the mood in war-time Russia, reflected in
Futurism and Non-sense Realism, resembled the German Dada
movement. There was the same feeling of uselessness, the same sense
of victimization in a hostile, senseless world. The ludicrous masks that
the Futurists wore or painted on their faces – in *Victory over the Sun*[1]
the actors wore papier-mâché heads half as tall again as their bodies,
and performed on a narrow strip of stage using marionette gestures to
accompany their 'non-sense' words – the guy-like costume they

186

adopted, the undignified public brawls and vociferous street language of their paintings and poetry, all these typical Russian Futurist traits indicate a Dada-like rejection of reality, a bitter mocking of themselves as useless misfits in a decadent society. This mood was essentially non-creative, negative, passive. The paintings produced were works such as Malevich's *An Englishman in Moscow*, or Pavel Filonov's *Man and Woman*. Filonov was closer to the analogous German movement than any other painter in Russia at this date, and in such a work as *People – Fishes* anticipated the Surrealists.

Ill. 121

Ill. 162

Ill. 163

There was extraordinarily little Expressionist painting in Russia, unless one includes a few paintings by Larionov and Goncharova and the work of Marc Chagall. Neither Chagall nor Filonov was typical of the Russian artistic world of their time; in Chagall this difference can be explained by his Jewish birth and his Paris schooling. His interest in the 'lubok' he shares of course with Larionov and the Moscow Primitivists, and he did actually contribute to most of Larionov's exhibitions during the years 1911 to 1914 when he was in Paris, thus remaining in contact with the art world of his native country. When he returned to Russia at the outbreak of war, he was drawn not into the circle of the Moscow Cubo-Futurists, but rather the group of Jewish graphic artists centred in Kiev, Odessa and his native town of Vitebsk. His work of this time does, however, reflect

163 Pavel Filonov, *People—Fishes, c.* 1915

164 Liubov Popova, *Italian Still-Life*, 1914

188

the current abstract schools in Russia, although always remaining representational – for which 'old-fashionedness' Malevich so ruthlessly dismissed him (see Chapter VIII). Immediately after the Revolution, some charming children's books, ranking among the first typographical experiments of 'modern' design and layout, were produced by this circle, which included El Lissitzky.

Ill. 167

Filonov was, however, a different case. Born in Moscow in 1883 and left an orphan in 1896, he went to live in Saint Petersburg. He had begun drawing at an early age, but did not pass the examination for the Academy of Art in 1902, when he first tried. However, a generous academician taught him privately for five years. In 1908 he entered the Academy at last, but had a disturbed career, being expelled after two years, and then reaccepted. In 1910 he finally left the Academy and became a foundation-member of the 'Union of Youth' Russian

165 Luibov Popova, *Architectonic Painting*, 1917

166
Marc Chagall,
*The Gates of
the Cemetery*,
1917

Futurist organization. Until 1914, Filonov was a constant if retiring
member of this Futurist movement, and contributed illustrations to
the early publications: as we have seen, he designed the backcloth,
with Shkolnik, for Mayakovsky's first play, *Vladimir Mayakovsky*.
Filonov saw active service during the war, although he continued to
paint during this time. After the Revolution, which Filonov greeted
with the enthusiasm of all these Futurist artists, he began to work out
his method of 'Analytical Painting'. By 1925 he had attracted a
numerous following and in that year set up a school under this name
in Petrograd which continued until 1928 when all private artistic
groups and organizations were dissolved. Filonov's painting is of
an extraordinary delicacy and sensitivity of touch. One has the

167 El Lissitzky, an illustration to a Jewish children's book, published in Vitebsk, *c.* 1918

168 Marc Chagall, designs for friezes for The State Jewish Theatre in Moscow, 1919–20

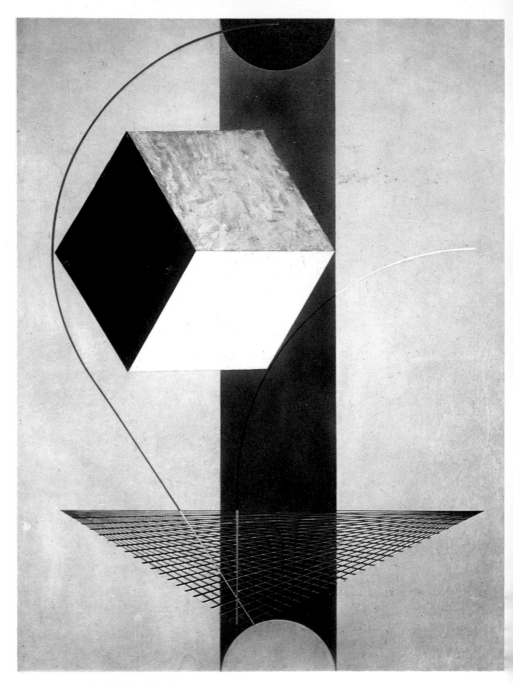

169 El Lissitzky, *Proun 99*, *c.* 1924

impression of watercolour from many of his oil-paintings, so fine and light are his brushstrokes. This fantastic technique was obtained through a fanatical devotion to his work – he would work eighteen hours a day on his paintings, which were minutely worked out in detail before being started on the monumental finished scale. Filonov's work can be related more to Paul Klee than to any other contemporary artist. There is the same interest in children's art and in the art of the insane; in both artists' work one's eye wanders among the various events within the frame; like a story or a journey, one gradually discovers the pattern and meaning in pictures which have no immediate formal unity. There is little likelihood of any actual link between these artists, however, for Klee did not send to any of the Russian exhibitions to which the older 'Blaue Reiter' and 'Die Brücke' members contributed; Filonov read little and never left his country. He lived as he died, in circumstances of great courage and heroism, during the siege of Leningrad in the Second World War.

While in Germany the art world during the pre-war years was dominated by the Expressionists and 'Blaue Reiter' group, in France the Cubism of Picasso and Braque had given rise to the Orphism of Delaunay and Kupka, the machine-painting of Marcel Duchamp and Picabia, and the dynamic Cubist works by Léger which bear such an affinity to Malevich's works of 1911–12; in Italy the Futurists continued their propaganda work, evolving a system to depict the dynamic in their sculpture and painting. Russian artists were in touch with all these movements, not only through periodicals and the occasional work sent to their exhibitions, but also through personal contact. Thus Georgy Yakulov was working in Paris in 1912–13 and was particularly close to the Delaunays; Alexandra Exter was a great friend of Léger and also went frequently to Italy to visit the Futurist painters and Boccioni the sculptor. Nadezhda Udaltsova (1886–1961) and Liubov Popova (1889–1924) had studied together at Arseneva's Gymnasium during the years 1907 to 1910. On leaving they took a studio together in Moscow and in 1912 set off for Paris, where they studied with Le Fauconnier and Metzinger. Like so many of their compatriots, they returned home at the outbreak of war in 1914. Chagall, Puni, Altman, Bogoslavskaya all returned from their long stay abroad in Paris; El Lissitzky returned from his architectural

170 Ivan Puni, *Plate on Table*, *c*. 1915

school in Darmstadt, and Kandinsky together with the other Russian
members of the 'Blaue Reiter' group came home from Munich.

Thus whereas the other art centres of Western Europe were broken
up and their members dispersed upon the outbreak of war, in Russia
the event served only to reunite them. Although a number of these
artists saw active service – Filonov spent the years 1915–18 on the
Rumanian front, Yakulov was badly wounded in 1917 – many of
them remained in Moscow or Petrograd. They were by no means
insensitive to the war and held a number of their exhibitions in aid of
the wounded; some of them, including Mayakovsky, were sent out
to the front as war artists, a tradition which was continued into the
Revolutionary period when these 'agit-prop' activities did much to
encourage and spread knowledge of the new régime.

The first occasion to celebrate this swelling of the ranks of the
Russian *avant-garde* was an exhibition held in Petrograd in February
1915. The show was called 'The Futurist Exhibition: Tramway V'.
It was financed by Ivan Puni, whose family was relatively well-off.
Puni and his wife Bogoslavskaya had rapidly made contact with
Malevich and his friends on their return from Paris in 1914, and were
among his earliest followers in Suprematism.

This exhibition again brought Malevich and Tatlin together. They had first met – like so many others in this world – through Larionov's exhibitions. But it was at this exhibition that they emerged for the first time as the leaders of two distinct schools.

Tatlin's works were by far the most radical in the exhibition. He showed 'Painting Reliefs' of 1914 and one of 1915: six in all. (This was *Ill. 154* the first group exhibition at which Tatlin showed these works.) Malevich showed works of 1911–14, beginning with *Argentinian Polka* of 1911, *Woman in a Tram* of 1912, the radical *Portrait of M. V. Matiushin* of 1913 and a number of works of 1914 which he called *Ill. 118* 'Alogist' or 'Non-sense Realist'. None of these paintings by Malevich was a new or unknown work; he sent no Suprematist work.

Among the other exhibitors there was as yet little cohesion of style, or commitment to either Malevich's or Tatlin's influence. Puni exhibited Cubist works, the most advanced of which was *The Card Players*. This work is related both to Picasso's Cubist constructions and to Tatlin's current work, but compared with the latter's 'Painting

171 Ivan Puni,
Suprematist Composition,
c. 1915

172
Nadezhda Udaltsova,
At the Piano,
c. 1914

Reliefs', it is far less advanced: it shows a witty ingenuity and decorative sense in the co-ordination of the scraps of clumsy iron and wood, but there is no reflection of Tatlin's idea of baring the material itself, or of piercing space to embrace a new dimension. In fact, the closest parallel is with the puppet-pathos of *Petrouchka* or another of Diaghilev's ballets, *Le Pas d'Acier*, which had a Constructivist set by Georgy Yakulov.

Ills 240, 241

Liubov Popova and Nadezhda Udaltsova sent Cubist works of their Paris period to this exhibition. They are interesting in that they give an idea of the Russian's attitude to this movement, for Cubism, like the earlier Impressionist movement, had a very different interpretation in Russia from the one it was given in France. Once again the Russian artist was not primarily concerned with a strict interpretation of the thing seen, but rather with a new way of constructing a

196

173
Liubov Popova,
The Traveller,
1915

painting. Cubist works by Malevich, Popova and Udaltsova, who were the chief representatives of this school in Russia, are constructed in an almost entirely abstract fashion. They are decorative co-ordinations of flat planes of colour with here and there a trivial detail such as the stars on the cap of *The Guardsman* by Malevich, or the vague representation of musical manuscript sheets in Udaltsova's *At the Piano*. In many of these so-called Russian Cubist works, letters are used to create another plane, as in *Geography* by Rosanova, *Petro-kommuna* by Altman, *The Violin* and *Italian Still-Life* by Popova, a device familiar from the works of Larionov and Goncharova as well as Braque and Picasso. But the letters in these Russian Cubist works are used abstractly; they do not exist in their own right as in Larionov's works, nor are they labels torn off the object as in Picasso's work, in order to analyze the object physically, but as in Picasso's late Cubist

Ill. 117

Ill. 172
Ill. 174
Ills 175, 164

197

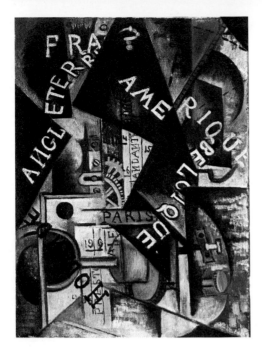

174 Olga Rosanova,
Geography, 1914–15

works, at his most abstract period, they are a means of juxtaposing different levels of reality.

'Futurist' painting in Russia was again fundamentally different from that of the Italian and French schools. Examples of so-called Russian Futurist painting which come closest to the Italian School in their inspiration are such works as Rosanova's *Geography* and Malevich's *The Knife-Grinder*. I will try to point out how little in fact these two works are related to the Italian movement and ideology.

Ill. 174 In *Geography* we are presented with a sliced view of a machine, an intricate clock-like interior. The machine cogs, however, are still. We are faced with the intimate workings of this relentless, inhuman organism, but we remain uninvolved. The intoxication with speed, the delirious abandon to a dynamic, implacable rhythm characteristic of the Italian artists' works, is entirely absent. Far from dominating and drowning one, the machine here stands pathetic, removed, a foreign secret world. It thus emerges that the machine is little more than a new pictorial element.

Ill. 157 Malevich's *The Knife-Grinder* is the outstanding example of the few first-class paintings which belong to this 'Futurist' movement in

198

Russia. Although this is an analysis of the movement of man and a machine, there is again no attempt to represent speed. The man and the machine are the representation of a series of arrested gestures; they trace the pattern of a series of movements in space and time from different points of view. Again, it is not the machine which dominates the man, but the reverse. The machine is not idealized – it is indeed an extremely primitive machine. Malevich is, it seems, preoccupied with the idea of the new man which emerges from machine-power: a super-man, man-become-machine. There is no subjective emotion such as we find in the work of Severini; the lines of the movement are not continued into space as with Boccioni. It is an internal compulsion 'devouring the green world of flesh and bones', as Malevich expressed his fundamental hostility to nature; it is an order-creating force in a world of chaos; the moment of transformation of man dominated by nature, to man the victor over his age-old enemy. Pressed within the

175
Liubov Popova,
The Violin,
1914

frame, the twisted figure is pushed flat against the surface of the canvas; the ruthless intensity of the cosmic forces which seem to be driving the man's transformation are given pictorial expression in the sharply contrasted tones and shapes: the curve against the straight, the black against white, flesh becoming steel. The man, urged into this new substance and rhythm, is propelled into new, unknown gestures. This machine rhythm is continued in the stairs in the background where, like a piston, the banister is cut short.

Man – if he is physically involved at all – is the master of the machine. It is not a case of man becoming willy-nilly displaced by this new centre of power in the world, as with the Italian movement, but rather of man become a demi-god, a new weapon to his hand for 'seizing the world from the hands of nature to build a new world belonging to himself'.[2] For to the Russian artists, nature is a force hostile to man – again in Malevich's words: 'Nature created her own landscape . . . in contrast to the form of man. The canvas of a creator-painter is a place where he builds a world of his own intuition.'[3] Thus for the Russian, the machine came as a liberating force, liberating man from the tyranny of nature and giving him the possibility to create an entirely man-made world, of which he will finally be the master. This vision of the machine as a liberating force was one of the reasons for the joyful welcome given to the Bolshevik régime a few years later – a régime which promised a new world, a new society transformed by the machine, by industrialization. This romanticization of the machine lies at the basis of all these 'isms' in art and literature which identified themselves with the Revolution, and in particular in the aesthetic of Constructivism.

As so often in the history of the modern movement in Russia it was in the theatre that Russian Futurism met with its most complete expression. Alexandra Exter's work was the pioneer force in this field. She was commissioned in 1916 by the progressive producer Tairov, the founder of the Moscow Kamerny Theatre in 1914, to execute sets and costumes for a play by Annensky entitled *Famira Kifared*, which was a brilliant success. During the next few years Tairov and Exter worked out a system of 'Synthetic Theatre'[4] in which the set, costume, actor and gesture were to be integrated to form a dynamic *Ill. 242* whole. These Kamerny Theatre productions were among the most important artistic events of the war-time and early Revolutionary

200

176 Alexandra Exter,
Venice, 1915

177 Alexandra Exter,
City-scape, c. 1916

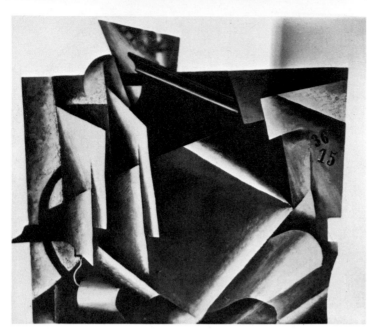

178 Liubov Popova, *Painting Relief*, 1916

period: in them one can see the gradual development of ideas from
Futurism to Constructivism, for both movements were either worked
out in, or almost immediately adapted to, the theatre. Thus in 1920,
when the movement had barely emerged, Yakulov designed Con-
structivist sets for Tairov's production of *Princess Brambilla*, and in the
same year Alexander Vesnin, another founder-member of the
Constructivist movement, designed the sets for the Kamerny Theatre
production of Claudel's *L'Annonce faite à Marie*, and two years later
of Racine's *Phèdre*. This association of the Futurists-become-
Constructivists with the Kamerny Theatre continued throughout the
1920s with the co-operation of the first generation of Soviet-trained
artists of the 'Obmokhu' group – the Stenberg brothers and
Medunetsky (see Chapter VII).

To return to the 'Tramway V' exhibition of 1915, the first Futurist
exhibition, as it called itself. Exter's contributions to this event
reflected her cosmopolitan background, for French Cubism, Italian
Futurism and Delaunay's 'Simultanéisme' are all reflected in works
Ill. 176 such as *Venice*. This painting is typical of the artist's feeling for brilliant

202

179
Luibov Popova,
*Architectonic
Composition*, 1917

180 Ivan Kliun,
Suprematist Composition,
c. 1916

colour, richly decorative rhythm and dynamic formal construction which were likewise characteristics of her theatrical designs.

This was only the second group exhibition in which Liubov Popova had taken part, but already her work is to be distinguished from that of others who participated, for its logic and unity. Indeed after Tatlin and Malevich, Popova was the most outstanding painter of the post-1914 abstract schools in Russia. Her work is not easy to categorize, although one can clearly distinguish the influence of Malevich in the *Seated Figure* of *c.* 1915. Likewise in her *Painting Reliefs* of 1916 the influence of Tatlin's 'Culture of Materials' and introduction of 'real space' into pictorial composition are evident. In her later *Architectonic Paintings* of 1917–18 she has evolved a personal style of abstract composition. These later paintings are very exciting. They are often executed on a rough board, and the angular forms – in strong blues, greens and reds – are brushed in on this crude, raw surface, leaving the impression of a lightning-swift movement, a darting, breathless meeting of forces, a kiss-imprint, as it were, of the driving energy around us. Before her premature death from scarlet fever in 1924, Popova like the other Constructivists did a good deal of work in the theatre, designing the sets for Meyerhold's production of *The Magnanimous Cuckold* and *The World Upside-Down* and also in industrial design, working with Stepanova in a textile factory. She was one of the most enthusiastic believers in production-art. A remark is quoted in the catalogue to her posthumous exhibition which was arranged in 1924: 'No artistic success has given me such satisfaction as the sight of a peasant or a worker buying a length of material designed by me.'[5]

Another newcomer to the artistic scene who exhibited at this 'Tramway V' exhibition was Kliun, soon to become a close follower of Malevich, an energetic personality and a prolific artist. He is of interest rather as a minor Suprematist whose work was typical of the school than for his own merit. He shows how the concern for decoration soon deteriorated after the Revolution into standard formulae and Suprematism lost its vitality as a creative movement in painting, being superseded by Constructivism in its various forms.

In December 1915, Puni and this same group of artists held a second exhibition in Petrograd: it was entitled '0.10. The Last Futurist Painting Exhibition'. This show, the public début of Malevich's

Ills 161, 178

Ills 165, 179

Ill. 245

Ill. 180

204

181 Olga Rosanova, *Abstract Composition, c.* 1916

182 Vassily Kandinsky, *Composition 6*, 1913

Suprematist paintings, was the occasion of much excitement and quarrelling among its organizers. The basic cause of trouble was the antagonism between Malevich and Tatlin which now came to a head. Tatlin furiously objected to the abstract painting of his colleague which he declared to be amateur and impossible to include in an exhibition of professional painters. Malevich on the other hand had a numerous following by now and a firmly established place as leader of the *avant-garde* – it was impossible to hold the exhibition without him. Malevich was adamant that he would show his Suprematist work at this exhibition, and nothing else. Feelings became so exacerbated by this quarrel that it ended up with Tatlin and Malevich actually fighting each other just before the exhibition was due to open. The other artists were in despair. It must have been a terrifying sight, the tall and weedy Tatlin with his desperate jealousy, and Malevich, his senior by fifteen years, a great big man with a passionate temper when roused. In the end, Alexandra Exter succeeded in stopping the fight and a compromise was found to placate the two artists' pride –

206

and allow the show to open: Tatlin, Udaltsova and Popova were to hang their works in one room, and Malevich with his Suprematist followers in the other. To make the difference clear, Tatlin stuck up a notice over the door to his room which read 'Exhibition of Professional Painters'.

Tatlin showed twelve works, one *Painting Relief* of 1914, five of 1915, and five new suspended *Corner Counter-Reliefs* of 1915. This was the first time that the latter works had been exhibited.

Udaltsova contributed works similar to those of the previous 'Tramway V' exhibition, and Popova sent Cubist works such as *The* *Ill. 175* *Violin*.

Malevich dominated the show – as Tatlin had sensed he would – with thirty-six Suprematist compositions. He also issued a manifesto:

Only when the habit of one's consciousness to see in paintings bits of nature, madonnas and shameless nudes has disappeared, shall we see a pure-painting composition.

I have transformed myself into the nullity of forms and pulled myself out of the circle of things, out of the circle-horizon in which the artist and forms of nature are locked.

183 Vassily Kandinsky, *White Background*, 1920

This cursed circle is always discovering something newer and newer, and distracts the artist from his aim and leads him towards ruin.

And only cowardly sense and paucity of creative strength in an artist, makes him yield to the deception, arresting his art on the forms of nature, fearing to do away with the foundation on which the savages and academies based their art.

To reproduce the hallowed objects and parts of nature is to revivify a shackled thief.

Only stupid and uncreative artists protect their art with sincerity.

In art truth is needed, not sincerity.

Things have disappeared like smoke before the new art culture. Art is moving towards its self-appointed end of creation, to the domination of the forms of nature.

Although this was the first exhibition at which Malevich exhibited Suprematist paintings, the large number of works with which he introduced this new style is another factor in support of his assertion
Ills 126–28 that the first *Square*, *Circle* and *Cross* had been painted in 1913, for it is difficult to imagine that these works were completed in under two years. Geometric elements in simple and then in progressively more
Ill. 132 complex relationships were shown: *House under Construction*, which is dated 1914 by Malevich, was shown at this exhibition; likewise *Black Trapezium and Red Square* can be identified in the general view of one wall of the exhibition. In this work the more complex trapezium shape has made its appearance and a third spatial dimension has been introduced by the method of progressive diminution. This work also obviously belongs to a considerably later period in its use of non-primary colours; the early Suprematist paintings had used only primary colours, but in the later works Malevich tended more and more to avoid them as his shapes became more nebulous.

After the exhibition, in a typically Futurist way, Malevich, with his new Suprematist followers, Puni, Menkov and Kliun, held an open discussion on Suprematism in the Tenisheva School of Decorative Arts in Petrograd. The lecture was advertised as 'On the movements reflected in the exhibition "0.10" and on Cubism and Futurism'. Malevich was billed to give a live demonstration of Cubist painting, which was reported a great success, rather more so than his explanations

of his new painting.[6] Perhaps it was for this lecture that Malevich arrived at the term 'Suprematism' to describe his new work, for the name is already used by the critics in the reviews.

If the public and critics remained scornful and indignant at his Suprematist painting, Malevich began to gain a great following among his immediate circle. A year later Suprematism was described as the reigning movement among these artists. 'Not for nothing did someone write in the Moscow Press that people are almost equally interested in Suprematist painting, *Famira Kifared* [Tairov's production at the Kamerny Theatre with sets by Exter] and the speeches of Miliukov in the Duma.'[7] By 1918 it was reported: 'Suprematism has blossomed throughout Moscow. Signs, exhibitions, cafés, everything is Suprematist. One may with assurance say that Suprematism has arrived.[8]

During the next two years before the outbreak of the Revolution, the younger artists pursued, in a more or less ruthless fashion according to their temperaments, the paths discovered by Malevich and Tatlin. A number of minor exhibitions held during this period give an idea of this development which seems to have been so little interrupted by the war, as a few years later they continued their ideas, impervious to the harshest physical conditions.

Kandinsky did not contribute to the two Petrograd exhibitions which I have described here, but remained quietly working in

184 Vassily Kandinsky,
Yellow Accompaniment,
1924

185
Alexander Rodchenko,
The Dancer, 1914

186 Alexander Rodchenko,
Compass and ruler drawing,
1913–14

187 Alexander Rodchenko,
Compass and ruler drawing,
1915–16

Moscow. It is not until 1920 that the impact of Suprematism begins to be discernible in his work, in a geometricization of forms. This was after Malevich's triumphant series of exhibitions in Moscow; culminating in his one-man show of 1919. One cannot help suspecting that the relations between Kandinsky and these artists after his return to Russia were very far from intimate. This is indeed confirmed if we notice which artists were colleagues of Kandinsky at this time. One of the few exhibitions to which he sent works was the 'Exhibition of Leftist Trends' held in Petrograd in 1915. At once it places him, for neither Malevich, Tatlin, nor Popova sent to this exhibition, but the Burliuks did, so did close neighbours and friends of Kandinsky at this time, the 'Cézannists' (of the 'Knave of Diamonds') and Nathan Altman, a recently returned *émigré* working in a Cubist style. The backbone of this rather unexciting exhibition were the new abstract compositions by Rosanova, which were very Futurist in feeling, sharp pointed forms organized in dashing dynamic combinations – with such titles as *Composition of Shining Objects*. They were executed in white, grey and black, which emphasized their formal energy.

With Tatlin's exhibition 'The Store' in 1916, a new figure was introduced to this little world, who was shortly to become one of its most energetic personalities in the Constructivist movement. This was Alexander Rodchenko. Rodchenko was born in Saint Petersburg in 1891. He was the son of a theatre-accessories craftsman and a laundress. The Rodchenko family was of very simple origin; they were first-generation townspeople whose forefathers had been serfs. Mikhail Rodchenko, Alexander's father, was a very skilled craftsman, and he passed on this gift to his son, who drew from a very early age, a faculty naturally encouraged in the atmosphere of the theatre in which he grew up. Rodchenko's earliest known drawings are for the theatre and were executed while he was still attending his local art school, the Kazan School of Art, in Odessa. He left this in 1914 before receiving his diploma and hastened to Moscow. There he joined the Stroganov School of Applied Art, but his intolerance of the academic life soon drove him to leave. Already by the end of 1914 he had begun experimenting with pencil and compass drawings. The earliest of these were still representational – for example, *The Dancer*. *Ill. 185*
This ingenious imitation of the Italian-cum-Malevich school of Futurism was then succeeded by entirely abstract designs. Whereas

188 Alexander Rodchenko,
Composition, 1919

Ill. 186

Ill. 187

The Dancer is a still-recognizable human figure which has been analyzed into geometric curved segments, these first abstract drawings are so highly formalized that the external source is no longer recognizable. In his works of 1915 and 1916 the composition has become freer and purely conceptual in its form based on the circle. It was five such drawings that Rodchenko sent to Tatlin's exhibition of 1916, 'The Store'.

This was Rodchenko's first contact with Tatlin and Malevich. The latter was apparently invited to contribute to this exhibition on the condition that no Suprematist works were to be included, for he sent only Cubo-Futurist and 'Alogist' works such as *An Englishman in Moscow*. Rodchenko's work of the next few years shows a vacillating

212

189 Alexander Rodchenko, *Abstract Painting*, 1918

attraction to first Malevich's and then Tatlin's ideas. From Malevich he derived the dynamic axis which characterizes his work throughout, and his use of pure geometric forms first in two-dimensional compositions and later in three-dimensional constructions and mobiles of *Ills 205, 206* 1920. From Tatlin, Rodchenko gained an interest in materials which is reflected in his works of 1916–17 with their play with surface textures, at first artificially imitated, and then in real materials. From a combination of these two influences Rodchenko evolved the system of Constructivist design in which he was a pioneer.

It was while working directly with Tatlin on the interior decoration of the Café Pittoresque that Rodchenko began to follow Tatlin's example in working in 'real materials and real space' and that the seeds of his ambition to become an artist-engineer were sown.

Tatlin was given the commission to design the interior of this basement theatre-café in Moscow by the industrialist Filippov early in

190 Alexander Rodchenko.
Line Construction, 1920

1917, but as he was virtually incapable of working on his own, he invited Georgy Yakulov, just back from the front badly wounded but full of enthusiasm for the idea to join him on it; he also recruited his new friend Rodchenko. All three contributed to the decoration of the café, which became a typical centre of this crazy war-time art world. Yakulov boasted to his pet friends Kamensky and Khlebnikov how he was creating in the Café Pittoresque 'a railway of the world's art in which a banner will be hung over the stage reading: "Orders to the army by a master of the new era."' Khlebnikov was caught up by Yakulov's idea of 'launching an express of the new movements in art into the world of man' and declared that he was determined to create in the Pittoresque 'all the chairmen of the world who would finally decide its fate'.[9]

This 'chairman of the world' idea referred to a great 'Carnival of the Arts' held in Petrograd a month previously. For the occasion artists, writers, composers and actors had hired buses of every colour into which they had piled and driven in slow procession along the Nevsky Prospect. Bringing up the rear came a large lorry on the sides of which had been chalked the words: 'The Chairman of the World'. In the lorry, hunched up in a soldier's greatcoat, sat Khlebnikov.

214

Such was the crazy, intoxicated atmosphere of this *avant-garde* world in pre-Revolutionary, war-time Russia. Exhilarated by a sense of power, tremendous optimism, and a giddy excitement as they stood on the brink of a new world, they yet found themselves unable to communicate this excitement to the society in which they found themselves. They felt cut off and useless, their art given no more than at best a mocking recognition as 'inane jokes', and so they were driven into this wild bohemian café-life of which the Pittoresque was a typical example. Everyone lived for the moment. Wild scenes of orgy occurred such as characterized the contemporary Dada movement centred in Zurich – and yet with it all and provoking this desperate energy, there was a desire to be recognized, to be con-

tributing members of society. From this stemmed the many scandals associated with this little bohemian world. Anything, everything was employed to rouse a reaction from the *bourgeois* stupor which surrounded them. Larionov and Goncharova would paint their faces, parade in fancy costumes, sea-shells on their ears, grotesque masks on their faces. Rich *bourgeois* would flock to the little *avant-garde* cafés to hear Mayakovsky, spoon in buttonhole and wearing ever more violent coloured shirts and jackets, pouring out rhymed abuse in his magnificent bass voice.

Tatlin, Yakulov and Rodchenko's constructions formed a fitting cadre for such a departure for the unknown. Their dynamic constructions in wood, metal and cardboard clung to the walls, squatted in the corners, hung from the ceiling of this tiny interior, destroying the idea of a room as an enclosed space with solid walls. Pillared construction-fittings were attached to the lights, forming rods and shafts of light with their cupping intersecting planes, thus further breaking up and 'dynamizing' the interior.

Ill. 194

192 Alexander Rodchenko, *Composition*, 1918

193 Alexander Rodchenko, *Abstract Composition*, 1918

194 Alexander Rodchenko, *Line Construction*, c. 1917
195 Alexander Rodchenko, *Abstract Composition*, c. 1920

This dynamic décor so involved the clientele that the scene to a spectator must have been very similar to a play, although the rich *bourgeois* audience which attended the Futurist activities was by its nature apathetic. However, such were the antics they witnessed that it is hard to imagine that they could have remained uninvolved – indeed from the number of scandals reported in the press from evenings in such cafés with these artists and poets fighting members of the audience one might imagine that police intervention was the

217

regular end to a successful Futurist entertainment. Roaring Futurist poets declaiming their latest 'Non-sense' verses, demonstrating and disputing painters proclaiming their rival manifestoes, the tiny stage loaded with miming giant puppet-figures, figures performing Greek classics in jeans or cardboard costume, strutting and gesturing in geometric movements in the latest 'Non-sense' play such as Kruchenikh's *Gli-Gli*, would bombard the senses of the audience from every side. When the Revolution came in October of this same year, these artists stopped at nothing to realize their wildly ambitious plans of a new world transformed to the likeness of their dreams.

196 A corner of the Café Pittoresque, Moscow, 1917, designed by Tatlin, Yakulov and Rodchenko

1917–21

In October 1917 came the Revolution. To the artists this was the signal for the extermination of the hated old order and the introduction of a new one based on industrialization. As Futurists they could not but respond to the appeal of such a régime which announced the advent not only of a communal way of life in which the artist would be an integrated member of society, but also one which was based on industrialization. 'Let us seize [the world] from the hands of nature and build a new world belonging to [man] himself,'[1] Malevich announced. The Revolution gave a reality to their activity and a long-sought direction to their energies – for there was no question in their minds of not identifying their revolutionary discoveries in the artistic field with this economic and political revolution: 'The events of 1917 in the social field were already brought about in our art in 1914 when "material, volume and construction" were laid as its "basis",' announced Tatlin;[2] 'Cubism and Futurism were the revolutionary forms in art foreshadowing the revolution in political and economic life of 1917,' said Malevich.[3]

And so these 'leftist' artists, as they came to be called, leapt to the cause of the Bolshevik Revolution, releasing their frustrated energies in a nation-wide propaganda war for the new world which they felt to be imminent. So anxious were they to prove themselves useful contributing members of this new society – 'growing with the stem of the organism . . . and participating in its expediency', as Malevich expressed it[4] – that they took into their own hands the active reorganization of the artistic life of the country. Now, they announced, was not the time for idle picture painting – a square of canvas is, after all, a feeble and irrelevant means of communication (with odious associations with the *bourgeois* system) when the streets are yours to paint, the squares and bridges the obvious arena of activity. 'We do not need a dead mausoleum of art where dead works are worshipped, but a living factory of the human spirit – in the streets, in the tramways, in the factories, workshops and workers' home.'[5] Thus spoke

Mayakovsky at a discussion 'for the wide working masses' held in the requisitioned Winter Palace in November 1918. This open discussion was organized by the 'Department of Fine Arts of the Commissariat for the People's Education' – known as IZO Narkompros. (These abbreviated titles were typical of this period; there are so many of them and they are so alike that it is often difficult for the historian to identify them. So quickly was one organization succeeded by another, and so numerous were these bodies, that often people who themselves took part in these historic events, are at a loss to explain a sequence or recognize a name-tag.) The theme of this discussion was 'A sanctuary or a factory?' It is reported that the discussion, the fourth of its kind, was a huge success with the audience. Apart from Mayakovsky, Osip Brik and Nikolai Punin, the champion of Tatlin, spoke. Punin described the place of art in society during the Middle Ages in Europe and urged a return to these relations. The artist must cease to be the victim, and his art an object of worship. Already we have the 'culture of materials' which points the way to the new proletarian art: an entirely new era in art must begin. 'The proletariat will create new houses, new streets, new objects of everyday life. . . . Art of the proletariat is not a holy shrine where things are lazily regarded, but work, a factory which produces new artistic things.'[6]

The intuitive need of these artists to be active builders, first indicated in Tatlin's constructions in 'real materials and real space', was now to be given an opportunity to be expressed. Leaving their painting – 'speculative activity' – and their paint and brushes – 'useless and outmoded tools' – they joyfully plunged into the experiment, blissfully regardless of the physical and practical sacrifices involved. Most of their fellow-citizens were entirely absorbed in the day-to-day bitter struggle for survival, but these artists, one feels on reading their manifestoes and descriptions of their discussions and activities, were hardly living in this grim present. It is difficult to believe that they were almost literally starving – with the chaos in the countryside leading to monstrous difficulties in transportation, living conditions were reduced to the most primitive. They rode lightheaded on the surge of release and the sense of a new-born purpose to their existence; an intoxication drove them on to the most heroic feats: all was forgotten and dismissed but the great challenge which they saw before them of changing the world in which they lived. Surely it is the

first time in history that it has been given to so young a group of artists to realize their vision in practical terms on such a scale.

In the four short years allowed them, known as the period of 'heroic Communism', these few artists succeeded in setting up museums of their art all over the country and reorganizing the art schools according to a programme based on their recent discoveries in abstract painting. They took charge of the decoration of the streets for the First of May and October Revolution anniversary celebrations; they organized street pageants depicting the Revolutionary take-over involving thousands of citizens – a novel and highly successful method of identifying a people with a cause; in the same spirit they organized dramatic 'mock' tribunals in the public streets to instil the elements of Soviet justice, or to bring to heel any other 'enemy of the people'; in the same way rudimentary education was given in, for example, the laws of hygiene; how to rear chickens, or plant corn, or the correct way to breathe, were the subjects of some of these pageants and poster propaganda efforts. The whole man, the healthy worker of the new society, was a common ideal to both the artist and the Communist régime.

One of the biggest of the public demonstrations to be so organized was the first anniversary of the October Revolution. All over the country, wherever they happened to be – Kiev, Vitebsk, Moscow or Petrograd – the artists volunteered to prepare a suitable demonstration for this great holiday.

Nathan Altman took charge of arrangements in Petrograd, still the capital of the country. He requisitioned the great square in front of *Ills 197–99* the Winter Palace, decorating the central obelisk with huge abstract sculptures – a dynamic Futurist construction was mounted at the base of the column. The buildings all round the square were camouflaged in Cubist and Futurist designs. Twenty thousand 'arshins' of canvas were used to decorate the square! Two years later, not content merely with decoration, Altman, Puni, Bogoslavskaya and their friends staged a re-enactment of the storming of the Winter Palace – with, of course, *Ill. 200* complete realism. The realism was provided by a whole borrowed battalion and their equipment, and thousands of good Petrograd citizens, the whole dramatized by giant arc-lights – obtained in a desperate last-minute smash-and-grab from an electrician's shop – which threw up against the sky Altman's abstract designs behind the

197–199 Nathan Altman's designs
for decorating the great square
in front of the Winter Palace in
Petrograd, for the celebration of the
first anniversary of the October
Revolution of 1917

200 A photograph of the re-enactment of the Revolution staged by Altman and fellow-leftists in October 1920

hastily erected stage. It was decided at the dress-rehearsal that 'Kerensky' looked a puppet-figure in such surroundings – and so fifty Kerenskys were placed on a rostrum, fifty identical puppets, performing identical gestures fifty times over, as the Red Army – standing on a lower rostrum on the right-hand side (like Hell and the devils in a medieval pageant) – gradually drove the ceremonial White Army dolls in splendid array from their proud superiority. The overthrow of the White Army was followed by the triumphant surging forward of the two thousand spectators as the battalion drove through the gates in their lorries accompanied by every kind of instrument, trumpeting, whistling, ringing the triumph of the Bolshevik Revolution. Small wonder that when the authorities heard about it later – no permission had been thought necessary for a theatrical pageant – there was a severe reprimand for the commander of the battalion who had known nothing about it. It might have been real![7]

201 An Agitation-Instruction train: The Red Cossack

On a smaller scale physically, but with the same enthusiasm, these artists, actors, writers and composers organized 'heroic-revolutionary' impromptu plays all over the country. Tatlin, Annenkov and Meyerhold designed sets while factory siren symphonies took place under Mayakovsky's supervision in his drive towards 'making the streets his brushes and the squares his palette'.[8] Trains decorated with Revolutionary themes were sent to the front carrying news of the Revolution – both political and artistic – to every corner of the country.[9] There seemed to be no limit to the ingenuity with which these artists made propaganda for the Revolution.

Lenin himself suggested early in 1918 that towns should erect propaganda monuments to the world heroes of the Revolution. The list of those to be honoured included Belinsky and Chernishevsky, but also Moussorgsky, Courbet and Cézanne. However, the project was by and large not much of a success.[10] Most of the artists who were commissioned to execute such monuments were of the realistic school, for sculpture in Russia had lagged far behind painting and the relatively small number of sculptors were hopelessly academic. The works which they produced were painfully naturalistic portraits, many times larger than life. They were stuck up on pedestals in the middle of Moscow in mid-winter, executed in the most primitive materials. If noticed at all, their *naïveté* apparently excited nothing but smiles. Those which tried to be more expressive, perhaps in a

Ills 201, 202

224

vaguely 'Cubist' or 'Futurist' style, insulted the citizens by their 'distortion' of much-loved faces. Sherwood's Cubist portrait of Bakunin could not be unboarded for days, because of such feeling against it – when it was, it was demolished in a matter of hours by anarchists!

The only monument whose style matched its subject was Tatlin's dynamic *Monument to the IIIrd International*. It was early in 1919 that the Department of Fine Arts commissioned him to execute this project which was to be erected in the centre of Moscow. During 1919 and 1920 he worked on it and built models in metal and wood with three assistants in his studio in Moscow. One of these was exhibited at the Exhibition of the VIIIth Congress of the Soviets held in December 1920. 'A union of purely artistic forms (painting, sculpture and architecture) for a utilitarian purpose' was how Tatlin described it.[11]

Ill. 203

202 The 'Red Star' Agitational-Boat

For it was not to be an idle symbol – how unsuited to the new economic order if a useless monument should be raised to its glory! No! It was to be dynamic, both in its outward form and inner activity. 'Least of all must you stand or sit in this building, you must be mechanically transported up, down, carried along willy-nilly; in front of you will flash the firm, laconic phrases of an announcer-agitator, further on the latest news, decree, decision, the latest invention will be announced . . . creation, only creation.'[12]

It was this quality of movement which was introduced as an aesthetic principle in Tatlin's Monument that immediately became a characteristic of the design of the emerging Constructivist movement. Gabo's first 'Kinetic models' and Rodchenko's mobiles likewise date from 1920.

Tatlin's Monument was to be twice the height of the Empire State Building. It was to be executed in glass and iron. An iron spiral framework was to support a body consisting of a glass cylinder, a glass cone and a glass cube. This body was to be suspended on a dynamic asymmetrical axis, like a leaning Eiffel Tower, which would thus continue its spiral rhythm into space beyond. Such 'movement' was not to be confined to the static design. The body of the Monument itself was literally going to move. The cylinder was to revolve on its axis once a year: the activities allocated to this portion of the building were lectures, conferences and congress meetings. The cone was to complete a revolution once a month and to house executive activities. The topmost cube was to complete a full turn on its axis once a day and to be an information centre. It was constantly to issue news bulletins, proclamations and manifestoes – by means of telegraph, telephone, radio and loudspeaker. A special feature was to be an open-air screen, lit up at night, which would constantly relay the latest news; a special projection was to be installed which in cloudy weather would throw words on the sky, announcing the motto for the day – 'a particularly useful suggestion for the intemperate North'.

Unfortunately the project never got further than the models which Tatlin and his assistants built in wood and wire. These models came to be a symbol of the Utopian world which these artists had hoped to build. In many ways it is typical of their hopes, so ambitious, so romantic and so utterly impractical. For though fired by the idea of actively taking part in building and organizing the new world, in

226

203 Vladimir Tatlin, *Monument to the IIIrd International*, 1919–20

dismissing the easel painting as an anachronism both in its tools and its social connotations, they were not equipped to become the artist-engineers of which they dreamed.

The Department of Fine Arts (IZO) was created in 1918 under the Commissariat for People's Education (Narkompros). It was responsible for the organization and running of the artistic life of the country under the new Soviet government. It was through their domination of this institution that the 'leftist' artists came to be called the official artists of the new society. Lunacharsky, the Commissar of Education, was a man of liberal outlook and broad culture. Before the Revolution when he had been living in exile he had known a number of his countrymen who had been studying art abroad in Paris, Munich or Berlin. Among these was his great friend David Shterenberg. He also knew Nathan Altman and was aware of Kandinsky's reputation in

204 Naum Gabo.
*Project for a
Radio Station,*
1919–20

205
Alexander Rodchenko,
Construction, 1920

206
Alexander Rodchenko,
Hanging Construction,
1920

Germany. When he returned to Russia to take up his appointment in the Bolshevik government, Lunacharsky naturally turned to these former friends and acquaintances to help him. David Shterenberg was appointed Director of IZO, and the executive consisted almost entirely of artists. Altman became head of the Petrograd section, and Tatlin of its Moscow counterpart. Both the 'right' and 'left' schools were invited, but it was the 'leftist' who responded and thereby gained that 'leftist dictatorship of the arts' which their right-wing colleagues so bitterly complained of later when they had taken heart again under the New Economic Policy in 1921. Kandinsky, Altman, Nikolai Punin the art critic, Osip Brik the Futurist writer and apologist of the Proletcult, and Olga Rosanova, who died so prematurely, were among other 'leftist' members of this IZO Kollegia.

One of the first actions of the Kollegia was to set up a Museum Bureau and Purchasing Fund, which became one of its most ambitious schemes. The government contributed two million roubles to buy modern works of art and to equip and set up museums throughout the country. During the years 1918–21 thirty-six museums were set up throughout the country and twenty-six more were planned at the time when the Kollegia was liquidated in 1921.[13] These museums were equipped with works bought from artists of every school, although there were angry protests in *Pravda* in 1918[14] against the fund being used to buy works of Futurists '. . . whose future is still extremely controversial', instead of Benois, Golovin and other 'World of Art' and established pre-Revolutionary artists. Lunacharsky himself answered this accusation. 'Purchases are being made from all artists, but in the first place from those artists who were outlawed during the reign of *bourgeois* taste and who are therefore not represented in our galleries.'[15] With this chain of galleries, Russia became the first country in the world to exhibit abstract art officially and on such a wide scale.

Rodchenko was the Director of the Museum Bureau. Although it was the Museum 'Kollegia' which actually selected the works, it was Rodchenko's job to decide to which towns the works should be allocated. Perhaps he was not quite the impartial arbiter that he might have been. Gabo tells the story that Kandinsky – a member of the Museum Kollegia – approached him one day to warn him that Rodchenko was proposing to send Gabo's composition *A Head* to a

tiny village Tsarevokokshaisk in the depths of Siberia. The indignant Gabo withdrew his work immediately, to the fury of Rodchenko!

Thirteen of these new galleries were entitled 'Museums of Artistic Culture', a name based on Tatlin's 'Culture of materials'. The idea of such a museum and its organization was put forward by Nikolai Punin, an editor of the influential 'leftist' organ *Iskusstvo Kommuni* (Art of the Commune), a weekly paper which ran from 1918 to 1919, and great friend and champion of Tatlin. The Museum of Artistic Culture was to be devoted entirely to artistic education 'to enable people to become familiar with the development and methods of artistic creation'.[16] In addition, there was to be an 'Historical Museum' and an 'Exhibition Museum' – the former having, of course, no claim to artistic influence, being simply a reference centre for scientific study. This attitude of dismissing the art of the past as having no creative contribution to make to the art of the present day was basic to Punin and his colleagues on the *Iskusstvo Kommuni* – it was to become one of the chief accusations levelled against the 'leftists' in later years.

The two principal galleries of Artistic Culture were organized in Moscow and Petrograd in 1918. They housed a permanent exhibition of 'leftist' art, and it was in the Petrograd Gallery that Tatlin produced Khlebnikov's play *Zan-Gesi* in 1923.[17] Malevich later lived in the *Ills 146, 147* building in Petrograd, being in charge of a laboratory of experimental painting in the gallery school during the years 1923–8. *Ill. 218*

In the summer of 1918 the old Petrograd Academy of Art had been closed, its teachers sacked and all its paintings requisitioned by the government. The school broke away and for a short time existed as an autonomous body. In October of the same year, however, it was re-formed under IZO as the Petrograd Free Studios (Svomas). The programme of the re-formed school announced:

1. All those wishing to receive specialist art training have the right to enter Svomas.
2. This applies to those over the age of 16. No kind of diploma of education is demanded.
3. All those who previously belonged to art schools are considered members of Svomas.
4. Applications will be accepted all the year round.

207 Kuzma Petrov-Vodkin, *1918 in Petrograd*, 1920

This announcement was signed by Lunacharsky and Shterenberg.[18] Added to this was the right to elect one's own professor and to divide into working groups according to one's choice. Altman, Puni, Petrov-Vodkin and later Tatlin, Malevich and Shterenberg had studios in Svomas.[19] This was a real revolution from the dead academic body which it had swept away, 'a clearing of the Augean stables' as it was called. Nevertheless such a very liberal organization soon led to a state of complete anarchy and chaos. In 1921 the Svomas were abolished and the schools were brought under the 'Akademia Khudozhest-vennikh Nauk', Academy of Sciences. In 1922 it was re-established according to a programme worked out by Kandinsky.

In Moscow much the same pattern evolved. In 1918 the College of Painting, Sculpture and Architecture was closed and re-formed, together with the previous Stroganov School of Applied Art, into the 'Higher Technical-Artistic Studios' (Vkhutemas). Gabo describes the set-up of the Vkhutemas thus:

What is important to know about the character of the institution is that it was almost autonomous; it was both a school and a free academy where not only the current teaching of special professions was carried out (there were seven departments: Painting, Sculpture,

232

Architecture, Ceramics, Metalwork and Woodwork, Textile and Typography) but general discussions were held and seminars conducted amongst the students on diverse problems where the public could participate, and artists not officially on the faculty could speak and give lessons. It had an audience of several thousand students, although a shifting one due to the civil war and the war with Poland. There was a free exchange between workshops and also the private studios such as mine. . . . During these seminars as well as during the general meetings, many ideological questions between opposing artists in our abstract group were thrashed out. These gatherings had a much greater influence on the later development of constructive art than all the teaching.[20]

Among those who had studios here were Malevich, Tatlin, Kandinsky, Rosanova, Pevsner, Morgunov, Udaltsova, Kusnetsov, Falk and Favorsky. The latter artist was an engraver who later had a great influence on the first generation of Vkhutemas painting students, such as Deineka and Pimenov, which arose as a reaction to the abstract schools in the early 'twenties.

Ill. 208

Ill. 213

The programme of the 'leftist' professors in the Vkhutemas was dictated by the Institute of Artistic Culture, an organization entirely

208 Vladimir Favorsky, an engraved illustration to the Book of Ruth, published in 1925

dominated by the 'leftists', which concerned itself with working out a theoretical approach to art under a Communist society. Its first branch was set up in Moscow in May 1920 as a section of IZO; in December 1921 it extended its activities to Petrograd under Tatlin, and to Vitebsk under Malevich.

The Institute of Artistic Culture – known as Inkhuk – was initially to be run according to a programme worked out by Kandinsky. This programme embraced Suprematism, Tatlin's 'Culture of materials' as well as Kandinsky's own theories. It was an attempt to systematize these various experiences into a pedagogical method. The programme was published in 1920 with the formation of Inkhuk.[21] It was divided into two parts: the 'Theory of separate branches of art' and 'Combination of separate arts to create a monumental art'.

The first part consists of an analysis of the specific qualities of each artistic medium. The point of departure is to be the psychological reaction of the artist to the quality. (For example: red is known to excite activity.) On the results of such analyses an Art Dictionary of conscious line and forms is to be made covering every medium. A dictionary of free, exceptional forms is also to be compiled in a similar way.

Colour is to be examined in (*a*) its absolute, and (*b*) its relative values.

a. The colours are to be studied first individually and then in combinations. These studies are to be co-ordinated with medical, physiological, chemical and occult knowledge and experience of the subject, e.g. sensory association and colour; colour and sound, etc.

b. Colour in combination with drawn forms. This is to be approached by:

1. Combination of primary colours with simple geometric forms.
2. Combination of complementary colours in similar forms.
3. Crossed combinations of primary and complementary colours in simple geometric forms.
4. Primary colours combined with free, exceptional forms.
5. Crossing combinations of colour and forms.

A dictionary noting the conclusions of such a programme is to be published.

234

The second part of the programme was to be devoted to the creation of monumental art. 'This would be most conveniently worked out in the theatre where the qualities of individual artistic media are to be worked out, e.g. words or movement can be reduced to their basic by means of repetition, combination, etc., until a state of ecstasy is induced.' Scriabin's work was quoted as an example of parallel streams of colour and sound.

These ideas, which were shortly afterwards to form the basis of Kandinsky's Bauhaus course, met with strong opposition on the part of the future Constructivists in Inkhuk. Engrossed with a rationalist conception of artistic creation, Kandinsky's ideas of art as a psychic, intuitive process were anathema to them. And so Kandinsky's programme was almost immediately turned down by a majority vote.

As a result of this dismissal of his ideas, Kandinsky left Inkhuk. At the end of the year he was invited by Lunacharsky to become a member of the Praesidium which was to reorganize the various educational and artistic institutions in Moscow as an Academy of Sciences. This was in accordance with Lenin's New Economic Policy, introduced in 1921, and formed part of Lunacharsky's scheme for the reorganization of the educational system of the country.

Kandinsky was destined never to see any of his programmes for art education put into practice in his native country. The one that he worked out for the new Department of Fine Arts in the Academy of Sciences was similar to that which he had proposed to Inkhuk,[22] but the authorities were occupied with acute problems of lack of food, fuel and living space, and it was shelved.

The Department of Fine Arts in the new Moscow Academy was not organized until 1922. By this time Kandinsky had left Russia to take up the post offered him in the Weimar Bauhaus.

With Kandinsky's departure from Inkhuk a new programme was worked out. After much discussion, 'pure painting' was dismissed by everybody, but the members of the Institute were divided on the next step to be taken and therefore divided themselves into two groups. The members of the first group were to devote themselves to 'laboratory art', those of the second to 'production art'. This division was to become more and more marked until it led to the dramatic split in the ranks of these 'leftists' in 1921.

The exhibitions organized under the new régime were dominated

by Suprematism. The first was held in December 1918, and was a large retrospective exhibition devoted to the work of Olga Rosanova, who had died of diphtheria a few months before. Rosanova was so typical a member of this *avant-garde* in Russia that it is worth while giving a brief outline of her life. Born in 1886 in a small town near Vladimir, she came to Moscow to do her art training in a private studio and then in the Stroganov School of Applied Art. She was a foundation-member of the 'Union of Youth' group in Saint Peters-burg and among the first to be associated with this Futurist movement. She was both a painter and a poet, contributing to most of the Futurist publications in one or other or both of these capacities; she was an ardent speaker in the many pre-war public discussions. Her place in the modern movement in Russia is not that of an innovator but, like Popova and Exter, of a talented follower. Her early work reflects the influence more of the Italian Futurists than the French Cubists, and her abstract painting, which dates from 1916, retained this dynamic force. After the Revolution, Rosanova, with her early connection with the Stroganov School, devoted her energies to the reorganization of industrial art in the country. It was due to her energies that a special sub-section in IZO was created in August 1918 dealing with this field: she brought many existing schools into this organization through personal persuasion and by travelling far and wide throughout the country. This needed a phenomenal courage and sense of mission, for conditions in the country at this time were chaotic and it was almost impossible for civilians to get transport. Before she died Rosanova drew up a plan for the reorganization of the museums of industrial art in Moscow which was later carried out. Her schemes for the reconcilia-tion of art and industry were likewise soon realized in the Con-structivist movement. When she was taken ill she was actually engaged in putting up banners and slogans in an aerodrome for the coming anniversary celebrations of the October Revolution, and died within a week of this. Her posthumous exhibition which opened a few weeks later included 250 paintings from Impressionism to Suprematism.

Following this, the next exhibition of interest was the 'Fifth State Exhibition', held at the beginning of 1919. It was entitled: 'The Trade Union of Artist-Painters of the New Art. From Impressionism to Abstract painting', and was held in the Museum of Fine Arts – now the Pushkin Museum – in Moscow. In keeping with the Revolutionary

theory, this was a jury-less exhibition to which anyone who felt the title to be apt for his work could contribute.

It was notable chiefly for the work of Kandinsky, who sent a number of paintings of 1917 such as *Descent*, *Grey Oval*, *Green Comb* and *Clarity*; and for the introduction of Anton Pevsner to the Moscow scene. Otherwise, the abstract schools were represented by Rodchenko, Stepanova and Popova. Neither Tatlin nor Malevich sent any pictures. On the other hand, there were several minor, passed-over artists such as the 'Knave of Diamonds' group, Russian members of the Munich 'Blaue Reiter' and Favorsky the graphic artist.

At this point it may be useful to give a brief sketch of the lives of Anton Pevsner and his brother Gabo, and their contribution to the post-Revolutionary art scene in Russia.

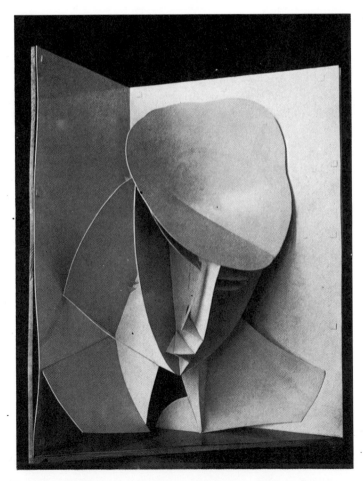

210
Naum Gabo,
Head of a Woman,
1916–17

Anton Pevsner (1886–1962) began to paint in 1902, having discovered and become fascinated by Byzantine art. In 1910 he went to Saint Petersburg and entered the Academy of Art, but the following year left for Paris, where he remained, except for a brief return to Russia in 1913, until the outbreak of war. While staying in Oslo during the war, Pevsner continued to paint Cubist works such as *Carnaval*, to which the early *Heads* of Gabo, his brother, produced in 1915 and 1916, bear a close relation. It was not until after the brothers had left Russia, early in 1922, that Pevsner began working on constructions. He and Gabo have continued to follow the theories which they evolved when still in Russia; their work, like so much in the history of the modern movement in Russian art, was introduced most dramatically to the West by Diaghilev in their designs for his ballet *La Chatte* (1926). Gabo and Pevsner belonged to the anti-production-art group in Inkhuk; to express their opposition to these future Constructivists they wrote their Realistic Manifesto.[23]

Ill. 209

Pevsner's younger brother Naum (born 1890), who later took his middle name Gabo in order to avoid confusion with his brother, had spent the war years in Oslo, where he had begun working on his first constructions in such materials as sheet-metal and celluloid. Gabo did not attend an art school, but after taking his university degree in medicine in Munich in 1912, he began an engineering course and also attended Wölfflin's lectures on the history of art. It was while working out mathematical problems that he first began to make constructions – his first works being cubes and geometrical figures. After his elder brother's arrival in Oslo, and probably under his influence, he began (1916–17) doing representational constructions with titles such as *Head* or *Torso*. In 1917 he returned to Moscow and produced some architectural designs such as *Project for a Radio Station*, not unlike the experiments of the future Constructivists. In particular Gabo shares with them an interest in the dynamic principle. Unlike his brother Anton, Gabo did not take part in any exhibition while in Russia and held no official position in the Vkhutemas. However, as he says: 'Unofficially I was as active in the life of the school as if I had an official appointment . . . my brother Anton Pevsner had a studio there teaching painting, but any of his students who wanted to learn sculpture were my students. . . .'[24]

Ill. 210
Ill. 204

To return to the 'laboratory art' faction of Inkhuk. The 'Fifth State

Exhibition' was eventually succeeded by the 'Tenth State Exhibition: Abstract Creation and Suprematism'. This was the culminating point of abstract painting in Russia and unlike the previous show was limited to the kernel of the 'laboratory art' group. Malevich sent his

Ill. 211 famous 'White on White' series to this exhibition. In the catalogue to the exhibition, Malevich wrote: 'I have broken the blue shade of colour boundaries and come out into white. Behind me comrade pilots swim in the whiteness. I have established the semaphore of

Ill. 212 Suprematism.' In reply to this, Rodchenko sent his *Black on Black* painting. His manifesto reads chiefly as a list of quotations: 'As a basis for my work I put nothing' (M. Stirner). 'Colours drop out, everything is mixed in black' (from Kruchenikh's play *Gli-Gli*). 'Murder serves as a self-justification for the murderer, for he tries thereby to prove that nothing exists' (Otto Weininger: Aphorism), together with many quotations from Walt Whitman. Popova, Stepanova, Alexander Vesnin and two representative works by Rosanova were also shown at this exhibition, which consisted of 220 works in all. This was the last group painting exhibition by this 'leftist' *avant-garde* in Russia.

Malevich, however, had a one-man show at the end of 1919 in which his work was summed up. It was called 'From Impressionism to Suprematism' and included 153 works. With this one-man show, Malevich announced that Suprematism as a movement in painting had come to an end. He told Pevsner that 'the cross' – which is the dominant symbol in many of his last works – 'is my cross', so personally did he feel this 'death of painting'. From this time, until NEP and his appointment as a Professor in the Petrograd Museum of Pictorial Culture, Malevich worked more and more in his school in Vitebsk.

There is a scandal attached to Malevich's take-over of this school. Originally, Chagall was appointed Director of his native Vitebsk School of Art in 1918. However, he made the mistake of inviting a few of his colleagues from Moscow to come and teach there, among whom was Malevich. Shortly afterwards, taking advantage of Chagall's temporary absence in Moscow, Malevich took over the school and informed Chagall that his work and methods were old-fashioned and irrelevant, and that he, Malevich, was the guardian of the 'new art', and future Director of the Vitebsk School of Art. Such was Malevich's stubbornness and power of repartee that he – typically

240

– had his own way, and the highly disgruntled Chagall left for Moscow, where he began working as a scenic designer for The State Jewish Theatre. One of his greatest works, sadly now destroyed, was his decoration of this theatre's vestibule with a great frieze.

Ill. 168

It was in Vitebsk that Lissitzky, who had been working with Chagall there since before the Revolution on Jewish book illustration, first came in contact with Malevich. Malevich was one of the most ubiquitous of those 'leftist' artists, whose constant travelling and simultaneous occupation of several posts during these first four years of the Soviet régime make tracing their movements and activities such a particularly nightmarish job for the historian – there are almost no accounts of this period; those that exist are one-sided or very sketchy; the reminiscences of people still living tend to be likewise contradictory. And so any account of this period has to rely largely on things like exhibition catalogues and newspaper reviews, which necessarily give a rather dry and schematic result.

Malevich renamed the Vitebsk school 'Unovis', which is short for College of the New Art,[25] and began there to evolve his pedagogical method. Our knowledge of his method of teaching is so far limited to what he himself has written on the subject. Much of the book, which appeared in German in 1927 as *Die Gegenstandlose Welt*, one of the Bauhausbücher series, is devoted to his theories of colours, forms and their interrelations. How far and in what way this was systematized in a practical teaching method is difficult to ascertain. Certainly, judging from the charts which Malevich sent to the German 'Kunstausstellung'[26] of 1927 in Berlin, there was little scientific basis for his theories, and it must have remained in fact a matter of intuition, not unlike that which Kandinsky advocated to Inkhuk. During this period in Vitebsk, Malevich wrote several other articles and brochures[27] dealing first with his personal road to abstract painting, and then on a more general level, writing of his views on life and religion. Malevich's language shows an odd mixture of the illiterate, the patriarch and the genuine poet, but his highly illogical use of words, often in two or three senses in the same work, makes his writing of dubious value in explaining his ideas. For the same reason these works are extremely difficult to translate, and lose much by translation. His sentences are sometimes of immense length – and he strings his words together in such a way that often the sense is conveyed by half-meanings and by

211 Kasimir Malevich, *Suprematist Composition: White on White*, 1918

the very obscurity of the expression. In translation they sometimes cease to have any meaning whatever.

Malevich spent little time in Moscow during 1920 and 1921, and thus he virtually conceded victory to the 'production art' group in Inkhuk. It was during this time that Rodchenko became more and more concerned with social questions and in common with his wife

212 Alexander Rodchenko, *Black on Black*, 1918

Stepanova, Alexander Vesnin, Alexandra Exter and Liubov Popova turned more and more towards the ideas of Tatlin and his 'Culture of materials', towards the idea of the 'artist-engineer'. These artists' last stand for 'speculative painting' before abandoning it for 'real work' was reflected in the exhibition '5 × 5 − 25' in which only the above-mentioned five artists took part.

1921–22

The artistic administration of the country during the first four years of the Soviet régime, known as the period of 'heroic Communism', presents a picture of extreme confusion and anarchy. By 1921, however, the civil war, the war with Poland, and the German and Allied intervention had come to an end with the Bolsheviks emerging triumphant. The country had been devastated by these seven long years of war and isolation, and was further prostrated by the appalling famines of 1921–2. But Russia was at last at peace and contact with the outside world was again possible. A period of reconstruction and demand for order thus came to replace the feverish atmosphere of the previous four years when no one had known from one day to another who was in power or what the next day held for them.

The general attempt to bring order into the country was reflected in the artistic administration by a reorganization of all existing bodies – which were legion – bringing them under the central administration of Lunacharsky and Narkompros ('The Peoples Commissariat for Education'). This measure was of little practical effect, however, due largely to the financial crisis and the consequent replacement of government patronage of art by that of the new *bourgeoisie*. The force of the Proletcult movement likewise opposed this centralization of artistic affairs under the aegis of a Party control.

The Proletcult – short for the 'Organization for Proletarian Culture' – was founded in 1906. It did not, however, become an effective body until the Revolution of 1917. Its doctrine was of a militant Communist order, and its professed aim the creation of Proletarian culture: 'Art is a social product, conditioned by the social environment. It is also a means of organizing labour. . . . The Proletariat must have its own "class" art in order to organize its forces in the struggle for socialism.'[1] The chief theorist of the Proletcult movement was Bogdanov, a Marxist who had always quarrelled with Lenin on the tenet, basic to the Proletcult movement, that there are three independent roads to Socialism: the economic, the political and the cultural.

On this theory Bogdanov proclaimed the Proletcult to be an autonomous body, independent of the Party; Lenin, on the other hand, held that all organizations should be under the central Party administration. This conflict soon came to a head, and in October 1920 Lenin took Lunacharsky to task for supporting the Proletcult's claim to be the 'true representatives of Proletarian culture'; in December he ordered the Proletcult to submit to the authority of Narkompros.[2] It is reported that Lenin said that such a monopoly by one school to the title of official Proletarian art was both ideologically and practically harmful.[3] However, the idea of a separate Proletarian culture persisted into the 'thirties and is now embodied in the official aesthetic of Socialist Realism.[4] This fierce rivalry for the title of 'Proletarian artist' was a feature not only of the first four years of the Soviet régime, but continued throughout the 'twenties until 1932 when 'Socialist Realism' was announced as the one official style, and all artistic organizations were brought under one central body, the 'Union of Artists'.

Immediately after the Revolution, the Proletcult set about putting into practice its long-prepared system. From the beginning there was a natural interest in uniting art and industry, since as the Proletcult was basically concerned with creating a mass-culture, industry was the natural starting-point for its activities. In August 1918 a Proletcult 'Art-Production sub-section' was formed on the lines of a programme drawn up by Olga Rosanova, who thereupon became head of this department until she died in November 1918.

In 1922, due to a combination of forces, most of the artists in Inkhuk who were moving towards Constructivism became members of the Proletcult. The partial return of the capitalist system introduced under Lenin's New Economic Policy brought to an end the 'dictatorship' which these artists had enjoyed during the four years of 'heroic Communism'. Under NEP a new *bourgeoisie* arose which was soon in a position to patronize the arts, unlike the penniless government, and naturally enough this new art patron inclined towards a familiar form, 'pre-Revolutionary' in every sense of the term. This return of the old enemy to power disgusted the 'leftist' artists, but it also meant that they had to look for other means of support, and industry was the obvious solution. However, this turning to industry was also a logical step in the internal development of ideas in Inkhuk, of the gradual

dismissal of easel painting and 'pure art' towards the idea of Constructivism and 'production art'.

With the transfer of the capital from Petrograd to Moscow in 1918 most of the 'leftist' artists congregated in the new centre of activity. These were months of extreme physical hardship during which most of the population was existing at subsistence level. For the artists this was a time of furious activity, largely confined to endless discussion and projected schemes. They were obsessed with the new role which they, as artists, were being called upon to play. Art was no longer something remote, a vague ideal of society, but life itself. The fact that 'life itself' was at that moment in a state of utter social and economic chaos did not disturb them; it made the ideal of a world transformed by mechanization all the more breathtaking and miraculous. They leapt forward in their imagination and designs to this inevitable future, a world of skyscrapers, rockets and automation – for indeed such is the world which, if examined, their projects foretold. The tragedy of these artists lies in the contradiction between the Utopia that they envisaged and planned and conditions as they actually were. Most of their projects either remained on paper or were realized only in make-believe, in theatrical productions. But of such plans and ideas there was no shortage.

Passionate debate was therefore their main occupation; the inevitable subject – the question of the role of the artist and of art in the new Communist society. It was largely as a result of these endless debates that the Constructivist ideology emerged.

Inkhuk in Moscow was the centre of these debates – although they took place everywhere and at all times.

From the outset there was a division among the Institute's members which became more and more pronounced as the year 1920 lengthened into 1921.

On the one side stood Malevich, Kandinsky and the Pevsner brothers. They argued that art was essentially a spiritual activity, that its business was to order man's vision of the world. To organize life practically as an artist-engineer, they claimed, was to descend to the level of a craftsman, and a primitive one at that. Art, they claimed, is inevitably, by its very nature, useless, superfluous, over and above workmanlike functional design. In becoming useful, art ceases to exist. In becoming a utilitarian designer, the artist ceases to provide the

source for new design. Malevich in particular felt that industrial design was necessarily dependent on abstract creation, that it was a second-hand activity, which drew its being from idealized studies of the 'contemporary environment' – such as his 'Arkhitektonics' and 'Planits' – which were to act as models for a new style of architecture. His pottery designs also are Suprematist 'ideas' of a cup or a teapot, rather than practical designs. The working out of a practical system of Suprematist design he left to his followers – such as Suetin.

Ills 137–39

Ills 216, 217

Ills 214, 215

On the other side, Tatlin and the ardently Communist Rodchenko insisted that the artist must become a technician; that he must learn to use the tools and materials of modern production in order to offer his energies directly for the benefit of the Proletariat. The artist-engineer must build harmony in life itself, transforming work into art, and art into work. 'Art into life!' was his slogan, and that of all the future Constructivists – not to be interpreted in the naïve sentimental way in which the 'Wanderers' and the Abramtsevo colony had 'taken art to the people', by idealizing the peasant and his

213
Yury Pimenov,
*Give to Heavy
Industry*, 1927

crafts as the source of life, but by utilizing and welcoming the machine. The machine as the source of power in the modern world would release man from labour, transforming it into art. Are not the artist and the engineer united by the process of work? The work-process in art and industry is alike governed by economic and technical laws; both processes lead to a finished work, an 'object'. But whereas the artist's creation is pursued to its completion, the engineer's 'object' is 'unfinished', it stops short at the functional. But the rationalized process of production is common to both; it is an abstract organization of materials. The engineer must develop his feeling for materials – through the method of 'Material culture' – and the artist must learn to use the tools of mechanical production.[5]

I have already described in the previous chapter how Kandinsky's programme was turned down by a majority vote in Inkhuk in 1920. Following this came an agreement that 'pure art' and easel painting were no longer valid preoccupations. The new ideology which now emerged was first expressed in a 'laboratory art' programme. There were two schools of thought in the interpretation of this new ideology: those who 'passed on' from easel painting by adopting a rationalizing, analytical attitude to their work, but who still continued to work with the traditional paints and canvas; and those who abandoned the medium altogether, following Tatlin's example, to work in 'production art' – Tatlin at this point was working on the design of a *Ill. 230* stove which would consume the minimum fuel and give out the maximum heat, a most justifiable occupation in those days when houses were being torn to pieces to provide firewood. Tatlin was, however, as always alone in his work, but his ideas were taken up and given a Marxist interpretation by Osip Brik, Tarabukin and Alexei Gan, not themselves artists but militant propagandists of the Proletcult idea in Inkhuk.

The ideology governing these two schools of 'laboratory art' became known as 'Objectism' The 'object' might equally well be a poem, a house or a pair of shoes. An 'object' was the result of an organized pursuit towards a utilitarian end, of the aesthetic, physical and functional qualities of the materials involved, whose form would emerge in the process of this pursuit.

With the crystallization of this 'Object' ideology in Inkhuk, many of those who were hostile to it left the Institute. The Pevsner brothers

248

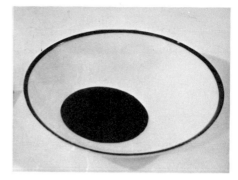

214, 215 Suetin, two plates with Suprematist designs, *c.* 1920

soon left Russia altogether, developing their Constructive Idea in the West. The elder brother Anton Pevsner went to France, Gabo went first to Berlin, then to England and finally to America. Kandinsky, as we have seen, studied in Moscow developing his theories, then left for the Bauhaus. Malevich began to concentrate his activities in Vitebsk.

No sooner had 'The Object' become defined as an ideology than a reaction arose against it. This 'Counter-Object' movement became known as Constructivism. Constructivism was worked out as an ideology in Inkhuk during the summer and autumn of 1921. It represented the change-over from the 'laboratory' stage to a programme for active production based on the experiments of the last four years. 'The Object' idea was dismissed as a romantic, impractical ideology which in practice would actually lead to reaction in industry. For the basic idea of the artist-engineer supervising the complete

216, 217 Kasimir Malevich, cup and teapot designed for the State Pottery, Leningrad, *c.* 1920

process of making an object meant, of course, that the mechanization would be reduced to a very primitive level. In actual mass-production, work is inevitably divided up into separate departments, and no one sees an object through from start to finish at a practical level. The new Constructivist ideology was above all concerned with a practical 'bridge between art and industry'.

An initial step in working out this new system was to sum up the 'laboratory' experience of the last four years.

In September 1921 Rodchenko, Stepanova, Vesnin, Popova and Exter held an exhibition in Moscow entitled '$5 \times 5 = 25$' which summed up the group's past year's work in 'laboratory art'. The catalogue which they produced with the exhibition is revealing of the state of mind of the time, both in the 'rationalized' descriptions of the paintings which it listed and the catalogue in itself, which was a charming piece of craftsmanship. I have seen two copies of this catalogue and both contained original watercolours by each exhibitor, as it were the signature of each artist. It is typical that the 'end of painting' which this exhibition announced should have been so decoratively expressed.

That this was consciously recognized as the last stand of easel painting as an expressive medium is made clear from the artists' own statements in this catalogue.

Ill. 212 Rodchenko declared: 'In 1919 at the Tenth State Exhibition for the first time I declared space constructions in painting *Black on Black*, at the Nineteenth State Exhibition of the following year I declared line as a factor of construction. At this present exhibition for the first time in art the three primary colours are declared.' The last statement was illustrated by three canvases of 1921 entitled *Pure Red Colour*, *Pure Yellow Colour* and *Pure Blue Colour*. Included in this exhibition were

Ill. 190 such works as *Line Construction* of 1920. There were also study-constructions of basic geometric elements like his *Construction of*

Ills 205, 219 *Distance*, worked out first on paper and then in materials. A little later

Ill. 206 Rodchenko developed his ideas in hanging mobiles, introducing the

Ill. 203 dynamic element which unites him with Tatlin (who was then working on his Monument project), and Gabo who was working on

Ill. 204 his 'Kinetic models' during 1920–1.

Stepanova declared: 'Composition is the contemplative approach of the artist in his work. Technique and industry have confronted art

250

with the problem of construction as an active process and not a contemplative reflection. The "sanctity" of a work as a single entity is destroyed. The museum which was a treasury of this entity is now transformed into an archive.' Popova contributed a series of 'experiments in painterly-force construction'. These were listed as 'space-volume', 'colour-surface', 'enclosed space construction' and 'space-force'. As an explanation of these works she wrote: 'All the given constructions are pictorial and must be considered simply as a series of preparatory experiments towards materialized constructions.' Exter contributed five abstract works of 1921 'which represent part of the general programme of experiments on colour contributing to the problem of mutual colour relationships, their mutual tensions and rhythms and the transfer to colour-construction based on the laws of colour itself'.

Another line of experiment in this 'laboratory art' was represented by the pupils of Tatlin and Rodchenko who worked on spatial constructions, 'immediate studies of materials in the material itself, in order to discover the aesthetic, physical and functional capacities of such materials', with a particular emphasis on those used in industry. An illustration of these ideas was the 1920 exhibition of the 'Obmokhu' group – 'Society of Young Artists'.

218 Malevich teaching pupils in the Institute of Artistic Culture, Leningrad, 1925

Ill. 220 The 'Obmokhu' exhibition showed the works of thirteen young Vkhutemas students. They exhibited their constructions in the school itself during May 1920. These works were mainly free-standing metal constructions. A dominant characteristic was the dynamic urge of these works: the spiral was a typical form. None of them was a solid piece of 'sculpture', but open-spatial compositions 'which dynamically intersect inner and outer space'. In the following year the most prominent of these 'Obmokhu' students, the Stenberg brothers and Kasimir Medunetsky, had a three-man show in the Vkhutemas.[6] By this time they had identified themselves with the Constructivists and in the following year, in November 1922, they subscribed to the declaration which denounced art 'as a speculative activity' and pro-
Ill. 239 ceeded to work chiefly in the theatre. Together with Exter, Yakulov
Ill. 242 and Alexander Vesnin they were the principal designers for Tairov and Meyerhold's revolutionary productions in the Moscow Kamerny Theatre during the 'twenties. The Stenberg brothers' cinema and theatrical advertisements and posters were pioneer examples of Constructivist typography and design.

As a continuation of this rationalization of 'laboratory art', in the autumn of 1921 a system of lectures was begun in Inkhuk in which artists reported on their work. Unfortunately none of these lectures

219 Alexander Rodchenko, *Construction of Distance*, 1920

220 A view of the first Obmokhu— Society of Young Artists— exhibition held in the Vkhutemas, Moscow, in May 1920

was published, but their titles give one an idea of the ground covered and the general direction of ideas: 'On the dialectical and analytical method in art', 'An analysis of the conception of the object of art', 'The rhythm of space', 'The aesthetic of easel painting'.

The first lecture in this series introduces a new and important figure to the scene. It was given in September 1921 by the architect-painter El Lissitzky and entitled 'Prouns – a changing-trains between painting and architecture'.

Lissitzky was an engineer by education. He had studied in Darmstadt during the years 1909–14. During the war he turned to architecture and completed his training with an architect in Moscow. In 1917 he began working with Chagall and other Jewish graphic artists on book illustration. Their works were chiefly published in Kiev, the *Ill. 167* centre of the Jewish artistic *avant-garde*. When Chagall was appointed Director of the Vitebsk School of Art in 1918, Lissitzky joined him there as a professor of architecture and graphic arts and they continued to produce books of a Cubist-Futurist style of illustration strongly influenced also by the peasant 'lubok'. It was from this Jewish tradition that the first post-Revolutionary experiments in typography, which are among the first examples of 'modern' typographical design, were done. It was here in Vitebsk in 1920 that Lissitzky designed his 'Story

Ill. 225 of Two Squares', published in Berlin in 1922, which seems to be the first fully developed example of the 'new typography' published in the West.

It was in 1919 that Lissitzky painted his first *Proun*, after seeing the great 'Tenth State Exhibition' of abstract painting in Moscow early in that year. This exhibition was Lissitzky's first contact with the ideas of Malevich and the other non-objectivist schools who exhibited on this occasion. Lissitzky's interest in lettering was soon combined with these new abstract compositions. A poster of his of 1919, reading *Ill. 226* 'Beat the Whites with the Red Wedge', is an amusing illustration of these 'leftish' artists' contribution to Bolshevik propaganda. In 1920 Lissitzky left 'Unovis', the Vitebsk school now under the leadership of Malevich, and moved to Moscow to become a professor in the *Ill. 169* Vkhutemas. Here he continued to work on his *Prouns*, which almost from their beginning reflect a combination of both Suprematist and Constructivist ideas. He was one of the chief channels of these ideas to the West for he travelled a great deal in Western Europe during the next few years – 1921–30 – visiting Germany, France, Holland and Switzerland, where he came in contact with all the chief personalities of 'the modern movement', working not only in the field of typo- *Ills 227, 228* graphy, but in exhibition and poster design, developing his method according to this synthesis of Constructivist and Suprematist principles.

221 Lev Bruni,
Construction, 1917

222 Pyotr Miturich,
Construction No. 18,
1920

223 Kasimir Medunetsky,
Construction No. 557, 1919

224 Pyotr Miturich,
Construction, 1920

Before describing the development of this synthesis in industrial design and his role as a channel of communication between Russia and the West we need to return to 1921 to trace the development of Constructivism in theory and practice.

Another of the lectures given in Inkhuk, in December 1921, was by Varvara Stepanova, who spoke 'On Constructivism'. This is interesting as an indication of the point at which the term 'Constructivism' was acknowledged by the artists to describe their ideas. At first this ideology had simply been called 'production art'. The term 'Constructivism' is said, as is the usual way with 'isms', to have been invented by an art critic.

The various contemporary statements by the artists themselves on Constructivism are for the most part incoherent, doctrinaire, an unco-ordinated series of slogans: 'Art is dead! . . . Art is as dangerous as religion as an escapist activity. . . . Let us cease our speculative activity [painting pictures] and take over the healthy bases of art – colour, line, materials and forms – into the field of reality, of practical construction.' These phrases are quoted from the first important publication of the group's ideology – *Constructivism* by Alexei Gan,

8 9 10

225 *The Story of Two Squares*. A book of ten pages invented and designed by
El Lissitzky, printed in 1922. Lissitzky also did a Dutch version for the periodical
De Stijl

1. About 2 Squares. El Lissitzky
2. To all, to all Young Fellows
3. El Lissitzky: A Suprematist story—about Two Squares
 in 6 Constructions: Berlin, Skythen, 1922
4. Do not read: Take—Paper...........Fold
 Blocks...........Colour
 Pieces of wood....Construct
5. Here are—Two Squares
6. Flying towards the Earth—from far away—and
7. and—see—Black Chaos
8. Crash—all is scattered
9. and on the Black was established Red Clearly
10. Thus it ends—further

published in Tver in 1922. The ideas in this book, by a future leading
Constructivist typographer and apologist of the movement, are
expressed as much in the layout as in the wording: Gan has strung one
or two staccato phrases banner-wise across a page, making free use of
heavy underlining bars, and he has juxtaposed different types, serif
and sans-serif, to punch a point home. If one wishes to look for a more

226 El Lissitzky, Street Poster, 1919–20. *Beat the Whites with the Red Wedge*

precise and reasoned explanation of Constructivism, one has to turn to the poets, such as Mayakovsky, the theorists Osip Brik and Boris Kushner in the magazine *Lef* or to Vsevelod Meyerhold the actor-producer whose theory of 'Bio-mechanics' is an adaptation of Constructivist principles to the theatre.

In Constructivism the emphasis throughout is on technique which was to replace 'style' of any kind.

The material formation of the object is to be substituted for its aesthetic combination. The object is to be treated as a whole, and thus will be of no discernible 'style' but simply a product of an industrial order like a car, an aeroplane and such like. Constructivism is a purely technical mastery and organization of materials on three principles:

 a. the tectonic (act of creation),
 b. the factura (manner of creation),
 c. the construction.

Ills 255, 256 This manifesto was published in the first number of *Lef*, the Constructivists' organ, in 1923.

227 El Lissitzky designed this pull-out folder for the catalogue to the Soviet section of the International Press Exhibition held in Cologne in 1930. It represents the interior of the pavilion, for the organization of which he was responsible

228 A section of the Berlin 1923 Russian exhibition whose arrangement was devised by Lissitzky on a dynamic basis of integrating the rooms with the works exposed

From this time date the first attempts on the part of these erstwhile abstract artists to devote themselves to practical, industrial design. Tatlin was by far the most uncompromising in his interpretation of these ideals and he was the only one of these artists who actually entered a factory – the Lessner metallurgical factory near Petrograd – in an attempt to become an 'artist-engineer'. Popova and Stepanova did, however, go and work in a textile factory, the Tsindel, near Moscow, where they designed fabrics. Rodchenko began co-operating with Mayakovsky on poster-propaganda work and developing a Constructivist method of design in typography, introducing photography as an expressive medium.

The activities of the Constructivists now had the backing of the efficient Proletcult organization, which provided them with regular work and a livelihood through its contacts with industry.

The Proletcult had early set about making contact with trade union organizations, and now under NEP the scheme gained added impetus. Artists began designing emblems, stamps, slogans, posters: by the early 'twenties they were creating workers' clubs in which everything from the tables and chairs to the slogans on the walls and the light-fittings were designed in a Constructivist style. It is interesting to note the constant geometrical basis for these designs. The use of an ideal proportion is a characteristic of Constructivist design and in this

Ills 231, 232
Ill. 235

Ill. 234 differs so radically from the functional 'New Life' system of design which Tatlin was evolving during the 'twenties.

It is important to distinguish between the work of the main body of Constructivists and that of Tatlin. Tatlin designed workers' clothes which would allow the maximum movement and warmth with the *Ill. 230* minimum weight and material; and a stove, likewise answering in its design as closely as possible to the functional requirements.

> The Constructivists worked in materials, but in an abstract fashion, as a formal problem mechanically applying technique to their art. Constructivism did not take into account the organic relation between the material and the tensile capacity, its working character. Essentially it is only as an outcome of the dynamic force resulting from these mutual relations that a vitally inevitable form is born.[7]

Tatlin worked very little with the Constructivists, although they came closest to his own ideas. This was typical of his character, for Tatlin always chose to work apart with a few chosen disciples, rather than with a general group. One of his pupils at the Vkhutein[8] in the late 'twenties, and afterwards a trusted assistant on the *Letatlin* glider on which Tatlin worked during the 'thirties, describes how Tatlin became distrustful of people to the point of madness and would never show anyone his work, having a horror of being imitated or made use of.

Tatlin took organic forms as the basis of his design. The natural movement and measure of man dictated his design; whereas the Constructivists, like the Dutch 'de Stijl' group, demanded that man should be moulded in Futurist fashion to an arbitrary geometric

229
Varvara Stepanova,
Textile design,
1922–4

proportion. Rodchenko's furniture design, for all his talk of con- *Ill. 236*
tinuing the material in its logical inherent pattern, is not so much a
discovered form in the material as a bending of the material to a basic
idea. His chairs are no more 'functional' than their predecessors, but
simply the conventional form stripped bare – no new examination of
the nature of a chair. This was far more the concern and field of
inquiry pursued by Tatlin in his teaching, during the years 1927–31,
at the Vkhutemas (which became 'Vkhutein' in 1925 – 'Higher
Technical Institute', the 'production art' idea having fallen into
disgrace). In 1931, this school was liquidated and reorganized in
common with all other artistic organizations, under a central Party

230 This newspaper cutting was headed *Tatlin's New Way of Life*. We see
the artist himself modelling the 'Functional' worker's outfit he has designed—
with cut-out patterns included. The stove was one specially designed by Tatlin
in the hard days of 1918–19 to consume the minimum of fuel while giving
maximum heat

231 A memorial stamp to commemorate Lenin's death, designed by Nathan Altman, 1924

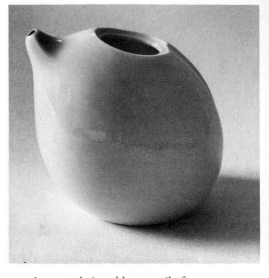

233 A teapot designed by a pupil of Tatlin's in the Moscow Vkhutein

232 Nathan Altman, design for a stamp, 1922

234 Vladimir Tatlin, a tubular steel chair with rubber moulded seat, c. 1927

235 Design by Alexander
Rodchenko for a Worker's
Club, exhibited at the Paris
Exhibition of Decorative Arts,
1925

нашего века конструктивизму не удалось с
достаточной отчётливостью осуществить свою
задача и привести на свои стороны квалифи-
цированные рабочие силы той или иной специ-
альности, то современная передовая архи-
тектура у нас и в Германии уже установила
теснейшую связь с конструктивизмом.

В РСФСР конструктивизм принят полиграфи-
ческим производством. Две такие огромные
материальные области художественного
труда, как архитектура и строительство и
фабрика печатной вещи, с нами.

Это, несомненно, факты огромного значения
и в этом залог новых побед конструкти-
визма в будущем.

АЛЕКСЕЙ ГАН

ФАКТЫ ЗА НАС

Работы конструктивистов свидетельствуют
о том, что конструктивизм не только на
словах разрешил проблему рационализации
художественного труда, но и на деле уже
осуществляет новые его виды, участвуя в
строительстве новой материальной культуры.

СТОЛ

236 Examples of multi-purpose
furniture and clothing
designed under Rodchenko at the
Moscow Vkhutemas, 1918–27

control, where Tatlin was head of the ceramic department and also taught furniture and general design.

In contrast to Tatlin's practical approach, the militant Constructivists' doctrinaire approach was not a fruitful one in the field of practical design. Their ideas were more all-embracing and led naturally to architecture, but this unfortunately was doomed to remain a paper-dream due to the economic distress of the country. It was not until the late 'twenties that it became possible to build more than exhibition stands or realize other than the most modest projects, such as Melnikov's design for a pavilion which housed the Soviet *Ill. 237* contribution at the Paris Exhibition of Decorative Arts in 1925. In this pavilion, the exhibits were dominated by the work of the Constructivists, and were far more radical than those of other countries, including Germany. The only obvious memorial to these early days of Constructivism actually realized in 1924 is Lenin's Mausoleum in the Red Square in Moscow. This was designed by Shchusev and was first built in wood, a material almost more precious than any during those days; later it was rebuilt in red granite. Few of the astonishingly pioneering projects of the Constructivist archi-

237 Konstantin Melnikov, The Soviet Pavilion at the Paris Exhibition of Decorative Arts, 1925

238 Ilya Golossov, Club of the Znev Commune Members, c. 1926

tects were actually built, for building on any scale became an economic possibility only in the latter 1920s; by the mid-1930s Constructivism was officially out of favour since the establishment of the dogma of Socialist Realism in 1932 by the Communist Party. In architecture as in all fields of design, this style was opposed to experiment and adopted the most conservative formulae – perhaps in reaction to the intense research of these years before. In the pictorial field 'Socialist Realism' took the 'Wanderers' as a model; for architecture it advocated a return to the classical style.

Deprived at first of their natural field of exploration in architecture, the Constructivists turned to the theatre and to propaganda industrial design. The theatre provided the best opportunity for realizing their highly mechanized Utopia, so pathetically at odds with the physical circumstances around them. Tairov, the Director of the Kamerny Theatre, was one of their most enthusiastic supporters, and had already employed a number of these would-be Constructivists before the Revolution in highly successful productions. After the Revolution he continued the partnership with Alexandra Exter and Yakulov. The latter artist's last work was a Constructivist set for Diaghilev's ballet *Le Pas d'Acier*. Tairov was the first to employ an architect to *Ills 240, 241* design his sets, when he invited Alexander Vesnin to design Claudel's *L'Annonce faite à Marie* in 1920 and *Phèdre* in 1922. This strengthened the idea of the theatre being a part of everyday life, dealing with

239 Scene from *Romeo and Juliet* with sets and costumes by Alexandra Exter. Produced in 1921

240, 241 A maquette of the set and costumes designed by Georgy Yakulov for the ballet *Le Pas d'Acier* produced by Diaghilev in 1927, and a scene from the production

242 Alexander Vesnin,
stage set for
Chesterton's play, *The
Man who was Thursday*,
produced in the Moscow
Kamerny Theatre in 1923

243 Lissitzky's model of his design for Sergei Tretyakov's *I want a child*,
1929, for Meyerhold's unrealized production.

everyday problems in everyday language, in an everyday surrounding, where the distance between actors and the audience was practically removed. It led eventually to the 'theatre in the round' idea evolved by Meyerhold and Okhlopkov in the late 'twenties. Conversely, this drawing of architects into the field of theatre and the vortex of ideas of the Constructivists was of immense importance; it led to the abrupt arrival of Russian architecture at the forefront of European design, a field in which they had been notably behindhand up till 1917.

Vsevelod Meyerhold, the theatrical director trained under Stanislavsky, was a leading Constructivist after the Revolution. His theory of 'Bio-mechanics'[9] was the application of Constructivist ideas in the theatre. A number of Constructivist artists worked for Meyerhold's theatre: Stepanova designed the sets for *The Death of* *Ills 244, 245* *Tarelkin* in 1922, and Liubov Popova for *The Magnanimous Cuckold* in the same year. Constructivism achieved its most complete realization in these theatrical productions, and in Sergei Eisenstein's early films.

The theory of Constructivism was not only an aesthetic but a philosophy of life. It affected not only man's environment but man himself. Man was to be the king of this new world, but a robot-king.

244 Varvara Stepanova. Stage set for *The Death of Tarelkin* produced by Meyerhold in Moscow in 1922

This Utopia envisaged a world in which art was no longer a dream-world to which the working man retired for relaxation and to regain his balance, but became the very stuff of his life.

Those of the Constructivists who sought most consciously to become artist-engineers found the fields of typographical and poster design to be the most fruitful. Here it was possible for the artist to make use of the most modern processes and skills and yet not to reduce the result to the level of the machine – as was inevitable in mass-production where industrialization, even at this point in Russia, demanded standardization. Thus Rodchenko, Lissitzky, Klutsis and Alexei Gan – who was largely the theorist of the group – worked out pioneer examples of modern typographical design. Rodchenko and Gan's *Ills 253, 254* work is the more purely Constructivist in principle: the predominance of the horizontal; the use of very heavy, square sans serif type; the Futurist machine quality. It is here that El Lissitzky's design combines Constructivist and Suprematist principles, and as such comes closest to creating the synthesis which we still recognize as 'modern' design. He uses the dynamic axis and the characteristic asymmetry of Suprematism; and he often weights the design at the top – characteristic of so many of Malevich's Suprematist paintings. He

245 Luibov Popova. Stage set for *The Magnanimous Cuckold*. Meyerhold Theatre, Moscow, 1922

246 El Lissitzky. A double page from the first edition of *For Reading Out Loud* by Mayakovsky, published in 1923

also, in his use of photo-montage, introduced the regular machine-rhythm of Constructivism.

Rodchenko and Lissitzky both incorporated photography into their typographical designs. Rodchenko's first printed photo-montage dates from 1923 when he illustrated Mayakovsky's anthology of poems *About This*.[10] Lissitzky and Rodchenko were responsible for doing the design and layout for most of the first editions of Mayakovsky's poetry published during the post-Revolutionary period.

Ill. 246 Lissitzky's design for *For Reading Out Loud* of 1923 is perhaps his finest piece of typography; Rodchenko worked in close co-operation
Ills 255, 256 with Mayakovsky on *Lef*, the organ of the Constructivists which ran from 1923 to 1925 and then in 1927–8 under the title of *Novii Lef* (New Left). This is probably his most important work, not only for the layout and the covers which he designed, but also for its inclusion of examples of his creative photography, although this is now difficult to appreciate, especially in reproduction, because of the poor quality

of the paper on which the magazine is printed. In his photography Rodchenko likewise worked out a Constructivist method. It has affinities with that of Dziga Vertov of 'Camera-Eye' and 'Kino-Pravda' documentary film fame, and with Sergei Eisenstein – for example, in the catching of movement at its height, the moment of maximum drama, obtained by a typically Constructivist low-angled shot.

Constructivism, unlike Suprematism, was essentially concerned with the social role of art; in many tenets it echoes the nineteenth-century 'Wanderers' – in the common disdain for 'art for art's sake' condemned by the 'Wanderers' as a 'dishonest occupation not worthy of a thinking man', and by the Constructivists as 'speculative activity' to be replaced by 'socially directed art-work'.[11] Both movements demanded that artists should concern themselves with reality 'a hundred times more beautiful than art', proclaimed Chernishevsky; 'The proletarian revolution is not a whipping cry but a real whip which chases out the parasitical from real life ... tearing oneself from speculative activity, one must find the way to real work, applying one's knowledge and skill to the real, live and expedient work'.[12] Both

247 The Stenberg Brothers. Poster design for Dziga Ventov's film *The Eleventh*, 1928

248 Klutsis, poster for first Five Year Plan: *Let us fulfil the plan of great works*, 1930

249 A cover design by Yuri Annenkov, 1922

250 El Lissitzky. Cover of the international Constructivist magazine of the arts edited by Lissitzky and Ilya Ehrenburg in Berlin in 1922

251 El Lissitzky, cover design for *Elephants in the Komsomol* by Mayakovsky, published Moscow 1929

252 Cover design by Lavinsky to the anthology of Mayakovsky's work entitled *13 Years of Work*. Volume 2, published 1922

253 Alexei Gan, cover design, 1927

254 Alexander Rodchenko, cover design to an anthology of Mayakovsky's poetry entitled *No. S*, 1927

movements led to extreme attacks on art itself 'which by its very
nature cannot be dissociated from religion and philosophy . . . we
declare uncompromising war on art!'[13] declared the Constructivists.
The famous discussion of the 1860s by Dobroliubov, one of the
prominent aesthetic philosophers of the nationalist movement,
entitled 'Shakespeare or a pair of boots?' echoes down the years and is
caught up again by these Constructivists. 'Neither to the right, nor to
the left, but to the needed.'[14]

Constructivism continued to be evolved as a working method
throughout the 'twenties in Russia, and during this period linked up
with the sympathetic movements in Western Europe. Contacts with
Russia had been resumed in 1921 with the lifting of the economic
blockade imposed by the Allies. Proof of this was a talk given in
Inkhuk by the art critic Kemeny, who came from Berlin for the
occasion. The lecture was entitled: 'On new directions in contem-
porary Russian and German art'. In the same year Lissitzky left for
Germany. The following year he and Ilya Ehrenburg, who had
accompanied him, edited a magazine *Veshch/Gegenstand/Objet* (there
were three numbers of this magazine, the second two produced
together) which propounded the 'object' aesthetic of Inkhuk of the

previous year, and brought together those parallel ideas which had arisen independently of one another all over Europe: those of the Jeanneret brothers' 'Esprit Nouveau' Paris group, of the Dutch 'de Stijl' – so close to Rodchenko's school of Constructivism – and those of the various non-objectivist Russian schools. This was the first post-war, multi-lingual, international magazine of the visual arts to unite the ideas and personalities which created the international functionalist school of design.

The most important mark of the return of Russia to the European artistic scene was the great exhibition of abstract art organized in the Van Diemen Gallery in Berlin in 1922, which later went also to Amsterdam. This exhibition summed up the history of the modern movement in Russian art, including as it did work by artists from the 'World of Art' of the 1890s up to the very latest Constructivists. It was the first notice the West was given of the schools of Russian abstract painting which had developed during the long period of isolation since the outbreak of war in 1914. This exhibition remains by far the most important and the only comprehensive exhibition of Russian abstract art to have been seen in the West. Not only was the content of this exhibition revolutionary, but also its presentation. El Lissitzky

255, 256 Cover design and a page from the magazine *LEF* by Alexander Rodchenko, 1923. This cover is one of the earliest and perhaps the most important piece of Constructivist typographical design for it is not only a cover-design with carefully constructed letters, but uses the new ideas in reproductive processes such as photo-montage and over-printing

Ill. 228 managed to get permission to design the interior of the gallery and arrange the works: in his organization of this exhibition he directly introduced the ideas which Tatlin and Yakulov had first applied in the Moscow Café Pittoresque, of using the wall space as a positive entity, an idea which Lissitzky so brilliantly further developed in his design for the Hanover Gallery room of abstract art for Alexander Dorner in 1926, and in the Soviet pavilions of so many international exhibitions during the 'twenties and early 'thirties, where he worked *Ill. 227* out a pioneer system of exhibition techniques, using photo-montage.

Conversely, through periodicals such as *SA* (Soviet Architecture)[15] the work which was going on in the West was introduced into Russia. This magazine published work and articles by Le Corbusier, Frank Lloyd Wright, Gropius and the 'de Stijl' group; it also discussed such things as the use of colour in interior design, its psychological and optical qualities. Later came *Arkhitektura SSSR* of 1933–6, which is particularly interesting for its articles dealing with the 'for and against' of Constructivist and functionalist architecture; it published most of the buildings of both these styles in Russia, including works by foreign architects such as the Centrsoyuz building of 1929, designed by Le Corbusier and built in Moscow. Many foreign architects came to Russia; for instance, the Dutch architect Mart Stam who worked on the Magnitogorsk project in Kazakhstan. For, as in Russia itself, so all over Western Europe artists were fired by the experiment of Communism which was so courageously being worked out there; from all over Western Europe artists looked to Russia for the realization of their 'new vision', for in Communism they saw the answer to the sad isolation of the artist from society which the capitalist economy had introduced. In Russia, under this new-born régime, they felt a great experiment was being made in which, for the first time since the Middle Ages, the artist and his art were embodied in the make-up of the common life, art was given a working job, and the artist considered a responsible member of society.

Text References

CHAPTER I

1. N. Chernishevsky, *Esteticheskie otnosheniya iskusstva k deistvitelnosti*

2. N. Polenova, *Ambramtsevo. Vospominaniya*, illus., Moscow, 1922

3. S. Yaremich, *Mikhail Alexandrovich Vrubel. Zhizn i tvorchestvo*. illus., Moscow, 1911

4. I. Zabelin, *Materiali dlya istorii ikonopisi po arkhivnim dokumentam*, 1850, and D. Rovinsky, *Obozrenie ikonopisania v Rossii do kontsa 17-ovo veka*

5. M. Voloshin, 'Surikov (Materiali dlya biografii)', *Apollon*, 1916, No. 6/7, pp. 40–63

6. Vrubel in a letter to his sister, May 1890, quoted in ref. no. 3

7. ibid.

8. ibid. pp. 80–86

9. ibid. pp. 31–33

CHAPTER II

1. see: *a* Alexandre Benois, *Vozniknovenie 'Mira Iskusstva'*, Leningrad, 1928

b Alexandre Benois, *Reminiscences of the Russian Ballet*, transl. Mary Britnieva, London, 1941

2. ibid.: *a*

3. Richard Muther, *Geschichte der Malerei im XIX. Jahrhundert*—to which Benois contributed the chapter on Russian art. Munich, 1893–4

4. A. J. Meier-Gräfe, *Modern Art*, 2 vols., 1908

5. see: ref. no. 1*a*

6. ibid.

7. ibid.

8. see: Prince Peter Lieven, *The Birth of Ballets-Russes*, London, 1936

CHAPTER III

1. S. Polyakov (ed.) *Vesi*, Moscow, 1904–9

2. P. Pertsov (ed.) *Novi put*, St Petersburg, 1906–7

3. Alexandre Benois (ed. 1903), A. Prakhov (ed. 1904–7), *Khudozhestvennoye Sokrovische Rossii*, St Petersburg, 1901–7

4. P. P. Veiner (ed.) *Stariye godi*, St Petersburg, 1907–16

5. Sergei Makovsky (ed.) *Apollon*, St Petersburg, 1909–17

6. Nikolai Ryaboushinsky (ed.) *Zolotoye Runo*, Moscow, 1906–9

7. Ya. A. Tugenkhold 'Frantzuskoye sobranie S. I. Shchukina', *Apollon*, No. 1–2, 1914. Includes complete list of works in collection

8. see: Alfred Barr Jr, *Matisse. His art and his public*, New York, 1951

9. quoted in: 'Le chemin de la couleur', *Art Présent*, No. 2, 1947

10. *Zolotoye Runo*, No. 6, Moscow, 1909

11. see: ref. no. 8.

12. S. Makovsky, 'Frantzuskoye sobranie I. A. Morosova', *Apollon*, No. 2, 1912. Includes complete list of works in collection to date

13. F. Filosofov, 'Mir Iskusstva tozhe tendentsia', *Zolotoye Runo*, No. 1, Moscow, 1908

14. N. Taravati, review of first *salon* of the 'Golden Fleece', *Zolotoye Runo*, No. 3, Moscow, 1906

15. N. Miliuti, 'O. Soyuze', *Zolotoye Runo*, No. 1, 1908

16. S. Makovsky, 'Golubaya Rosa', *Zolotoye Runo*, No. 5, 1907

17. ibid.

18. Introduction to *Zolotoye Runo Katalog Vuistavki Kartin*, 1909

19. see: ref. no. 8

20. see: ref. no. 18

21. see: *Color and Rhyme*, No. 31, 1956, p. 19, col. 3

22. *Zolotoye Runo*, No. 7/9, Moscow, 1908, pp. 5–66

23. *Zolotoye Runo*, No. 10, Moscow, 1908, pp. 5–66

24. *Zolotoye Runo*, No. 2/3, Moscow, 1909, pp. 3–30

25. K. S. Petrov-Vodkin, *Khilinovsk*, Leningrad, 1930, and the sequel *Prostranstvo Evklida*, 1932

CHAPTER IV

1. see: Graziella Lehrmann, *De Marinetti à Maiakovksi*, Zurich, 1942

2. see: Nikolai Khardzhev 'Mayakovsky i zhivopis' in *Maiakovksi. Materiali i issledovania*, Moscow, 1940, and *Russkoye Slovo*, No. 84, Moscow, 1914

3. see: Randa, *Vecher*, St Petersburg, 8 March 1909

4. These were the programme headings for the first part of a lecture entitled: *Having come myself* by Mayakovsky, given on 24 March 1913.

5. see: ref. no. 1

6. see: *Apollon*, No. 3, 1914

7. see: Katherine Dreier, *Burliuk*, New York, 1944, p. 66

8. Ludwig Gewaesi, 'V Mire Iskusstva' in *Zolotoye Runo*, No. 2/3, Moscow, 1909, pp. 119–20

9. E. Nisen (transl.), *O Kubisme*, St Petersburg, 1913; M. Voloshin (transl.), *O Kubisme*, Moscow, 1913; extracts also published with commentary in *Soyuz Molodezhi*, Sbornik, No. 3, St Petersburg, 1913

10. see: Larionov, *Luchism*, Moscow, 1913

11. Benedict Livshits, *Polutoraglazii Strelets*, Moscow, 1932

12. see: Katherine Dreier, *Burliuk*, New York, 1944, p. 59

CHAPTER V

1. see: N. Khardzhev, 'Mayakovsky i zhivopis' in *Mayakovsky. Materiali i issledovania*, Moscow, 1940, p. 358.

2. Larionov recalls that he chose this title for his exhibition because of a story he had read in a newspaper of a group of French painters who tied a brush to a donkey's tail and placed it tail-wise in front of a prepared canvas. The result was said to have been exhibited at the following public *salon* and to have received serious attention from a number of eminent critics before its origin was unmasked.

3. from Malevich's unpublished biography

4. see: *Oslinni Khvost i Mishen*, Moscow, 1913

5. On the back of one of his paintings, *The Violin and the Cow*, 1911, Malevich wrote 'The alogical collusion of two forms, the violin and the cow, illustrates the moment of struggle between logic, the natural law, bourgeois sense and prejudice. (signed) K. Malevich, 1911.'

6. see: Vyacheslav Zavalishin, *Early Soviet Writers*, New York, 1958, for a comparison of Bely's and Malevich's work and ideas.

7. see: G. Habasque, 'Les documents inédits sur les débuts de Suprématisme' in *Aujourd'hui: art et architecture*, No. 4, 1955.

8. Quoted from Tatlin's statement in *Vuistavka rabot zasluzhennovo deyatelya iskusstv V. E. Tatlina. Katalog*, Moscow, 1932

CHAPTER VI

1. see: *Pobeda nad solntsem*, Futuristicheskaya opera. Kruchenikh, Matiushina i Malevicha, Moscow, 1913

2. see: K. Malevich, *O novikh sistemakh v iskusstve*, Vitebsk, 1920

3. ibid.

4. see: Alexander Tairov, *Das Entfesselte Theater*, Potsdam, 1923

5. *Posmertnaya vuistavka Khudozhnika-Konstruktora Popovoi. Katalog*, Moscow, 1924

6. 'Khudozhestvennaya Kronika' in *Apollon*, No. 1, 1917, p. 37

7. ibid.

8. Nikolai Punin, 'V Moskve. O novikh khudozhestvennikh gruppirovkakh', *Iskusstvo Kommuni*, No. 10, 9 November 1919

9. See: V. Kamensky, *Put entusiasta*, 1931

CHAPTER VII

1. Quotation from Kasimir Malevich's manifesto published in *Desyataya Gosudarstvennaya Vuistavka. Bespredmetnoye tvorchestvo i Suprematism. Katalog*, Moscow, 1919

2. 'Nasha predstoyashchaya rabota. V. E. Tatlin i dr. in *VIIIoi S'ezd Sovetov. Ezhednevnii Bulletin S'ezda*, No. 13, 1921, p. 11

3. Quotation from Kasimir Malevich, *O novikh sistemakh v iskusstve*, Vitebsk, 1920

4. ibid.

5. 'Meeting ob iskusstve' in *Iskusstvo Kommuni*, No. 1, 7 December 1918

6. ibid.

7. I am indebted to Bertold Lubetkin, the Constructivist architect, for this description. He personally took part in this pageant and was one of the smash-and-grab raid party on the electrician's store.

8. see: a poem by Vladimir Mayakovsky, *Order to the Army of Art (Prikaz Armii Iskusstva)*

9. see: *Iskusstvo Kommuni*, No. 18, 7 April 1919

10. see: *Iskusstvo Kommuni*, No. 7, 9 January 1919

11. see: ref. no. 2

12. N. Punin, 'O pamyatnikakh' in *Iskusstvo Kommuni*, No. 14, 9 March 1919

13. 'Spisok museei i sobranii organizovannikh Museinim Bureau Otdela IZO N.K.P.' in

Vestnik Otdela IZO Narkomprosa, No. 1, 1921

14. *Pravda*, 24 November 1918

15. *Iskusstvo Kommuni*, No. 1, 7 December 1918

16. 'V Kollegii po delam iskusstva i khudozhestvennoi promuishlennosti. Muzeinii vopros' in *Iskusstvo Kommuni*, No. 8, 19 November 1919

17. see: *Zhizn Iskusstva*, No. 20, 1923

18. *Iskusstvo Kommuni*, No. 4, October 1918

19. see: *Iskusstvo Kommuni*, No. 1, 7 December 1918

20. Quoted from: *Gabo. Constructions, Sculpture, Paintings, Drawings Engravings*. Lund Humphries, London, 1957. 'Russia and Constructivism. An interview with Naum Gabo by Abram Lassaw and Ilya Bolotowsky, 1956'

21. *Programma Instituta Khudozhestvennoi Kulturi*, IZO Narkomprosa, Moscow, 1920

22. see: *Iskusstva*, 1923. 'Zhurnal Rossiiskoi Akademii Khudozhestvennickh nauk'

23. reproduced: *Gabo*, London, 1957. bibl.

24. see: ref. no. 20

25. 'Uchilishche novovo iskusstva'

26. These charts were included in the exhibition of Malevich's work which toured Europe; in London this exhibition was held at the Whitechapel Art Gallery in October 1959.

27. see: Bibliography

CHAPTER VIII

1. see: Sidorov (ed.), *Literaturniye manifesti*

2. see: *Gorn*, No. 1, Moscow, 1922

3. see: *Argonavti*, Moscow, 1923

4. see: E. J. Brown, *The Proletarian Episode in Russian Literature, 1928–1932*, New York, 1953

5. see: Alexei Gan, *Konstruktivism*, Tver, 1922

6. 'Vuishie Khudozhestvenniye Tekhnicheskiye Masterskiye': (The Higher Artistic Technical Studios)

7. Quotation from a statement by Tatlin in his exhibition catalogue: *Vuistavka rabot zasluzhennovo deyatelya iskusstv V. E. Tatlina. Katalog*, Moscow, 1932.

8. The Vkhutemas became the 'Vkhutein' (Higher Technical Institute) in 1928

9. For an explanation of Meyerhold's theory of 'Bio-mechanics' see: Huntley Carter, *The new spirit in the Russian theatre, 1917–1928*, New York, London, Paris, 1929

10. For an explanation of Rodchenko's work in Constructivist design see: Camilla Gray, 'Alexander Rodchenko. A Constructivist designer', *Portfolio*, London, New York, 1962

11. see: Alexei Gan, *Konstruktivism*, Tver, 1922

12. ibid.

13. ibid.

14. Tatlin quoted in: S. Isakov, 'Khudozhniki i revoliutsia' in *Zhizn Iskusstva*, No. 22, 5 June 1923

15. A. A. Vesnin and M. Ya. Ginsburg, *S.A. Sovetskaya Arkhitektura*, Moscow, 1925–9

Selected Bibliography

GENERAL WORKS

Alexandre Benois, *History of Russian painting*, New York, 1916 (English translation of *Istoriya Russkoi Zhivopisi v XIX veke*, St Petersburg, 1902)

Louis Réau, *L'Art russe de Pierre le Grand à nos jours*, 1922. 2 vols. bibl.

Richard Muther, *Geschichte der Malerei im XIX. Jahrhundert*, Munich, 1893–4 (Chapter on Russian art by Alexandre Benois)

Alfred Barr Jr, *Cubism and Abstract Art*, New York, 1936. bibl.

El Lissitzky and Hans Arp, *Die Kunstismen*, Zurich, 1925

Louis Lozowick, *Modern Russian Art*, New York, 1925

André Salmon, *Art russe moderne*, Paris, 1928

Konstantin Umansky, *Neue Kunst in Russland 1914–1919*, Munich, 1920. bibl.

L. Moholy-Nagy, *Von Material zu Architektur*, Munich, 1929. (English translation: *The new vision; from material to architecture*. New York, 1938)

L. Moholy-Nagy and L. Kassak, *Buch der neuer Künstler*, Vienna, 1922 (almost entirely illustration material)

Collection of the Société Anonyme: Museum of Modern Art, 1920. Yale University Art Gallery, New Haven, Connecticut, 1950. bibl.

Erste russische Kunstausstellung. Catalogue. Berlin, 1922. Introduction by D. Sterenberg

A. Dorner, *The way beyond art*, New York, 1947

A. Behne, *Von Kunst zur Gestaltung*, Berlin, 1925

C. G. Holme, *Art in the USSR*, The Studio, Special No., 1935

G. K. Lukomskij, *History of modern Russian painting*, London, 1945

G. H. Hamilton, *The art and architecture of Russia*, London, 1945

BACKGROUND WORKS

Alexander Tairov, *Das Entfesselte Theater*, Potsdam, 1923

Jan Tschichold, *Die neue Typographie*, 1928

Jay Leyda, *Kino. A history of the Russian and Soviet film*, London, 1960

J. Gregor, *Das russische Theater*, 1927

W. R. Fuerst and S. J. Hume, *Twentieth century stage decoration*, 1928

G. Kepes, *Language of vision*, New York, 1944

V. Erlich, *Russian Formalism*, The Hague, 1955

Vyacheslav Zavalishin, *Early Soviet Writers*, New York, 1958

E. J. Brown, *The Proletarian Episode in Russian Literature, 1928–1932*, New York, 1953

L. Trotsky, *Literature and revolution*, New York, 1925

L. Moholy-Nagy, *Vision in motion*, New York, 1947

O. M. Sayler, *The Russian theatre under the Revolution*, New York, London, 1922

A. Voyce, *Russian architecture*, New York, 1948

Film form; The film sense. Essays in film theory by Sergei Eisenstein. Edited and translated by Jay Leyda, New York, 1947

Huntley Carter, *The new spirit in the Russian theatre, 1917–1928*, London, New York, Paris, 1929

Huntley Carter, *The new theatre and cinema of Soviet Russia, 1917–1923*, London, 1924

Igor Stravinsky and Robert Craft, *Igor Stravinsky Memories and Commentaries*, London, 1960

Kurt London, *The seven Soviet arts*, London, 1937

M. D. Calvocoressi and G. Abraham, *Masters of Russian Music*, London, 1936

G. E. Abraham, *On Russian Music*, London, 1939

E. Lo Gatto, *Storia della letteratura russa*, Rome, 1960

Ernest J. Simmons (ed.), *Through the glass of Soviet literature. Views of Russian society*, New York, 1953

G. Struve, *Twenty-five years of Soviet Russian literature, 1918–1943*, London, 1944

G. Struve, *Soviet Russian literature, 1917–1950*, Oklahoma, 1951. bibl.

G. Reavey, *Soviet literature today*, London, 1946; New Haven, 1947

C. Frioux, *Maiakovski par lui-même*, Paris, 1961

D. Magarshack (ed.), *Stanislavsky on the art of the stage*, London, 1950

K. Stanislavsky, *My life in art*, Boston, London, 1924

I. Ehrenburg, *People and Life*. Memoirs of 1891–1917. English translation by A. Bostock and Y. Kapp. London, 1961

Boris Pasternak, *Safe Conduct*, London, 1959

A. M. Ripellino, *Majakovskij e il teatro russo d'avanguardia*, Turin, 1965

NATIONALIST MOVEMENT

S. K. Makovsky, *Talachkino. L'Art décoratif des ateliers de la Princesse Tenicheva*, St Petersburg, 1906

M. D. Calvocoressi, *Moussorgsky*, London, 1946

F. Chalyapin, *Man and mask*, London, 1932

G. E. Abraham, *Rimski-Korsakov. A short biography*, London, 1945

WORLD OF ART AND SYMBOLISM

Prince Peter Lieven, *The Birth of Ballets-Russes*, London, 1936

S. L. Grigoriev, *The Diaghilev Ballet, 1909–1929*, London, 1953

Alexandre Benois, *Reminiscences of the Russian Ballet*, London, 1941

Alexandre Benois, *Memoirs*, London, 1960

S. P. Diaghilev, *Théâtre Serge de Diaghilev*, Paris, 1924

N. Ryaboushinsky (ed.), *Le Toison d'Or* (magazine), Moscow, 1906–9. (First six months published in French and Russian; remaining issues in Russian only but with French titles and index)

PRIMITIVISM AND FUTURISM

Graziella Lehrmann, *De Marinetti à Maiakovski*, Zurich, 1942

Blaue Reiter, Exhibition catalogues, Munich, 1911, 1912.

Blaue Reiter Almanach, Munich, 1912

Neue Künstlervereinigung. Katalog. Munich, 1911.

David Burliuk (ed.), *Color and Rhyme* (magazine), No. 31, Hampton Bays, New York, 1956

ABSTRACT SCHOOLS

Guy Habasque, 'Documents inédits sur les débuts de Suprématisme', *Aujourd'hui: art et architecture*, No. 4, 1955

Kasimir Malevich, *Die gegenstandslose Welt*, Munich, 1927. (English translation from this German translation published as: *The Non-objective World*, Chicago, 1960)

M. Chagall, *Ma vie*, Paris, 1931

Julien Alvard, 'Les Idées de Malévitch.' *Art d'Aujourd'hui*, No. 5, July 1953

ART AND REVOLUTION AND CONSTRUCTIVISM

R. Fülop-Miller, *The mind and face of Bolshevism*, London, 1927

'G' (magazine), ed. Gräff, Kiesler, van der Rohe, Richter. Berlin, 1923–6

'ABC' (magazine), ed., Stam, Witwer, Lissitzky. Basle, 1925

N. Gabo, 'The concepts of Russian art', *World Review*, London, 1942

El Lissitzky, *Russland. Die Rekonstruktion der Architektur in der Sowjetunion*, Vienna, 1930

Jan Topass, 'Affiche en URSS'. *Arts et Métiers graphiques* (magazine), 1935

Exposition international des arts décoratifs et industriels modernes. URSS. Catalogue, Musée des arts décoratifs, Paris, 1925

Pressa. Katalog des Sowjet-Pavillons auf der internationalen Presse-Ausstellung, Cologne, 1928

R. Banham, *Theory and design in the first machine age*, London, 1960

Esprit Nouveau (magazine), ed. Le Corbusier, Ozenfant; Paris, 1920–5

Broom. An international magazine of the artists published by American artists in Italy. ed. H. Loeb, A. Kreymboro: Rome, 1921–8

Zarnowa (ed.) *Blok* (magazine) Lodz, 1924–8

Paul Westheim, 'Russian art under Lunacharsky', *De Stijl* (magazine), 1919

Max Eastman, *Art and the life of action*, 1935

Max Eastman, *Artists in uniform: A study of literature and bureaucratism*, London, New York, 1934

E. Ehrenburg, 'L'Art russe d'aujourd'hui', *Amour de l'art* (magazine), 1921

J. Freeman, J. Kunitz, L. Lozowick, *Voices of October*, 1930

L. Moholy-Nagy and A. Kemeny, 'The Dynamic Constructive System of Forces', *Sturm* (magazine), No. 12

E. and C. Paul, *The Proletcult (proletarian culture)*, New York, 1921

Camilla Gray, 'The genesis of Socialist Realism'. *Soviet Survey*, January–March, 1959

MONOGRAPHS ON ARTISTS

A. Levinson, *L. Bakst* (catalogue), Paris, 1928

A. Levinson, *The story of Léon Bakst's life*, London, 1923

Katherine Dreier, *Burliuk*, New York, 1944

I. Kloomok, *Marc Chagall: His Life and Work*, New York, 1951

J. J. Sweeney, *Marc Chagall*, New York, 1946

L. Venturi, *Marc Chagall*, New York, 1945

P. Galauné, *M. K. Čiurlionis*, Kaunas, 1938

V. Čiurlionyte-Karužiené, P. Galuané, etc. (ed.) *M. K. Čiurlionis*. Vilnius, 1961

Jan Kříž, *Pavel Nikolaevič Filonov*, Prague, 1966

Gabo. Construction, Sculpture, Paintings, Drawings, Engravings, Lund Humphries, London, 1957. bibl.

R. Olson and A. Chanin. *Naum Gabo, Antoine Pevsner*. New York, 1948

Exposition de Natalie Gontcharova et Michel Larionov. Catalogue, Galerie Paul Guillaume, Introduction by Guillaume Apollinaire, Paris, 1914

Larionov and Goncharova, Arts Council Retrospective Exhibition Catalogue, London, 1961. Introductory essays by Mary Chamot and Camilla Gray

The Goncharova-Larionov exhibition, Kingore Galleries, New York. Introduction and catalogue by Christian Brinton, 1922

V. Parnack, *Goncharova-Larionov; · l'art décoratif théâtral moderne*, Paris, 1919

Will Grohmann, *Kandinsky*, London, 1960. bibl.

Horst Richter, *El Lissitzky*, Cologne, 1958. bibl.

Camilla Gray, 'El Lissitzky. Typographer', *Typographica*, 1960

Jan Tschichold, 'El Lissitzky', *Imprimatur III*, 1930

El Lissitzky, Catalogue, Stedelijk van Abbemuseum, Eindhoven, December 1965

Kasimir Malevich, 1878–1935. Exhibition catalogue. Whitechapel Art Gallery, London, 1959. Introduction by Camilla Gray

Julien Alvard, 'Les idées de Malévitch', *Art d'Aujourd'hui* (magazine), No. 5, July 1953

Guy Habasque, 'Documents inédits sur les débuts de Suprématisme'. *Aujourd'hui: art et architecture*, No. 4, 1955

M. Duchamp. K. Dreier, C. Giedion-Welcker, Le Corbusier, R. Drouin, *Antoine Pevsner*, Paris, 1947

René Massat, *Antoine Pevsner et le Constructivisme*, Paris, 1956

Ausstellung Puni, Catalogue, Gal. der Sturm, Berlin, 1921

Camilla Gray, 'Alexander Rodchenko. A Constructivist designer', *Typograhpica*, London, June 1965

Oscar Bie, *Constantin Somoff*, Berlin, 1907

ARTISTS' WRITINGS

N. Gabo, 'The constructive idea in art', *Circle*, London, 1937

N. Gabo, 'The concepts of Russian art', *World Review*, London, 1942

N. Gabo, 'On constructive realism', *Architects' Year Book*, 1952. Also a Trowbridge Lecture, Yale, 1948

N. Goncharova, *Les Ballets Russes*, Paris, 1955

V. Kandinsky, *Uber das Geistige in der Kunst*, Munich, 1912. (An English translation: *The Art of Spiritual Harmony*, London, 1914)

V. Kandinsky, *Klänge*, Munich, 1913

V. Kandinsky, *Rückblicke* (autobiographical essay), Berlin 1913

V. Kandinsky. *Punkt und Linie zur Fläche*, Munich, 1926. (An English translation: *Point and Line to Plane*, New York, 1947)

El Lissitzky (with H. Arp), *Die Kunstismen 1914–1924*, Zurich, 1925

El Lissitzky, see: *Merz*, 1924, No. 8/9

El Lissitzky, 'Prouen' (Quotations from a letter), *ABC*, No. 2, Basle, 1925

El Lissitzky, 'Story of Two Squares' published in *De Stijl*, 1922 (in Dutch)

282

List of Illustrations

283

284

285

286

288

290

291

Index

References in italics denote illustration numbers

296